NEW ACCENTS

General Editor: TERENCE HAWKES

Studying British Cultures

Studying British Cultures brings an interdisciplinary approach to the study of national and cultural identities in Britain. The essays provide an overview of the development of British Studies and tackle the complexities involved in studying British cultures today.

All the contributors have been instrumental in establishing British Studies internationally, and here they address the key issues through their diverse positions in Cultural Studies, Literary Studies, language teaching and education. What they all share is a belief in the idea of culture as a plurality of discourses, rather than a fixed, unitary concept.

Studying British Cultures is essential reading for all students and scholars concerned with the study of contemporary Britain.

Susan Bassnett is Professor in The Centre for British and Comparative Cultural Studies at the University of Warwick. She has published extensively in the fields of Translation Studies, Comparative Literature, Theatre History and Inter-cultural Studies. She is author of *Translation Studies* (Routledge, 1991) and with Tracy Davis is currently editor of the Routledge *Gender and Performance* series. Her latest book, co-edited with Harish Trivedi, is entitled *Post-colonial Translation* (forth-coming Routledge, 1997).

NEW ACCENTS

General Editor: TERENCE HAWKES

IN THE SAME SERIES

Studying British Cultures

An Introduction

Edited by
SUSAN BASSNETT

London and New York

First published 1997
by Routledge
11 New Fetter Lane,
London EC4P 4EE

Simultaneously published in
the USA and Canada
by Routledge
29 West 35th Street,
New York, NY 10001

Typeset in Baskerville by
Ponting–Green Publishing Services,
Chesham, Buckinghamshire
Printed and bound in Great Britain by
Clays Ltd, St. Ives PLC

British Library Cataloguing in
Publication Data

A catalogue record for this book is
available from the British Library

Library of Congress Cataloguing in
Publication Data

A catalogue record for this book has
been requested

ISBN 0-415-16581-4 (hbk)
ISBN 0-415-11440-3 (pbk)

Contents

General editor's preface

How can we recognize or deal with the new? Any equipment we bring to the task will have been designed to engage with the old: it will look for and identify extensions and developments of what we already know. To some degree the unprecedented will always be unthinkable.

The *New Accents* series has made its own wary negotiation around that paradox, turning it, over the years, into the central concern of a continuing project. We are obliged, of course, to be bold. Change is our proclaimed business, innovation our announced quarry, the accents of the future the language in which we deal. So we have sought, and still seek, to confront and respond to those developments in literary studies that seem crucial aspects of the tidal waves of transformation that continue to sweep across our culture. Areas such as structuralism, post-structuralism, feminism, Marxism, semiotics, subculture, deconstruction, dialogism, postmodernism, and the new attention to the nature and modes of language, politics and way of life that these bring, have already been the primary concern of a large number of our volumes. Their 'nuts and bolts' exposition of the issues at stake in new ways of writing texts and new ways of reading them has proved an effective statagem against perplexity.

But the question of what 'texts' are or may be has also

become more and more complex. It is not just the impact of electronic modes of communication, such as computer networks and data banks, that has forced us to revise our sense of the sort of material to which the process called 'reading' may apply. Satellite television and supersonic travel have eroded the traditional capacities of time and space to confirm prejudice, reinforce ignorance, and conceal significant difference. Ways of life and cultural practices of which we had barely heard can now be set compellingly beside – can even confront – our own. The effect is to make us ponder the culture we have inherited; to see it, perhaps for the first time, as an intricate, continuing construction. And that means that we can also begin to see, and to question, those arrangements of foregrounding and backgrounding, of stressing and repressing, of placing at the centre and of restricting to the periphery, that give our own way of life its distinctive character.

Small wonder if, nowadays, we frequently find ourselves at the boundaries of the precedented and at the limit of the thinkable: peering into an abyss out of which there begin to lurch awkwardly formed monsters with unaccountable – yet unavoidable – demands on our attention. These may involve unnerving styles of narrative, unsettling notions of 'history', unphilosophical ideas about 'philosophy', even unchildish views of 'comics', to say nothing a host of barely respectable activities for which we have no reassuring names.

In this situation, straightforward elucidation, careful unpicking, informative bibliographies, can offer positive help, and each *New Accents* volume will continue to include these. But if the project of closely scrutinizing the new remains nonetheless a disconcerting one, there are still overwhelming reasons for giving it all the consideration we can muster. The unthinkable, after all, is that which covertly shapes our thoughts.

TERENCE HAWKES

Contributors

Christopher Brumfit is Professor of Education and Director of the Centre for Language in Education at the University of Southampton. He has degrees in Literature, Applied Linguistics and Education, and has worked substantially in Tanzania and the UK, with lengthy working visits to China, India and Canada. He has published thirty books on language and literature in education, most recently *Language Education in the National Curriculum* (Blackwell, 1995).

Michael Byram studied French, German and Scandinavian Studies at King's College, Cambridge, and took a PhD in Danish Literature. He then taught foreign languages in a comprehensive school before becoming a member of the School of Education of the University of Durham, where he is now Professor of Education with a special interest in foreign language pedagogy and the education of linguistic minorities.

Robert Crawford's collections of poems include *A Scottish Assembly* (Chatto, 1990), *Sharawaggi* (with W.N. Herbert; Polygon, 1990), *Talkies* (Chatto, 1992) and *Masculinity* (Cape, 1996). His critical books include *The Savage and the City in the Work of T.S. Eliot* (OUP, 1987), *Devolving English Literature* (OUP, 1992) and *Identifying Poets* (Edinburgh UP, 1993). He has recently edited a select bibliography of Modern Scottish Literature for

the British Council. He is Professor of Modern Scottish Literature at St Andrews University and an associate director of the St Andrews Scottish Studies Institute.

David Dabydeen was born in Guyana and grew up in England. He read English at Cambridge and presently teaches at the University of Warwick. His first book of poems, *Slave Song* (1984), was awarded the Commonwealth Poetry Prize. He has published two other collections of poetry, and three novels.

John Drakakis is Reader in English Studies at the University of Stirling. He is a graduate of the University of Wales at Cardiff, and he obtained his PhD from the University of Leeds. He has published books and articles on Shakespeare, Critical Theory, and Radio Drama, and he is currently the General Editor of the Routledge *English Texts* and *New Critical Idiom* series. He has just completed an edition of the 1597 Quarto of *The Tragedy of Richard III* for the *Shakespeare Originals* series, and he is currently editing a volume on *Tragedy*, and completing a book on *Shakespearean Discourses*.

Alan Durant is Professor and Head of the School of English, Cultural and Communication Studies, Middlesex University, London. As well as articles on literary and cultural criticism, music and education, his publications include: *Literary Studies in Action* (with Nigel Fabb; Routledge, 1990); *How to Write Essays, Dissertations and Theses in Literary Studies* (with Nigel Fabb; Longman, 1993); *Ways of Reading: Advanced Reading Skills for Students of Literature* (Martin Montgomery *et al*; Routledge, 1992); *The Linguistics of Writing: Arguments between Language and Literature* (edited by Fabb *et al*; Manchester University Press, 1987); *Ezra Pound, Identity in Crisis* (Harvester, 1981); and *Conditions of Music* (Macmillan, 1984). He has lectured extensively around the world on the teaching of English language, literature and media.

Antony Easthope is Professor of English and Cultural Studies at Manchester Metropolitan University. His publications include *Poetry as Discourse* (1983), *What a Man's Gotta Do* (1986), *British Post-Structuralism* (1988) and *Literary into Cultural Studies* (1991).

Katie Gramich is Senior Lecturer in English and co-ordinator of Welsh Studies at Trinity College, Carmarthen. She is a

comparatist whose main research interests are in the literatures of Wales in both Welsh and English, particularly writing by women. She is co-editor of the bilingual journal *Books in Wales/Llais Llyfrau*. She is currently writing a critical biography of the Welsh feminist, 'Moelona'.

David Punter is Professor of English Studies at the University of Stirling. He is the author of *The Literature of Terror* (Longman, 1980); *Romanticism and Ideology* (with David Aers and Jon Cook; Routledge, 1981); *Blake, Hegel and Dialectic* (Rodopi, 1982); *The Hidden Script: Writing and the Unconscious* (Routledge, 1985); and *The Romantic Unconscious: A Study in Narcissism and Patriarchy* (Harvester, 1989); and two small volumes of poetry. He is editor of *Introduction to Contemporary Cultural Studies* (Longman, 1986) and *William Blake: Selected Poetry and Prose* (Routledge, 1988). He has also published upwards of seventy articles and essays on romantic and modern literatures and on literary and cultural theory.

Sabina Sharkey is course director of the MA in British Cultural Studies at the University of Warwick where the new MA in Irish Studies has more recently been introduced under her guidance and directorship. As a guest lecturer she has contributed widely to a number of contemporary initiatives in British cultural studies within and outside Britain. Her publications are on aspects of gender and culture and she is currently completing a book on gender and colonial identity relations in seventeenth-century Ireland.

Acknowledgements

I should like to thank all those involved in the development of British Cultural Studies in the 1990s, whose contributions to discussions have been so valuable. The possibility of holding international meetings has frequently been realized by the generous assistance of the British Council, to whom thanks are also due. Nick Wadham-Smith deserves special praise for all his help and useful critical comments, as does Martin Montgomery, who has done so much to establish the field.

My thanks also to Talia Rodgers for her thoroughness and patience. Above all, thanks to Terry Hawkes, whose painstaking editing and endless good-humour have been so inspiring.

S.B.

Introduction
Studying British cultures
SUSAN BASSNETT

In the late 1980s a new interdisciplinary subject began to appear on the syllabus in a number of different countries. It was known variously as British Studies or as British Cultural Studies. In some cases the subject was linked to English-language learning, its objective was the study of British life, institutions and culture, and it was based upon the belief that successful communication can only take place where there is adequate awareness of the cultural context within which a language is used. This variant of British Studies is similar to what the Germans call *Landeskunde*, or Area Studies. It is primarily studied outside the English-speaking world, and is intimately connected to the study of the English language. British Studies offers students an alternative to American or Australian Studies, for example, and provides a bridge between language study and the social sciences.

The subject has also developed within literary studies, with consequent differences of content and methodology. Here the term British Cultural Studies is most frequently employed. The emphasis is on the study of cultural products, the approach derives from Cultural Studies and it is therefore founded on an examination of different discourses, not only on the study of language and institutions. This means that the subject can be studied by native speakers of English as well as by language

learners. It also means that there is a comparative and cross-disciplinary dimension to a great deal of research in the field.

Cultural Studies and British Studies

The origins of Cultural Studies can be traced to the late 1950s or early 1960s and to three key texts: Richard Hoggart's *The Uses of Literacy* (1957), Raymond Williams's *Culture and Society 1750–1950* (1958) and E.P. Thompson's *The Making of the English Working Class* (1963). In the preface to the 1987 edition of his book, Williams claimed that these three works are generally considered to have begun a new British intellectual and political tradition which gradually evolved into the subject known as Cultural Studies. The term 'Cultural Studies' was not originally used in the writings of the so-called founding fathers but gained credence after the establishment of the Birmingham Centre for Contemporary Cultural Studies under the director-ship of Richard Hoggart in 1964.

Williams, Hoggart and Thompson shared a common con-cern about what was understood in post-war Britain by 'cul-ture'. Their belief, that culture involved a whole way of life and thus was not the privilege of any particular class or intellectual elite, was a radical one and had immediate impact. In *Culture and Society*, Williams argued that in the modern world culture would be so complex that no individual could ever grasp it in its entirety. Culture would therefore always be fragmented, partly unknown and partly unrealized:

> any predictable civilization will depend on a wide variety of highly specialized skills, which will involve, over definite parts of a culture, a fragmentation of experience. . . . A culture in common, in our own day, will not be the simple all-in-all society of old dream. It will be a very complex organization, requiring continual adjustment and redraw-ing. To any individual, however gifted, full participation will be impossible, for the culture will be too complex.[1]

Today, such pluralism hardly seems radical. We have come to accept this notion unhesitatingly, because it seems so ob-vious. But in the 1950s, it challenged a fundamental premise of homogeneity, the existence of a single entity that could be controlled by those who decreed what culture was and what it

was not. The working-class writers of the late 1950s were derided in many quarters as 'kitchen sink' authors, their subject matter deemed a lapse of taste, a degeneration from some ideal of literary production. 'Culture' was still thought of as the property of a group who determined what should and should not be admitted to its realm. Hoggart, Thompson and Williams challenged that view, arguing that culture is multi-faceted and includes the products of different class, ethnic and generational groups.

At the same time, their theoretical and historical work was matched by the emergence of the creative artists and organizations which characterized what has come to be known as the 'generation of 1956': the working-class novelists and playwrights such as Alan Sillitoe and Shelagh Delaney, Joan Littlewood's Theatre Workshop, Clive Barker and Arnold Wesker's *Centre 42* project, Charles Parker and the radio ballads, the folk song revival that spread so rapidly in the early 1960s. The public prominence of working-class creative artists of all kinds, the development of the popular music industry, the invention of the teenager, the evolution of cultural phenomena targeted at quite specific groups, all reinforced the idea that a culture might not be a single all-encompassing entity but a complex network of different systems, a Babel of different languages.

Hoggart and Williams saw culture as plurivocal and as process, a shifting mass of signs rather than something that could easily be categorized and examined. The subject called Cultural Studies proved likewise not easy to categorize; it defied labels and resisted answers, preferring instead to ask questions. From its earliest manifestations, it crossed disciplinary boundaries and questioned assumptions about the validity of disciplines. As it developed as a field of study, it widened into different, often conflicting lines of enquiry. However, despite divergences, its radical parameters meant that virtually from the outset Cultural Studies challenged the orthodoxies of the academic establishment. The Birmingham Centre embarked on a series of projects that went beyond the limits of the canonical texts studied in literature departments. Hoggart's principal concern was to re-evaluate working-class culture and oral culture, previously marginalized or excluded from the canon. His successor, Stuart Hall, made the Centre more

internationalist, less literary in focus and less resolutely English, by shifting attention to mass media culture, to youth culture and the theoretical work of European and American sociologists and critics.

In his chapter in this volume, 'But what *is* Cultural Studies?' Antony Easthope traces the transformations that Cultural Studies in Britain have experienced since the late 1950s, and argues that there have been effectively three phases: what he terms the Culturalist phase of the 1960s, the Structuralist phase of the 1970s and the Post-Structural–Cultural Materialist phase of the last twenty years. The latest stage, he argues, involves the rejection of any positivist ideas of objectivity, so that the point of view of any writer or spectator is always inscribed in their account of anything. This means that whatever we study, our own subjectivity is a crucial element.

Today, Cultural Studies is recognized as a field that invites a pluralistic approach. Questions of race and gender have been added to the initial concerns of class, generation and ethnicity. Moreover, the field has developed from its specifically British-focused origins to reach other parts of the world. In their book *Relocating Cultural Studies* the editors Blundell, Shepherd and Taylor point out that during the Thatcher years of the 1980s, Cultural Studies fragmented and was developed in different ways in Australia, Canada and the United States:

> In these locations the theoretical and substantive concerns that came out of England have had to be not so much inflected as renegotiated. While none of these locations is free of class, the class-dominated concerns of English cultural studies (and particularly its preoccupation with spectacular sub-cultures) afforded little space for concerns which were not indigenous to English cultural life. It is of interest, for example, that all three locations to which cultural studies was exported have continuing and serious debates about the place of aboriginal peoples in white-dominated societies. These concerns are not present in England, and Europeans in general might have difficulty relating to them.[2]

Blundell, Shepherd and Taylor show how priorities in Cultural Studies need to be redefined in different contexts. Here they suggest that what they significantly call *English* cultural studies was preoccupied with class issues, while Australian, Canadian

and United States versions of the subject focus upon the place of aboriginal peoples in white-dominated societies. But they erroneously state that such concerns are not present in England. On the contrary, many European societies are having to look long and hard at their cultural traditions, and the place of different aboriginal groups or of immigrant groups is fundamental to debates in Britain, France, Germany, Italy and Eastern Europe, because in the 1990s old questions concerning national identity and national culture are once again being raised. Franz Fanon pinpointed the difference between *nationalism*, with all its dangers of inherent racism and xenophobia, and *national consciousness*, which is an inclusive, not an exclusive concept and embraces racial, religious and ethnic difference. This distinction is a vital one in any society that is striving towards multiculturalism.[3] In Britain Salman Rushdie has spoken of the 'new empire within Britain'[4] while Hanif Kureishi's protagonist in *The Buddha of Suburbia* declares that he is an Englishman born and bred, not something he is especially proud of, but definitely an Englishman, 'a new breed as it were, having emerged from two old histories'.[5]

What is Cultural Knowledge?

One of the fundamental questions that continues to preoccupy theorists in foreign language learning is: what kind of knowledge is required for an understanding of another culture? Knowledge of a culture varies and there is no consensus. At one end of the scale we might find phrase books and tourist guides that tell us emphatically that all British people enjoy the traditional breakfast of eggs and bacon every morning and instruct us to learn phrases such as 'What a lovely day today!' as a conversation opener. At the other end of the scale, we might find a course that teaches students facts about the political and economic institutions of Britain, with topics such as Law and Order, the Monarchy, the Parliamentary System or the Family. Neither of these approaches is wholly satisfactory, for contact with another culture involves not only the acquisition of basic information but a complex hermeneutic process for the individual. Anyone learning another language, for example, embarks on a voyage of discovery, during which

perceptions are altered, unquestioned assumptions about culture and identity are challenged. As Jürgen Kramer points out:

> On the one hand, appropriation of a foreign means of signification (like the English language) does not leave it 'untouched': in acquiring bits and pieces of information we transform it (usually through reduction) in such a way that we can use it. On the other hand, our appropriation of a foreign means of signification does not leave us 'untouched', either: in the process of acquisition, our world-view changes. . . . (it) is a hermeneutic process in which we expose our own cultural identity to the contrasting influences of the foreign language and culture.[6]

Kramer emphasizes the hermeneutic process involved in studying any culture. For culture is a complex network of signs, a web of signifying practices, and anyone studying a culture needs to construct their own map of knowledge, recognizing also that any such map will need to be modified as the contours of the cultural landscape shift and evolve. Moreover, the drawing of the map will vary according to the individual: someone who is born into a culture and grows up in it will necessarily have a different perspective from someone who learns about that culture in their adult life, having spent their formative years elsewhere.

In his chapter, 'Cultural Studies and foreign language teaching' Michael Byram suggests that although anyone can study a culture there are fundamental differences between those who see themselves as 'native' and those who are encountering the culture through another language. This distinction between an 'insider' and 'outsider' perspective is one of the key differences between the study of cultures linked to foreign language learning and the interdisciplinary field known as Cultural Studies. Byram argues that Cultural Studies as it developed in the British tradition was primarily produced by 'insiders', those with privileged access through language and personal history. He notes that Cultural Studies and foreign language learning have until recently been poles apart. He criticizes Cultural Studies for its parochialism, its excessive emphasis on the 'insider' as both subject and reader, in similar terms to Blundell, Shepherd and Taylor. But he also criticizes the simplistic assumptions about culture that often underlie foreign language

teaching where the emphasis is on an uncritical reading of surface phenomena.

The chapters in this book stress the distinction between Cultural Studies and cultural knowledge as studied within a language-learning framework, and argue for closer integration between factual material and the observer's point of view. Meaning, we believe, is constructed, not found, hence it is fundamental to examine ways in which meanings develop and how they circulate. The study of British cultures, therefore, cannot be simply an examination of facts and institutions, it must also involve a study of the discourses that shape them.

The different approaches to the study of cultures have led also to a terminological confusion that needs to be resolved. We have chosen to use variously all three terms in current circulation: Cultural Studies, British Cultural Studies and British Studies, though the title of this book has sought deliberately to sidestep the difficulties caused by that confusion. We have decided on *Studying British Cultures* in order to emphasize that this is not another collection of essays focusing on the British tradition of Cultural Studies, nor is it a handbook for British Studies of the traditional *Landeskunde* variety. It is a collection of essays by authors with very different views on how to study culture, and with very different views on what constitutes British culture, or cultures. The unifying principle, however, is the belief that the debates on terminology conceal a more fundamental issue, one which concerns definitions of Britishness and questions of cultural identity. In this respect, what is happening in Cultural Studies within the British context as suggested by the contributors in this book is very similar to the processes of transformation that have swept through Cultural Studies in Australia or the United States. For Cultural Studies, Area Studies and foreign language teaching have begun to move closer together, aided by the work of intercultural theorists such as Edward Said, Gayatri Spivak and Homi Bhabha.

Stereotypes and Otherness

As Immanuel Wallerstein points out, culture is involved in the specific; it is 'the set of values or practices of some part smaller than some whole'.[7] The problem is that much public and

political rhetoric moves continuously away from the particular towards the universal, so we find politicians referring to 'the British people', a phrase that erases differences of race, ethnicity, religion, nation, age or gender in a bland generalization. Discourses of nationalism likewise slide easily into contrasting the chosen people with other groups, to the detriment of all those held to be outsiders. At times of crisis, as happened in Britain during the Second World War, for example, the myth of a homogeneous island people battling against the rest of the world for survival resurfaces, and differences are subsumed within the notion of a united group. To a lesser degree, the same distinction is maintained today through other forms of discourse: sport, where commentators refer to 'us' and 'our team', advertising, where stereotypes of national characteristics are frequently used to sell products (the loud-mouthed American tourist, the aggressive German at the seaside resort, the devious Latin-American and so on) and in humour systems, where other groups are ridiculed and debased. A common type of joke in English opens with the Englishman, the Irishman and the Scotsman, and the Englishman generally emerges as the victor. If told by a Scot, the outcome might well be different.

The study of stereotypes is an important aspect of intercultural studies, for all cultures construct other cultures through a range of discourses. Foreign language teaching has often utilized stereotypical knowledge, and much guidebook literature is constructed around the stereotyped expectations of a given readership. But stereotypes have a genealogy, and tracing the emergence of national stereotypes is an important, and relatively neglected area of study. An investigation of stereotypes of Britishness (Stuart Hall points out that the archetypal buttoned-up, stiff-upper-lipped Englishman is always a *man*[8]) would necessarily involve questioning how those stereotyped images have evolved and how and why they are sustained. The surge of jingoistic anti-German feeling in the British media during the 1996 European football championship was manifested through fifty-year-old stereotypes from the Second World War, despite the fact that both states are members of the European Union. The power of such stereotypes despite the changed political reality shows how important it is to study more of a culture than institutional structures. Fact-based

knowledge is obviously important, but knowledge of cultural diversity involves a great deal more.

The study of British cultures can be undertaken from an infinite number of starting points. From the most distant viewpoint, Britain appears to be a single unit, a cluster of off-shore islands close to the European mainland. If our imaginary camera moves in slightly, Britain begins to dissolve into two distinct geographical units in the form of two large islands, with distinctive Celtic and Germanic traditions. Closer still, and the four nations emerge, then the regional variants, the urban–rural divide, the ethnic differences, the generational divisions and the countless other units that, when combined, make up the whole that is the British Isles.

Traditional (British) Cultural Studies looked primarily, almost exclusively, at *English* culture, accepting without question the old imperial equation of British with English, because attention was centred on other more pressing issues of the moment such as class or gender. But in recent years, the use of 'British' as a synonym for 'English' has been called into question from many different sources. In this book, the chapters by Katie Gramich, Robert Crawford and Sabina Sharkey explore Welsh, Scottish and Irish relations with Britain. They reflect what Krishan Kumar has called 'the four nations approach to British Studies'.[9] This emphasis on an investigation of the historical evolution of the term 'British' and of its ideological implications represents an important shift in cultural studies research within Britain. In his study of popular fantasies of masculinity, *Soldier Heroes*, Graham Dawson begins with a warning to anyone who does not recognize the difference between the terms 'English' and 'British':

> The common interchangeability of 'English' and 'British' as designations of identity poses problems for any cultural historian sensitive to the full range of national identities within the 'United Kingdom of Great Britain and (Northern) Ireland', who yet wishes to explore the shared 'Britishness' that has resulted from belonging to 'the imperial race'. The epithets of 'Englishman' and 'Englishwoman' came to refer not only to English people in the strict sense, but also to the Scottish, Welsh and Irish who also enjoyed the privileges of

'being British' in the colonies, and to settlers and their descendants in the white Dominions.[10]

Many of the chapters in this book are concerned with the need to analyse these terms, as part of a process of reassessment and revision that derives in part from the end of empire and in part from a cultural revival in many parts of the British Isles that has provoked a resurgence of questions of national and cultural identity. Closer links with the EU have contributed to this process, for not only has funding gone to strengthen Welsh, Scottish and Irish arts projects, but the Celtic languages have benefited from the EU minority language policy. The great explosion of literary production in many parts of the British Isles, the emergence of Irish cinema as a significant development, the spread of Welsh language television and the popularity of Irish-, Scots- and Welsh-speaking music groups across Europe since the 1980s suggests a rejection of any globalizing idea of Britishness, despite the continued use of phrases such as 'the British people' in political rhetoric.

Nor is the uneasiness with the term 'British' linked only to the aboriginal peoples of the British Isles. The transition of society to multiculturalism and multi-ethnicity, which has happened more visibly in England than elsewhere in the British Isles, has also contributed to anxiety about the ideological implications of the terminology and to the debates about national identity. For any sense of a *national* identity is also implicitly concerned with otherness, with what is *not* part of the national heritage. If nationalism is about belonging, about 'us', then anyone who is not 'one of us' is one of 'them'. This bipolarity is built into ideas of national identity. Either you belong, or you do not belong and are an outsider. Images of home can be contrasted with the foreign, civilization with barbarity. Homi Bhabha, for example, discusses the classic stereotype of the English weather to illustrate the difficulties of what he calls the liminality of cultural identity. To invoke images of the English weather, he argues, is also to invoke images of its colonial alternative:

It encourages memories of the 'deep' nations crafted in chalk and limestone: the quilted downs; the moors menaced by the wind; the quiet cathedral towns; that corner of a foreign field that is forever England. The English weather also revives

memories of its daemonic double: the heat and dust of India; the dark emptiness of Africa; the tropical chaos that was deemed despotic and ungovernable and therefore worthy of the civilizing mission.[11]

The contrast between the wildness of the colonies and the harmonious order of English society in this kind of mythical imagery reinforces the problems of integration experienced by different social groups living in Britain today. The idea of England being at the centre of things, with everyone else somewhere out on the margins is long gone as a political reality, and the question of what constitutes British identity is now a matter of urgent debate. The old equation of whiteness and Englishness does not hold, and the hegemony of England has been challenged. The diversity of cultural histories within the British Isles is the reason why we have chosen here to speak of British cultures, in the plural, even as we recognize the limitations of the term 'British'.

In his chapter, Christopher Brumfit draws attention to the difficulties of devising a British Studies curriculum, and to the fundamental problem of the contents of such a curriculum in terms not only of 'knowledge about Britain', but of the kinds of image of Britain that may be presented. Given the history of Cultural Studies as a contestatory field, devised and initially developed by theorists and historians of the Left, and given the lack of consensus as to the desirability of using the term 'British', it is clear that there is unlikely to be consensus over a curriculum. The questions that Brumfit asks touch upon key questions that politicians of different persuasions are asking within the British context. Michael Portillo, for example, the right-wing Conservative minister, coined the phrase 'the new British disease' in a speech given to the Way-Forward group on 14 January 1993, arguing that the country was beset by 'the self-destructive sickness of national cynicism'. He complained about the climate of self-criticism in British intellectual life, and proposed that:

Our mission must be to rebuild national self-confidence and self-belief. We need to assert the value and the quality of the British way of life and of British institutions. . . . We are proud of our history, proud of our language, proud of our culture, proud of our military skills, proud of our democratic

institutions, proud of our commerce and business, our exporters and investors.[12]

This unquestioned use of 'our' effectively denies all difference and eliminates at a stroke any language but English. Brumfit rightly warns against the facile adoption of the idea not only of Britain as a set of given facts but as 'something to believe in', reminding us of the dangers inherent in 'blood, language and soil' nationalism.

Questions of Timing

It is not accidental that interest in studying British cultures has begun to develop so rapidly in the 1990s. As Martin Montgomery has argued, the late twentieth century manifests two overriding tendencies: an increased interpenetration of cultures on the one hand, and the steady rise of regionalism, sometimes in extreme and dangerously nationalistic forms, on the other.[13] The British situation provides a particularly interesting case-study of a society in transformation at the end of the twentieth century.

The demise of the British Empire was followed by the movement of peoples from the former colonies into the British Isles. Today, it is impossible not to recognize the process of transformation of many parts of England, and to a lesser extent parts of Scotland and Wales, into a multicultural, multi-ethnic society. And, as David Dabydeen reminds us in his chapter, this changing pattern of cultures also carries a history and necessarily involves a reconsideration of the legacy of years of imperial expansion and colonization.

It is less than a century since Kipling published his famous poem expounding the myth of English racial purity, *The Islanders*, which stated bluntly: 'No doubt but ye are the People – absolute, strong and wise'.[14] Today, in multiracial Britain, there is a great deal of doubt. Writing in the *Independent on Sunday* on 2 April 1995, Neil Ascherson commented that there appears to be no consensus about what Britain might be, even at the highest levels:

> In the end, however, the London conference could not decide which world it was talking about, or what sort of Britain it meant. Prince Charles, the Prime Minister, the

Foreign Secretary – all seemed to grow fabulous wings and serpent limbs as they begged this inexpressible Britain to express itself again.

Ascherson goes on to suggest that the problem of Britishness is basically a problem of Englishness:

The reason that the Prince, the Prime Minister and the Foreign Secretary think that there is a self-knowledge problem is that they are English, and therefore get England and Britain and nation and state all muddled up. The Scots and the Welsh, by and large, do not find Britain puzzling. Some of them do not want to stay with it, but at least they know what it is. They are Scottish or Welsh in national identity, British in citizenship.[15]

What makes it timely to study British cultures, then, is the fact that a great many processes of change are happening simultaneously. And in rethinking questions of cultural identity and Britishness, all kinds of new perspectives are evolving.

In his chapter, entitled 'Fictional maps of Britain', David Punter refers to what he calls 'the psychology of British Cultural Studies' and shows how impossible it is to arrive at a consensus about the cultural identity of contemporary novelists classified simply as 'British writers'. Similarly, John Drakakis takes the case of William Shakespeare, emblem of English greatness, and demonstrates how the proliferation of different readings of the Bard have resulted in him becoming 'primarily a collage of familiar quotations', and no longer a unified and unifying canonical figure.

Underlying the chapters by Punter and Drakakis is another plurality, not only of identities and discourses, but of approaches and methods. For if there is no such thing as one 'British culture', so there is no such thing as a single canon of British texts. In this respect, the study of British cultures reflects its links with Cultural Studies, where there is also no canonical core of texts. In his chapter, Alan Durant argues that British (Cultural) Studies, with its pluralistic and anti-canonical approach has taken over from English Literature as the cultural component of English as a foreign language (EFL) courses. But he warns, as Christopher Brumfit does, against a resurgence of 'Little Englandism' in a new guise. For Durant, the priority of

British (Cultural) Studies should be to examine procedurally 'how cultural references in the English language carry specific meanings and values in all cultures where the language is used'.

This collection is divided into two sections. In Part I, essays by Antony Easthope, Alan Durant, Christopher Brumfit, Michael Byram and David Punter establish the theoretical and methodological parameters from which we believe the study of British cultures can embark. All these contributors recognize the gap that has existed between 'insider' cultural studies practice and 'insider' EFL practice, but equally, all recognize that the gaps have started to close, and that the rapprochement between cultural studies, literary studies and foreign language study is part of a wider process that sees greater emphasis placed on cultural awareness in many fields, including management and business studies, law, economics and the sciences.

The chapters in Part II focus on specific topics. Robert Crawford looks at recent developments in Scottish Studies and Katie Gramich looks at the problems of the relationship between British and Welsh Studies in chapters that challenge assumptions about the global application of the term 'British'. Sabina Sharkey's essay looks at key issues in Irish Studies and argues that tradition, like history, is always constructed selectively. All three chapters explore questions of cultural hegemony and cultural/national identity.

In his essay on teaching West Indian literature in Britain, David Dabydeen questions the relationship between British theorists and Caribbean literary production, arguing that West Indian peoples are not merely the products of colonial cultural values. Dabydeen's plea is for recognition of a plurality of voices in West Indian cultures and for a rethinking of the relationship between European and West Indian thought. Like Sharkey, he draws attention to the need to look at the history of colonialism, and its legacy in a post-colonial world.

Finally, John Drakakis's essay on Shakespeare explores the impossibility of a single, canonical approach to literature and questions assumptions about definitions of literary significance. In his concluding paragraph, he points out that history is a multiform trace of discontinuous, conflicting practices in which variable elements of power come together, disperse and are reconstituted. This takes us back full circle to our starting point, with culture conceived of as a shifting mass of signs.

Shakespeare, that great cultural icon, has been made and remade as often as ideas of Englishness and Britishness have been refashioned.

Notes

1 Raymond Williams, *Culture and Society 1750–1950* (London: The Hogarth Press, 1993), p.333.
2 Vanda Blundell, John Shepherd and Ian Taylor (eds) *Relocating Cultural Studies: Developments in Theory and Research* (London: Routledge, 1993), p.7.
3 Franz Fanon, *The Wretched of the Earth* (Harmondsworth: Penguin, 1967), p.199.
4 Salman Rushdie, *Imaginary Homelands* (London: Granta Books, 1991).
5 Hanif Kureishi, *The Buddha of Suburbia* (London: Faber & Faber, 1991), p.3.
6 Jürgen Kramer, 'Cultural Studies in English Studies: A German Perspective', in Michael Byram (ed.), *Culture and Language Learning in Higher Education*, special issue of *Language, Culture and Curriculum*, vol. 6, no.1, 1993, pp.27–45.
7 Immanuel Wallerstein, 'The National and the Universal: Can There Be Such a Thing as World Culture?', in Anthony King (ed.), *Culture, Globalization and the World System* (London: Macmillan, 1991), pp.91–107.
8 Stuart Hall, 'Old and New Identities: Old and New Ethnicities', in Anthony King, op. cit., pp.41–69.
9 Krishan Kunar, '"Britishness" and "Englishness": What Prospect for a European Identity in Britain Today?', in Nick Wadham-Smith (ed.), *British Studies Now Anthology* (London: The British Council, 1995), pp.82–97.
10 Graham Dawson, *Soldier Heroes. British Adventure, Empire and the Imagining of Masculinities* (London: Routledge, 1994), p.293.
11 Homi Bhabha, 'DissemiNation: Time, Narrative, and the Margins of the Modern Nation', in Homi Bhabha (ed.), *Nation and Narration* (London: Routledge, 1990), p.319.
12 Michael Portillo, *Observer*, 16 January 1994, p.22.
13 Martin Montgomery, Opening Lecture, *Britain 2000 Seminar*, Vienna, April 1995.
14 Rudyard Kipling, 'The Islanders', in *Rudyard Kipling's Verse. Inclusive Edition 1885–1926* (London: Hodder and Stoughton, 1927).
15 Neal Ascherson, 'The Search for British Self-knowledge Could End in the Usual Muddle', *Independent on Sunday*, 2 April 1995, p.27.

Part 1

Part 2

1

But what *is* Cultural Studies?
ANTONY EASTHOPE

The mere presence of a spectator . . . is a violation

Jacques Derrida[1]

The study of national cultures, national languages and national literatures all developed with the rise of the nation state inaugurated in 1776 and 1789. In the Westernized world, by the 1960s, study of the national literature had been codified into a university discipline which taught a canon of established texts (the word 'canon' comes from the canon of accepted books of the Bible and the religious comparison is only too fitting).

People sometimes say, 'why don't you forget all this theory and get back to literature itself?'. But this 'literature itself' is nothing like as innocent, self-evident, value-free as its defenders sometimes pretend. The study of 'literature itself' (and this may be a familiar story) only developed in a context heavily laden with assumptions – with theory in fact – though these have now become so much a matter of habit we tend to forget what they are. I think we must reject any idea of 'literature itself' and move towards a new conception, a new methodology. To get there let me spell out, even at the risk of some caricature, what was assumed by the study of literature in and for itself.

Literary study proceeded in the belief that literature came down from heaven, touched its reader with greatness, and then immediately went back to heaven again. Literary study was based on three theoretical principles, all of which have to be refuted:

- The great literary text was just there, in itself, to be read by the sympathetic reader who set aside all questions of use, interest or purpose (the text was its own purpose).

3

- The great literary text was intrinsically great, containing within itself its own perfection and not dependent on anything outside it.
- Literature is not popular culture.

The academic study of great literature only became properly instituted in the West in the 1930s. If you go back to the founding fathers (Empson, Richards, Leavis and others) you can detect how literary study was constructed on the basis of a forgotten contrast: the canon of literature was defined in opposition to popular culture (ballads, broadsheets, football, music hall, cheap novels, newspapers, the cinema, radio, popular song, television, and now video). No one studies great literature unless they are paid, either as a student or a teacher – popular culture in contrast is what we all pay to enjoy.

Now for the assumptions:

Assumption 1, the notion of the text 'in itself', relies ultimately on the idea of the aesthetic introduced by Emmanuel Kant in the 1790s: the view that there is a special realm of aesthetic experience which exists for its own sake and which is defined against the material concrete world in which we live. Art inhabits that domain. I would argue that the text cannot interpret itself, is always read in a context, is always inevitably caught up in a world of human uses, interests and purposes (including showing you are a real gent because you enjoy literature 'for its own sake').

Assumption 2, that the great text is simply great, cannot be demonstrated. There have been many attempts to isolate and define the feature of the great text which guarantees its greatness. Terms on offer here include 'imaginative power', 'imaginative unity', 'richness', 'complexity', 'complex irony', 'thematic realization', as well as the view that some feature of the great text 'defamiliarizes' its meaning or that it 'foregrounds' its own textuality or reflects on itself. My conclusion is that no attempt to show that the great text is great and will always stay great because it secretes some magic literary ingredient, some special internal feature, has ever succeeded. The reason is that the text exists as it is read, and the text itself cannot guarantee how it will be read. Even Shakespeare's greatness may fade unless people go on treating him as great.

Assumption 3, that the literary canon is securely opposed to popular culture, falls if you can't demonstrate some intrinsic literary feature of the literary text which gives it a special privilege over the works of popular culture. Cultural studies, then, would look at both texts from the old 'canon' and from popular culture together, alongside each other, on equal terms.

If, as I think we must, we move forward from literary studies to cultural studies, this will entail not just a change in the object of study (additional texts) but a transformation in the *method* of study. Instead of the old, formalist concern with the text 'in itself' and the search for its hidden greatness, the text must be understood in context. But what sense of 'context' is appropriate? What method should we use? What *is* Cultural Studies?

British Cultural Studies

For more years than I care to mention I have been reading the work of Raymond Williams, Richard Hoggart, Stuart Hall and others. Kindly informed by American colleagues that all this was now to be known as 'British Cultural Studies' I felt both pleased and a little patronized, like a man suddenly told that all his life he had been speaking prose.

Certain historical factors shape the development of British Cultural Studies. It grows from within the English tradition which inherits a concern with the moral state of culture, a tradition exemplified in the work of Samuel Taylor Coleridge, John Stuart Mill, Matthew Arnold and, in the twentieth century, F.R. Leavis. This concern itself derives in part from the anxieties arising from a manifest contrast between the ideal unity of a national culture and the actual existence of class divisions within that society. British society has exhibited a split between the gentry and the people since at least the seventeenth century. Increasingly from 1900, with the development of the modern mass media, this split has become a chasm. Art in the high cultural tradition and the popular culture of the masses now present themselves as irretrievably separated domains. Hardly anyone who enjoys Madonna also enjoys Milton and fans of Abba generally have little enthusiasm for Aeschylus.

During the 1950s the new prosperity in Britain posed the question of society's cultural divisions even more urgently as

new media were introduced and older media appeared in new forms (so-called 'commercial' television in opposition to the state-sponsored broadcasting of the BBC began in 1954). Accordingly, from the 1950s, the form of cultural critique represented by British Cultural Studies began to develop.

In the work of Raymond Williams and Richard Hoggart, British Cultural Studies emerged from literary criticism but wanted to break with its formalism, elitism and aestheticism. If you want to move away from literary study, the most promising place to start is with a recognition of audience; who reads a text, where, how, and what for (all the questions repressed by traditional literary study). Williams and Hoggart turned therefore to the social sciences, to sociology, ethnography and, above all, history and social history, for ways to set the text in a context, to flesh out the sense of reading and response as forms of culture produced by the activity of a whole society.

But in leaning on the social sciences and their notion of the objectivity of the social formation, the founding parents wanted to retain from literary study a sense of 'genuine personal response', individual experience, subjectivity as lived actively in the creation of culture. They did not want to go all the way with the social sciences because their instinct was that these tended to fix society as a knowable object, a thing (and their instinct was dead right for we can now see that culture as understood by the social sciences leads only too quickly into 'communication studies', 'media studies' and the 'sociology of mass media').

So, for essentially political reasons, Williams and Hoggart were determined to stress culture as a process, as transformation, as active construction and experience. The foundational project of British Cultural Studies, then, was to bring together into a single intellectual perspective a conception of objectivity with a conception of subjectivity. At the risk of losing some suspense in my argument let me say now that for me cultural studies is defined by this 'problematic', the set of questions and answers arising from the relation and interaction between objective structural conditions and subjective experience, between culture on the one hand as constructed collectively and on the other as experienced by a class, group or individual.

In exploring this problematic British Cultural Studies has so far been through what I shall discriminate as three broadly

separate movements. To understand what is at stake means following these through in some detail. The first of these we may term Culturalism.

Culturalism

Writing in 1930, the year after the world economic crisis, F.R. Leavis set out the following position on the role and significance of the high cultural tradition:

> In any period it is upon a very small minority that the discerning appreciation of art and literature depends ... The minority capable not only of appreciating Dante, Shakespeare, Baudelaire, Hardy (to take major instances) but of recognizing their latest successors constitute the consciousness of the race (or of a branch of it) at a given time. Upon this minority depends our power of profiting by the finest human experience of the past; they keep alive the subtlest and most perishable parts of tradition. Upon them depend the implicit standards that order the finer living of an age, the sense ... that the centre is here rather than there. In their keeping is the language, the changing idiom upon which fine living depends, and without which distinction of spirit is thwarted and incoherent. By 'culture' I mean the use of such language.[2]

This needs little commentary: high culture as represented in the literary canon is an elite preserve for defence against 'mass civilization'; it is a castle immune to the 'red death', that is, popular culture. And the qualifying term 'culture' is reserved exclusively for high culture and denied to the rest of the members of society, the actual majority, who are seen as simply *without* culture.

This liberal elitist tradition is challenged in the work of Raymond Williams. In *Culture and Society 1780–1950*, published in 1958, Williams undertakes a sustained struggle to think of culture as an attribute of all members of a society, not merely the economically privileged. Culture, he argues, pertains not to the development of a single class but to 'the development of a whole society', and this must include 'steel-making, touring in motor-cars, mixed farming, the Stock Exchange, coalmining, and London Transport'.[3] The aim of Williams's

somewhat grim-jawed argument is to validate working-class culture precisely *as* culture. To do this he reviews the British tradition of writers on culture (from Coleridge to George Orwell) assessing in each case how far the writer is open to the idea of popular culture as valid culture.

At this time Williams writes from a position that is explicitly not that of a Marxist, for he refuses to take culture as a simple *expression* of economic class (or a complex expression of it, for that matter). He worries especially about high culture in terms of the Marxist framework, posing the following alternative: 'Either the arts are passively dependent on social reality, a proposition which I take to be . . . a vulgar misinterpretation of Marx. Or the arts, as the creators of consciousness, determine social reality.'[4]

His insistence is that art and culture, including working-class culture, can *create* consciousness, and so culture does not just reflect pre-existing economic and social forces. Clearly, against the sociologism of (vulgar) Marxism, Williams is trying to hold together a notion of culture as both social construction and personal experience, objective conditions and the possibility of subjective transformation.

Richard Hoggart in *The Uses of Literacy*, published in 1957, also defends traditional working-class culture, locating it particularly in trade union organization, forms of choral and group singing, and the institution of brass bands, but also in moral attitudes still imbued with Nonconformist Protestantism. From this ethical base he attacks what he terms 'candy floss' culture represented by such 1950s commercial products as cheap magazines, popular newspapers, popular songs, and what he calls 'spicy books'. The content of the last of these can be assessed from such typical titles as *The Killer Wore Nylon*, *Broads (Girls) Don't Like Lead*, *Sweetie*, *Take it Hot*. A moralizing stance is always susceptible to unconscious betrayal, and so it is in Hoggart's case, for the titles of these 'spicy books' are not the result of careful research but rather of the author's own imagination. He has, as he admits, made them up himself: they are his own 'imitations'.[5]

Williams and Hoggart together stand for the Culturalist phase of British Cultural Studies. Their work exposes some of the problems of this kind of account, problems that might be schematically listed as follows:

1 Culturalism fails to distinguish adequately between texts and society – rather they are deliberately run together as 'culture'.
2 It is humanist, conceiving people as freely expressive (and this appears symptomatically in the way Williams at this juncture objects to Marxism on the grounds that it denies freedom to the human subject, whether individual or collective).
3 It is moralizing, referring always to a politics arising primarily as a form of moral choice and in terms of personal experience.
4 Although it aims to contest the dominance of the high cultural artistic tradition, in effect it leaves that tradition in place since it seeks merely *another* place for working-class culture as well (sometimes termed the 'enclave' theory).
5 Its method and procedure, as you might expect in Anglo-Saxon culture, is empiricist, pragmatic and descriptive; there is simply no attempt at theory.

Overall, Culturalism seeks to relate objective structure to subjective experience by running the two together into the notion of 'culture'. The amalgam is not stable, as we shall see. For the next stage or moment in British Cultural Studies, what may be called 'Marxist Structuralism' or 'Structuralist Marxism', takes off very much from a sense of the limitations of the preceding work of Williams and Hoggart.

Structuralism

In 1964 Richard Hoggart helped to found the Birmingham Centre for Contemporary Cultural Studies, with himself as Director, a position later taken over by Stuart Hall (now Professor of Sociology at the Open University). The 1960s witnessed the rise of the so-called 'New Left', associated particularly with the Structuralist Marxism of Louis Althusser. Stuart Hall and the Birmingham Centre were deeply influenced both by Althusserian Marxism and by the semiology of Roland Barthes, whose work *Mythologies* first came out in France in 1957.

The Structuralist moment in British Cultural Studies arises through a critique of the previous Culturalism. It refuses to see

people as freely expressive and culture as a matter essentially
of group or individual experience and choice. Structuralism,
rather, envisages human subjectivity as determined by *structures*,
which are at once economic, ideological and semiological.
Another list:

1 Structuralism rejects the humanism and moralizing attitudes
 of Raymond Williams and Richard Hoggart, replacing the
 notion of culture with that of *ideology*, replacing the notion of
 experience with that of *signs* or *representations* which provide
 a position for the subject.
2 It also rejects the view of working-class culture as at best an
 enclave within society, proposing instead a Marxist analysis of
 cultural forms in relation to the economic structure of society
 as a whole; since the political economy is capitalist, ruling-
 class culture (high culture) and working-class culture (popu-
 lar culture) are not free and separate developments to be
 assessed from some external point – rather they depend on
 each other and are produced together, just as capital depends
 upon labour; in this, Marxist Structuralism relies profoundly
 on Althusser's theorization of the social formation as a
 whole, a totality whose interrelations should be understood
 in terms of their 'relative autonomy'.[6]
3 Similar arguments maintain also for semiological structures;
 by drawing on Saussure's distinction between *langue* and
 parole it was proposed that as rules generate linguistic texts,
 so all texts have to be understood as the effect of larger
 linguistic and discursive structures.
4 Marxist Structuralism does distinguish text from society,
 attributing an autonomy to the text, but it believes text and
 society should be understood together within a concept of
 totality, in terms of Althusser's account of the relative
 autonomy of specific practices (popular novels, for example,
 would be one of these practices).
5 Marxist Structuralism was systematic, rationalist in method
 and theoretically explicit, in striking opposition to the
 empiricism of the previous Culturalist wave.

It's not so easy to illustrate the phase of Marxist Structuralism
in British Cultural Studies because it is not defined in any single
book or pair of books but by a whole range of writing: the film
journal *Screen* in its work on cinema, especially between 1973

and 1978; the essays of Stuart Hall and others (papers on advertising and television, for example); the annual publications of the Birmingham Centre; the meetings (and subsequently published *Proceedings*) of the University of Essex Sociology of Literature Conference (1976–82). Running through all of this work there was a great deal of explicit theoretical debate.

If Culturalism presided over the 1960s, Structuralism dominated the 1970s. It is symptomatic that in 1980 Stuart Hall published a famous paper, 'Cultural Studies: Two Paradigms' which, in assessing Culturalism versus Structuralism, tended to point beyond both, evidence of a need to find a further synthesis for subject and object.[7] Briefly, Hall argues that the strengths of Structuralism are threefold: its recognition of 'determinate conditions' and grasp of society as a kind of machine; its theorization of culture in terms of 'levels of abstraction', that is, an understanding of relative autonomy; and its 'decentring of "experience"' and analysis of subjectivity as an effect rather than point of origin. However, Hall also points to the failure of Structuralism to address the problem of transformation – it is not able satisfactorily to explain change and how people do choose, exercising a degree of freedom. Culturalism, of course, grew precisely on this ground, making such a humanist conception its main affirmation. We read Hall's brilliant essay, playing off Structuralism and Culturalism against each other, in the expectation of a resolution or synthesis. Alas, none is forthcoming, no rabbit pops out of the conjuror's hat. The essay ends as follows: 'Culturalism and Structuralism . . . define where, if at all, is the space, and what are the limits within which such a synthesis might be constituted.'[8]

In terms of the problematic of cultural studies my judgement would be that, according to its lights, Marxist Structuralism aimed to relate object and subject by defining the second in terms of the first, as the effect of structures. The subject consists only of an assigned position (except of course for the supreme subject who's doing the analysing). Marxist Structuralism, committed as it is to a conception of totality, presupposes its own point of origin as unsituated, somehow outside and looking on. Perched up there above the struggle, like Moses on Sinai, the well-versed Marxist Structuralist theoretician of culture can

see everything except himself. From his (less often, her) supposed vantage point he can measure exactly the degree to which texts and cultural practices repeat or challenge the dominant ideology. The sense of a total perspective on culture, objective structures and subjective positions together, has been gained at the price of the omission from that totality of two crucial aspects of subjectivity in the cultural studies problematic: ordinary people are treated as simply duped by the texts they enjoy, offering no resistance to them; superior people (cultural theorists, that is) have a supernatural immunity to the structures they describe. What I shall treat here as the third movement of British Cultural Studies comes about as a response to these and other difficulties.

Post-Structuralism and Cultural Materialism

If you go for a walk and it starts to drizzle, at first you don't get wet and then suddenly you find yourself soaked through. So it is with most intellectual changes – the moment of transformation goes unnoticed. During the middle of the 1970s, a number of intellectual forces compelled a more general shift of position. One of these was certainly the question of the relation between capitalism and patriarchy, as it became increasingly obvious that a feminist politics could not be theorized inside the Marxist or Althusserian sense of totality. For example, in a seminal article which did not disregard economic questions entirely but did move the notion of totality to the background, Laura Mulvey demonstrated that Western culture is widely structured by a single visual regime (one operating in photography, commercial art, advertising and the cinema) which she characterized as promoting the idea of 'Woman as Image, Man as Bearer of the Look'.[9] While men were positioned as active desiring viewers, women were invited to identify themselves as the passive objects looked at.

Another contribution to the pervasive rethinking came from recognition of the decentring of the subject. Psychoanalysis, first introduced into the cultural studies debate by Althusser's account of ideology, refused to stay in place, for it admitted the view that subjectivity is determined in and through the process of unconscious in a way that exceeds any notion of the subject as a position determined by ideology. In controversy, then, is

the conception of totality. From now on, no centre to the social formation, no totality, no relative autonomy (at least as conceived in the Althusserian model) and no truth (capital T). What soaked through in this development is what is now acknowledged under the name of postmodernism. From here on, plot-lines proliferate and it gets harder to stick to a clear narrative.

The postmodern/post-Structuralist turn in cultural studies (dominant from, say, 1980) directed fresh attention towards textuality and to the neglected question of subjectivity, the individual's own response to and involvement in culture and cultural practices. Of this, one important symptom in 1977 was the book by Roz Coward and John Ellis, *Language and Materialism*, which attempts to keep up a notion of totality founded in the conception of language associated with Jacques Lacan. Coward and Ellis aim to argue that the subject is an effect of textuality, so maintaining a continuum between society and the text. But this manoeuvre provides no more than a temporary respite from deeper problems because, wherever it moves, the debate encounters one insurmountable fact. There is a disjunction between the subject conceived as effect of the text (the implied reader) and the subject as an empirical reader (who may respond to the text in a potentially infinite variety of unanticipated ways). This would put in some doubt Mulvey's account of gender and the visual regime mentioned above.

At this point Raymond Williams returned to the field. In what a football metaphor would describe as a late run, he affirmed the central importance of practice in cultural studies. In an essay of 1973 Williams proposed that works of art (symphonies, plays, poems) were 'not objects but *notations*'; and he took this somewhat enigmatic assertion as warrant that cultural studies should proceed by looking 'not for the components of a product but the conditions of a practice',[10] that is, we should set aside formalist questions about texts and concern ourselves with the conditions of their production and reproduction (forget about the score of Beethoven's Ninth, what matters is that it holds all those genteel folk sitting in disciplined silence in the concert hall). With the slogan of 'culture as practice' Williams promises to reintroduce the analysis of culture as a process of active transformation.

This essay by Williams has been profoundly influential. It is

the baton passed to them by Raymond Williams that Jonathan Dollimore and Alan Sinfield pick up in founding 'cultural materialism'. In *Political Shakespeare: New Essays in Cultural Materialism* in 1985 they write:

> 'Materialism' is opposed to 'idealism': it insists that culture does not (cannot) transcend the material forces and relations of production. Culture is not simply a reflection of the economic and political system, but nor can it be independent of it. Cultural materialism therefore studies the implication of literary texts in history.[11]

This sounds reassuringly like classic Marxism but the position is given a more contemporary inflection when it is explained that texts are to be considered not in terms of the material forces surrounding their moment of origin but rather that of their *reproduction*, in other words the continuing cultural practices in which they are presented:

> A play by Shakespeare is related to the contexts of its production. . . . Moreover, the relevant history is not just that of 400 years ago, for culture is made continuously and Shakespeare's text is reconstructed, reappraised, reassigned all the time through diverse institutions in specific contexts. What the plays signify, how they signify, depends on the cultural field in which they are situated.[12]

Cultural Materialism, indebted as it is to the work of Michel Foucault with its post-Structuralist refusal of notions of totality, truth and centredness, retains the political theme of Raymond Williams (if not much else), and has this to its credit over some other post-Structuralist versions of cultural studies. It does not, however, succeed any better at a coherent analysis of object and subject in cultural studies, or rather it resolves the problem only by equating subjectivity with *response*, albeit response in a 'cultural field'.

Response is a large issue, and I want to digress on to it for a paragraph. To those more familiar with the cultural studies debate the idea of response is less exciting than it appears at first glance. Briefly, I would begin by asking just how *interesting* are 'actual' responses? In any case, the analysis of 'actual' response depends upon and can never be any better than the theory of society within which – inevitably – response is to be

defined and measured. Unless response is to be individual, there is no escape here from all the old, familiar problems of sociology. Since an audience is a group, what constitutes a group? Is it to be defined by age, by class, by sex, by regional origin, or what? 'Actual' response, apparently so substantial and material, on inspection turns out to be far less actual than was hoped.

British Cultural Studies in phase 1, Culturalism (1960–9), tended to elide object and subject into a single, vague notion of culture. In phase 2, Marxist Structuralism (1970–9), a synthesis was achieved in which subjectivity was defined as the effect of objective ideological and semiological structures: the subject was a position. But the synthesis was merely temporary, resting as it did on a notion of totality which by the mid-1970s had begun to prove incomplete (you can't have a partial totality). Phase 3, post-Structuralism and Cultural Materialism (since 1980), in a double movement really, emerged from a postmodern rejection of totality and the death of the Grand Narratives. While (I would argue) they each were able to give a more appropriate attention than Marxist Structuralism to subjectivity as both the reader's response and the analyst's situation within the world he or she wished to analyse, they did so only by weakening a sense of how the text was rooted in society and attenuating awareness of the relation between subjective response and objective social structures and conditions.

Across these variations British Cultural Studies has struggled for over twenty years to find a powerful and analytically coherent theoretical frame within which to hold together both text and society, culture as subjective experience and culture as objective historical structure. No such totalizing synthesis has been found. My sense now is that it won't be, that objective and subjective cannot be integrated in a single theory. The reason is, to change the terms, that text and context always slide past each other. Although texts are always read in contexts and within institutions, they always exceed any given context of reading with the power to engage other readings in other contexts (these contexts are not determined in a voluntarist manner, by the whim of the individual reader, but by the field of different historical forces which produce interpretations). So also with subject and object; subjective process and objective

conditions, although always in relation, are never in an *even* or commensurate or totalizable relation.

The aim of British Cultural Studies was to theorize object and subject together as culture; the outcome of my history has been to suggest that no such combined theorization is possible. Does this, then, nullify cultural studies? I would say, 'No', and it was partly for this reason that I dallied with the tricky topic of postmodernism. For postmodernism asserts that the age of comprehensive schemas, Grand Narratives and totalizing theories is beyond our grasp (and always was). There is no objection on these grounds to following through the already established discipline of cultural studies, its way of thinking about the interaction between object and subject.

I would go further, in fact, and at the risk of a certain academic imperialism propose that cultural studies has got it right. On one side, there can be no return to the naïve subjectivism of traditional literary study. On the other, at present, we are still faced with a practice in the social sciences and study of history which remains locked in some positivist notion of a 'science of history', and analysis of the social formation as an impersonal and 'objective' phenomenon (though there are signs – for example, in feminist history – that this situation is changing). When historical study thoroughly takes on board the idea of subjectivity as I have described it, then it will have developed into . . . cultural studies.

In conclusion, I want to gesture briefly towards some examples of work in cultural studies and how they might properly address subjectivity.

- There might be a historical study of, say, park design, demonstrating how the design and architecture of the privately owned gardens of the great eighteenth-century landowners were carried forward and adapted for the publicly accessible municipal parks of the British Victorian city. Fine, but to count as cultural studies, in my view, this would have to find room to discuss the kind of subjectivity promoted by those park designs, how the individual was expected to become a well-behaved viewer, an aesthete, a lover of nature, and an amateur botanist, as he or she traversed the carefully ordered walks.
- Cultural studies already has a well-developed account of how

the text seeks to include the reader within its effect, as subject for a position (Laura Mulvey's analysis of the masculine and feminine viewer for cinema is a notable example). But such analysis should envisage not only the implied reader, but broaden its account to take in the empirical reader, a sense of audience, the institutions of reception – in this respect, then, the *context* of the text.

• Awareness of the empirical reader must include the person who's doing the cultural analysis, their own investment, how they are seduced by their own work. Cultural studies should always compel attention to subjectivity in terms of the assumed position and point of view of the practitioner. What is the *look* of the sociologist, anthropologist, ethnographer or expert in cultural studies when examining forms of social activity, British horror films of the 1960s, say, or transvestite prostitutes in Rome?

I can't do better here than to invoke the section of Derrida's *Of Grammatology* entitled 'The Violence of the Letter'. The text implies at least four levels of understanding. At one, there are the Nambikwara, an Indian tribe of South America, who cannot write about themselves because their culture is entirely oral. These were studied, perhaps invaded, by the French anthropologist, Claude Lévi-Strauss, who wrote them up in his book, *Tristes Tropiques*, and this forms a second level of discourse which Derrida cites at length, for example, a description of an encampment of the Nambikwara which concludes: 'In one and all there may be glimpsed a great sweetness of nature, a profound nonchalance, an animal satisfaction as ingenuous as it is charming, and, beneath all this, something that can be recognized as one of the most moving and authentic mani-festations of human tenderness.'[13]

These citations have the effect of showing how Lévi-Strauss appropriates the Nambikwara to his own Western, Romantic, idealizing humanism; and so there is a third level, at which Derrida implicitly criticizes Lévi-Strauss, distances himself from him, appropriates him indeed to his own purposes. So there are the Nambikwara, Lévi-Strauss, Derrida – and now us, who, as I recount this adventure, are inevitably placed as masters of the whole scene, appropriating in our turn the other appropriators.

Derrida's argument would show that to study, to examine, to observe part of human culture, to treat it as an object, is always to patronize, to invade and to betray. In his assertion, cited above as an epigraph, 'The mere presence of a spectator ... is a violation.' Should we conclude that it would be best to give up science altogether and withdraw entirely from any attempt at systematic knowledge? Certainly not, but the passage on the Nambikwara does point up that any pursuit of knowledge necessarily constitutes an aporia, a situation which puts us in the wrong either way. Thus, to refuse systematic study is to remain ignorant; to observe (in however liberally sympathetic a spirit) is to appropriate. Derrida wants us to remember that every objective account, account of an object, includes its own subject, the point of view of writer or spectator. Cultural studies, having already followed a trajectory anticipating this perception, should continue to be promoted and encouraged, especially if it can keep this epistemological sense of subject and object at the heart of its developing enterprise.

Notes

1 J. Derrida, *Of Grammatology* (Baltimore: Johns Hopkins University Press, 1976); p.113.

2 F.R. Leavis, *Mass Civilization and Minority Culture* (Cambridge: Gordon Fraser, 1930), pp. 3–5.

3 R. Williams, *Culture and Society, 1780–1950* (Harmondsworth: Penguin, 1963), p. 230.

4 Williams, op. cit., p. 266.

5 R. Hoggart, *The Uses of Literacy* (Harmondsworth: Penguin, 1957), p.213.

6 See Louis Althusser, *For Marx* (London: New Left Books, 1977).

7 Stuart Hall, 'Cultural Studies: Two Paradigms', *Media, Culture and Society*, vol. 2, no. 2, 1980, pp. 57–72.

8 Hall, op. cit., p.72.

9 L. Mulvey, 'Visual Pleasure and Narrative Cinema', *Screen*, vol. 16, no. 3, 1975, p.11.

10 R. Williams, 'Base and Superstructure in Marxist Cultural Theory', *New Left Review*, vol. 82, Nov./Dec. 1973, p.16.

11 J. Dollimore and A. Sinfield, *Political Shakespeare: New Essays in Cultural Materialism* (Manchester: Manchester University Press, 1985), p.7.

12 Dollimore and Sinfield, op. cit., p.12.

13 Derrida, op. cit., p.117.

2
Facts and meanings in British Cultural Studies
ALAN DURANT

'Knowing' a society

'Knowing' another society differs from 'knowing' one you feel
yourself to be a member of. For an inhabitant of a culture,
social knowledge – at least where it hasn't been formally
channelled through an off-the-peg 'citizenship' programme –
is largely built on slowly acquired competence over a long
period of time; it develops by means of (generally unconscious)
intuitions, as well as through a type of experiential 'case law'.
For the visitor or student, on the other hand, specialized social
knowledge depends largely on a conscious learning process.

The conscious learning process characteristic of what is
emerging as the distinct field of British Cultural Studies (some-
times simply 'British Studies') is served by a range of resources,
including visits, 'expert' native informants, textbooks, and
audio-visual and multi-media materials. But these resources are
different from each other in principle, and of variable usefulness
in practice. 'Natives' of a culture, for instance (the term itself is
problematic, though whoever it refers to is often considered an
exemplary guide) may take deep, structural aspects of their own
culture for granted, and highlight instead a collection of
features which are of relatively little interest to the visitor or
student. By contrast, although a student's or visitor's observa-
tions may not be accompanied by much self-confidence, the

scope for contrastive analysis they allow may offer a far richer resource than the monocultural native's perspective.

The so-called native and non-native perspectives cited here differ in ways which can be usefully compared with the parallel case of the teaching of English Literature. With native speakers, literature teaching typically presumes some perception on the part of the learner of the status or reputation of texts, authors, themes and conventions, if not familiarity with texts themselves. A degree of general, cultural competence (for example, regarding imagined readerships or audiences, as well as critical goals, values and procedures) is also often tacitly assumed alongside relatively sophisticated intuitions about the language. Pedagogic emphasis is typically placed accordingly on extending students' experience of works and authors, while at the same time defamiliarizing received ideas or assumptions in an effort to develop critical awareness. Special use can be made of unusual, experimental or 'deviant' texts in such teaching, since these highlight literary or cultural issues which are otherwise unlikely to be directly acknowledged as issues at all. In the case of non-native speakers, by contrast, there is a need to establish, rather than presume (and on that basis deconstruct), cultural parameters and unstated, underlying conventions, especially where the difference between the learners' own culture and the target culture is large. Pedagogic emphasis tends accordingly to be placed either on contrast with the students' known, 'home' culture, or on more detailed exposition of information which would be self-evident and/or redundant for native-speaker learners.

An important consequence of the distinctions drawn here (though it has only recently been fully recognized) is that English Literature syllabuses for non-native speakers cannot be appropriately modelled on the 'authority' of courses aimed at native speakers: students' needs and aspirations differ between the two cases. As I will suggest below, similar distinctions apply in the case of British Cultural Studies.

Two traditions: confluence or watershed?

The sorts of divergence between perspectives identified above can be traced in the formation of British Cultural Studies as a field ('formation' both in the sense of historical development and current content and priorities).

Roughly speaking, there are two understandings of what 'British Cultural Studies' means. On one hand, the phrase is used to mean updated 'civilization' courses: what in many countries would be understood by such terms as *cultura inglesa* or *Landeskunde* (where the main concern is with history and social institutions, and where key texts might include Anthony Sampson's *The Changing Anatomy of Britain* or the HMSO *Aspects of Britain* series prepared by the Central Office of Information). Such courses, for non-native speakers, provide useful data about British institutions and patterns of behaviour.[1] On the other hand, 'British Cultural Studies' is widely taken in Australia and North America to mean 'cultural studies as practised by British scholars'; this usage signals a tradition of work effectively from Richard Hoggart and Raymond Williams (often with reference back to earlier arguments in T.S. Eliot, the Bloomsbury Group, and F.R. Leavis) through to the Birmingham Centre for Contemporary Cultural Studies (especially work by Stuart Hall), and into recent work by Paul Gilroy, Angela McRobbie, and many others. This field of cultural studies, by contrast with the 'civilization' emphasis, is theoretical and often Marxist-influenced; it combines sociological, literary and historical approaches in order to investigate the changing formation of British society from a critical standpoint, and explores assumptions, traditions and conventional attributions of value; in doing so, it is also highly suggestive about general principles and procedures of cultural analysis.[2]

Each of these different understandings has a complex history and set of current positions. The reason for distinguishing them here is that they are shaped by different forces, and if confused can pull the content and methods of any unreflective new course in 'British Cultural Studies' in conflicting directions. It is certainly less than clear that the two perspectives are easily reconciled.

British Cultural Studies is not, however, merely one or other (or a hybrid) of two intellectual traditions. Like any other field, besides having a 'content' it serves broader social functions and interests, and adopts specific pedagogic practices. In the last decade, for instance, there has been a reduction of emphasis on traditional 'English Literature' within EFL, largely as a

result of the influence of communicative syllabuses. The effect of this contraction has been amplified by simultaneous critiques in first-language literature studies of the English Literature canon and an accompanying new emphasis on media and cultural studies, the detailed content of which does not travel well (since many of the texts and issues in question have not had significant or analogous impact in countries where foreign language study of English occurs). These combined forces – coupled with parallel, theoretical critiques of literature and high culture in other national traditions and the recent international popularity of 'area studies' – have undermined the previously unquestioned position of English Literature as the cultural component of EFL. There nevertheless remains a need for some kind of cultural content for EFL, not least because of the otherwise anodyne character of constructed 'language' materials. At advanced levels in particular, where language acquisition involves more than narrow instrumental skills, it is considered important to explore aspects of social usage and stylistic inventiveness in ways which require analysis of samples of language attentive to how discourse is embedded in its social contexts of use rather than simply whether an utterance is idiomatic or grammatically correct.[3]

British Cultural Studies conveniently fills a vacuum created by the relative displacement of English Literature as the cultural component of EFL. It has been helped in achieving this role by its convenience to a larger political agenda in which, as part of British government efforts in favour of 'buying British' and 'batting for Britain', the English language is seen as one more exportable resource and as an opportune conduit for the dissemination of British cultural values. To the extent that the English language is increasingly recognized as something international (and where 'owned' at all, then owned by North Americans), linking EFL to some version of unique 'Britishness' also offers an edge in an increasingly competitive international language teaching market. I return to these values of British Cultural Studies, somewhat sceptically, in my conclusion.

Resources and data in British cultural studies

In practical terms, we draw extensively in learning about another culture not only on our own experience (e.g. through

travel) but on conventional sources of social knowledge. These sources are not always freely available outside the culture in question; but at least it's reasonably clear what they are: surveys, histories, interviews, biographies, photos, maps, adverts, television programmes, records and tapes, films, and so on. (In fact, it is often the social circulation and prominence of these sources in the target culture which confers their educational usefulness – something which conversely can make 'marginalized' or 'alternative' texts, which are often especially effective in native-speaker contexts, pedagogically less useful in foreign language classrooms.) Devising an appropriate curriculum for British Cultural Studies depends, at least to some extent, on bringing together a suitable range of such resources; and a lot of work has been done, by teachers and publishers, in collating and distributing sources of cultural evidence or data.

Partly because of the apparent solidity of such materials and the information they contain, cultural knowledge is often considered to consist of networks of facts. Where study of the culture is required to progress beyond rote learning into analysis, these facts can be deemed to invite correlations, which in turn make possible hypotheses and ultimately forms of causal explanation. The evident result can then appear a respectable, academic form of cultural understanding.

How far there can be said to be facts at all, however, remains problematic. What we conventionally call cultural 'facts' are representations, and as such are already mediated by previous interpretation. This is the case, whether we come across our 'facts' in surveys or tables, on film or television, or simply in the form of other people's stories or anecdotes. Because of their mediated character, 'pristine facts' present courses with the unavoidable issue of their *means of representation*, including the key question of point of view. Understanding means of representation involves developing skills in looking beyond the surface sense of texts or situations in order to take into account the rhetorical or stylistic techniques involved in their making. As regards situations, this means filling out bare observational data about behaviour into fuller 'thick description' of intentions, strategies and codes which give such behaviour significance.[4]

Point of view, in particular, originates in the social experience, history and position of the speaker or writer and so

in effect speaks, if in qualified or modulated ways, for specific cultural aspirations and interests. The desire for a decisive and synoptic 'overview' of a culture, even where such an overview might provide a convenient classroom focus, is conceptually misguided to the extent that it disguises rather than invites commentary on the constructed and inevitably selective points of view presented.

The need to acknowledge questions of point of view (and means of representation more generally) arises especially because cultural knowledge is made up not only of bits of information but of meanings. So how meanings are created, how they circulate and how significance and value become attached to them need to be integrated within programmes of study. Priority in British Cultural Studies should accordingly to be given not only to the accumulation or presentation of 'facts' but to ways of developing skills in interpreting or 'reading' such facts. The question of *how* this can be achieved in the classroom is one I return to towards the end of this piece.

In order, in the meantime, to stimulate discussion of how different sorts of material might be incorporated into British Cultural Studies programmes, it is useful to review the main conventional sources of classroom information currently in use, with cautionary notes on how they might be regarded.

Interaction with people

This resource includes visitors and friends in or from the target culture, as well as encounters with travellers, traders and officials. Such encounters undoubtedly offer 'quality' and 'depth' of experience; but because each person's experience is unique and to some extent haphazard, it is risky to consider such experience representative. (In this regard, there is a special need to beware taking expatriates as representative, since their experience of their 'home' culture may be distant, inflected by nostalgia, or consist of unusually idiosyncratic views or positions.)

From the particularity of individual encounters, it is common practice to move inductively towards generalizations; and certainly the mental modelling of social patterns and situations is essential, if experience is to be more than an unstructured flow. Equally, however, such generalizations run the risk of

creating or reinforcing essentialist notions and damaging stereotypes, of the kind 'taxi drivers/shop keepers/the British are generous/suspicious/unfriendly/comical' and so on. It is always necessary to question how representative the original experience was or could be in principle, as well as to query the observer's own role in shaping (or modifying) any 'typical' experience. Such caution is needed if the originating experience is to bear the weight of any speculation based on it.

Personal recorded testimony of others

Autobiography, diaries, reminiscences and other forms of first-person narration offer records of lived experience, or personal and community history. The appeal to immediate experience, perception and sensibility which characterizes first-person reflections accounts for the obvious usefulness and interest of Tony Benn's diaries or Margaret Thatcher's memoirs. Equally, it explains something of the attraction of, for example, the actor/director Kenneth Branagh's autobiography, or Marianne Faithfull's *Faithfull* (co-written with David Dalton), or Nick Hornby's *Fever Pitch* – all of which have in recent years been popular non-fiction titles in Britain.

With sources of this kind, the question how far social experience is imaginatively reconstructed within conventional narrative genres as it is retold is crucial. So is the question how far such experience can be generalized. Both questions clearly invite debate, especially where the documents under discussion circulate publicly and can be contextualized in a syllabus by linking them to reviews as well as to broader public reaction. Interlocking documents can in such case studies form a montage which offers multiple points of view and starts off the process of assessing the 'accuracy' of any single, given account.

Visiting places

Travel broadens the mind. But in the richness of its interest, travel invites attention to the contingent as much as to the 'essential'. For study purposes, broadening needs to be connected with deepening. Understanding travel experiences inevitably involves conceptualization, selection and critical judgement (raising, once again, the central questions of point

of view and the proliferation or questioning of stereotypes). An incident such as buying a drink or finding a bus stop outside a museum *may* have as much cultural impact – and possibly offer as much insight – as the museum's rooms full of exhibits, depending on how details or illustrative instances are construed.

It is also worth remembering that travel takes place in the present: the historical sense it offers is based on current representations and evidence of the past, rather than somehow on the past itself. Historical buildings are certainly evidence of the past; but that evidence is mediated by present conventions of tourism and heritage marketing, and is reconstructed in the image of the present rather than being somehow fixed or authentic. (Before the present period, too, historical layering links different strata in the constructed past, for example when Neo-Gothic and Medieval styles overlap and become retrospectively confused.) When the complexities of travel are taken into account, the immediate immersion it offers needs to be set alongside, and in educational practice combined with, the superficially less attractive possibilities of more geographically remote study and enquiry.

Exposure to the country's media

Increasingly, the most commonly used resources in a British Cultural Studies programme are media texts: photographs, newspaper articles, magazines, adverts, pop records, and videos of films and television programmes. Usefully, such resources are widely available: *The Times*, *The Economist*, BBC World Television, a range of commercial satellite stations, British records and CDs, and other sources are extensively distributed internationally. Such sources make possible detailed consideration of the social circulation of meanings, and can be conveniently used in classrooms.

The images, meanings and values presented in media texts need to be located, however, in the larger context of media conventions, institutions and patterns of ownership. Only a selected range of images of a society is represented in its mainstream media, and conventions for interpreting the realism, irony, offensiveness or quality of such images must be shaped accordingly.

Even in isolation, texts provide a valuable resource, since their discursive patterning directs inferences to be drawn, and so signals assumptions, presumed contexts, and likely audience attitudes. But if media texts are to provoke debate, they are better embedded in (even brief and schematic) discussion of the contexts and histories of the media forms and institutions in which they have been produced.

Social rituals and customs

As in ethnographic work generally, there is much to be gained by observation of – or participation in – social rituals and forms of conventional behaviour. These might include sport (such as football, darts, ten-pin bowling or dog racing); shopping in shopping centres (examining the range of products on sale, as well as social behaviour); the theatre (including the 'perform-ance' of the audience); weddings (or other festivities such as parties); pubs, restaurants and cafés; and many other locations and situations. More particular conventions of behaviour, such as modes of address, who shakes hands with whom and on what occasions, who sits where at social gatherings, are also revealing.

The interest of social rituals and customs can take one of two main forms. Some will be particularly interesting because of their cultural specificity and novelty (to the observer); in these cases, alongside potential for insight, there is nevertheless a risk of mistaking the contrived for what is judged typical or au-thentic, or conversely of exoticizing the experience. (Consider the complexities of history and myth in morris dancing, cei-lidhs, a ploughman's lunch, or English country houses, for instance.) The interest of other social rituals is less obvious but equally significant. Where behaviour occurs more or less equivalently across two or more cultures being compared, interesting hypotheses open up regarding the *causes* of cross-cultural regularities: speculation is likely to range from sup-posed universals of human identity through to arguments about the penetration and effects of multinational corporations and forms of cultural imperialism.

Social institutions

Much of the traditional source material for British Cultural Studies consists of lengthy accounts of constitutional issues,

legal procedures, and ecclesiastical, military and municipal history. In fact, knowledge gained by students on these topics goes in many cases far beyond that of peer-group inhabitants of British culture – arguably because the contrasts with other social systems make such material interesting in a way that it isn't to the large proportion of the British population which is monocultural. Information on such topics provides a necessary and relevant framework within which to interpret contemporary developments, or for reflecting on underlying historical principles or unspoken assumptions of British society.[5]

Two notes of caution are appropriate, nevertheless. The first is that such structures typically present a 'conservative' image of the society: they prioritize the society's established, public institutions rather than its informal networks, subcultural or local associations, or street-life. The second reason for caution concerns the impulse on the part of a student or observer to interpret local events or changes in the light of the larger history of social institutions: in such cases, awareness of or intuitions based on historical or structural patterns may be attributed to agents within the British social process who may themselves be quite oblivious to large-scale historical and cultural trends grasped by the outsider.

Surveys, statistics and charts

Recognizing that 'facts' are always social constructs often operates as a justification for ignoring them altogether. But it is possible to view and assess statistical and survey information in ways which combine interest in observing patterns and tendencies with appropriate open-mindedness about ultimate accuracy or factuality. If such an approach is adopted, documents such as the survey material provided by HMSO *Social Trends*, in the National Census, in electoral analyses, or in market research data may not only inform but set an agenda for discussion and argument. Nor need information always be used for its original purposes. The volume *British Rate and Data* (*BRAD*), for instance, is a guide to the audited circulations of newspapers and magazines, divided into social-classification categories. Its aim is to provide advertisers with information correlating cost of advertising with readerships delivered; but it serves equally well as a general profile of readers and in this

way can offer useful context for discussion of the meanings of
adverts, articles or images in any given newspaper or magazine.
With care, it can be used to extrapolate attitudes and tastes in
different social strata.[6]

Heuristic contrasts and oppositions

It is not only data, or sources of evidence, of the kind described
so far which act as resources in British Cultural Studies. In
between raw data, so called, and specific interpretations of
individual situations or texts lie general structures or templates
for thought. These are the frames, scripts, schemas or proto-
typical (or arguably stereotypical) mental constructs into which
any new piece of evidence is placed. In the widely used book
referred to above, Anthony Sampson remarks that British
society is peculiarly given to perceiving itself in terms of binary
oppositions: left/right; rich/poor; north/south; black/white;
high cultural/popular cultural; old money/new money;
standard/non-standard; bosses/unions; defence/prosecution;
Labour/Conservative; tabloid/broadsheet. As with all binaries
in cultural analysis, these pairs form homologies when one is
overlaid on another. An argument may contend, for example,
that the possessors of 'old money' revere 'high culture' while
their 'new money' neighbours favour 'popular culture', or that
there is a preponderance of poor, northern supporters of
Labour, or whatever. Such polarities are frequently reductive,
simplifying complex historical textures and neglecting contra-
dictions within social networks of judgement and distinction.
For pedagogic purposes, however, they do offer conceptually
structured ways into difficult topics, and in doing so reflect (and
so can expose for comment) much of the terminology of
popular British debate.

Reading signs and styles

Stretching beyond the convenience of simple polarities, more
complex schemes of analysis present themselves, as the various
signs and styles of a society are explored. Social representations
of all kinds – in architecture, fashion, garden style, people's
book or record collections, register distinctions between dif-
ferent spoken greetings, and so on – all act as significant

cultural indicators: as what might be called signs of the national culture. Such indices change, and change in meaning (not least because much of their meaning comes from contrasts they enter into with a network of concurrently changing surrounding signs, as is perhaps especially evident in the rapidly changing fashions of clothing and speech styles). They are also sites of dispute and cultural conflict, as differing values and ideologies are contested. Both of these aspects of cultural signs – change and conflict – can be seen, for example, in different images of royalty, of women, of the police, of religions, of Scotland, Wales and Northern Ireland, in representations of ethnic minorities, in changing patterns of English usage, or in attitudes towards sexuality. Each can be tracked, as a sort of case study, in changing media imagery. Importantly, too, these signs can be related back to issues connected with the multiple regional, class, ethnic and gender identities which make up contemporary British culture, and which, more specifically, overdetermine the social identity of any single individual.

From materials to learning

The general point which I hope emerges from these brief descriptions is that in British Cultural Studies it is necessary to engage actively with sources, and to interrogate them. 'Sources' need to be viewed, that is to say, *in the sense of starting points* rather than being relied on as authoritative 'sources' *in the sense of origins*. What follows from this, concretely, is that emphasis needs to be placed in courses on discussion and problem-solving at least as much as on presentation of information. In such workshop-based classes, it seems desirable to emphasize, rather than disguise, questions of point of view. This is not only because no neutral 'overview' is theoretically possible. It is because interest in acquiring knowledge of another culture – or, put another way, in at least dispelling ignorance about it – is likely to be closely linked with cultural curiosity; and cultural curiosity will be most encouraged (or reinforced, where it already exists) through curriculum processes directed towards exploration, discovery and discussion.

But how exactly should such classroom work proceed? Assuming that British Cultural Studies functions primarily as

an adjunct to EFL, rather than as an autonomous discipline (since in the latter case it is better characterized as simply a particular interdisciplinary mix of already existing fields: sociology, history, law, literature, and so on), I would suggest that 'topic' or 'theme' organization is an appropriate syllabus-organizing device. Topics might range across food and cooking customs, the legal and judicial system, holidays, clubs and societies, leisure interests, church architecture, shops and markets, landscape, patterns of sexual preference, housing and gardens, social attitudes, forms of political expression and agitation, political satire, and very many other areas. They might also focus on established cultural stereotypes, and proceed to investigate and offer critiques of them. There seems to be little need for any fixed list or fixed order of themes; and student choices can be beneficially incorporated. Learning will take place cumulatively, as much on the basis of the analytic and comparative methods adopted as on account of the particular content presented.

The second point to make, I believe, is that the pedagogic focus of British Cultural Studies courses should be largely on *discourse*. This is both because discourse of various kinds is the principal source material likely to be presented in the classroom, and because it is in forms of linguistic and audio-visual rhetoric that cultural patterns are most clearly represented and mediated, even if their content is about other aspects of material organization. Equally importantly, emphasis on analysing modes of discourse also maintains the close link with EFL. Enhanced language proficiency is essential if students are to be able later to pursue their studies independently, beyond the materials actually presented in the classroom. The range of kinds of discourse offered for study must, of course, be broad. It also needs to be varied along a range of continua such as the age, gender, class, ethnicity and social position or relative power in the society of the speaker, as well as selected topic and stylistic register. Choice of texts and other materials along such lines can readily be made within the thematic syllabus organization suggested above. The value of such discourse work lies finally in how effectively it supports development of a combined form of communicative and cultural competence – or set of relevant intuitions and skills – as much as in its provision of specific cultural knowledge about Britain.

Readings in context

If Cultural Studies were to consist merely of juxtaposed
samples of discourse, however – albeit an enlarged corpus by
comparison with programmes made up of literary works – the
field would still suffer from a potentially serious drawback:
that it is concerned primarily with judging what any given
discourse means on the basis of textual codes combined with
each student's personal inferences. The scope for whimsical
readings and for misinterpretations is considerable, given
cross-cultural interferences. What should in my view most
distinguish Cultural *Studies* from such individual readings is
that in cultural analysis, meaning is conceived in terms of social
patterns of interpretation, which locate any given reading
within a larger distribution of other people's different readings.
Cultural facts (whether texts, events, situations or whatever) do
not have singular meaning, but rather a changing variety of
interlocking (often conflicting) meanings *for* particular indi-
viduals and social groups. Investigating cultural meaning is
accordingly a question of establishing patterns within the
society as regards who forms particular interpretations of any
given material being studied. Within this general perspective,
it is appropriate in teaching to give special attention to
considering apparent social 'facts' as 'disowned representa-
tions', and to trace them back to their proponents and sup-
porters in order to look at the social production of dominant
versions of knowledge, orthodoxy and authority.

The sort of socio-cultural emphasis in interpretation en-
couraged here points towards what might be thought of as an
'ecology' of cultural forms and meanings: an overall image of
a cultural environment within which texts and meanings cir-
culate.[7] But there is a further stage of investigation to which
Cultural Studies should also aspire. The 'ecology' perspective,
as I have outlined it here, is limited by a lack of concern with
history or causation. Understanding a culture requires in-
vestigation of how and why representations differ in the extent
to which they are entertained and reproduced by members of
a population. Some representations (such as personal desires,
fears, attitudes or beliefs) may be entertained only moment-
arily, never to be written down or conveyed to others. These
scarcely become cultural facts at all, and are in any case
unlikely to be accessible for classroom consideration. Others

(such as personal letters, shopping lists, notes and sketches) *are* represented in a transmissible or reproducible form, but have limited circulation in time or space. Others again become culturally influential and valued, but only for a brief period; these are typically fashions or 'epidemics' (and include buzz-words, sudden ideological crusades, fashions, pop cultural arte-facts, media tie-ins and so on). Others again are reproduced in relatively stable forms widely in the society over a long period, and form cultural traditions (or 'endemics'); such representa-tions include religious and moral beliefs, social customs, cere-monies and commentaries on canonical literary works. When the social circulation of representations begins to be mapped in these dimensions, it becomes possible to explore changing forms of relevance which are found in each and which sustain (or fail to sustain) each representation as regards further dissemination or reproduction. Analysing cultural forms and meanings in this way amounts to what has recently been characterized meta-phorically as a sort of 'epidemiology of representations'.[8]

Such an epidemiology of representations sets an ambitious programme for cultural research. At the same time, it can influence student studies at more introductory levels. Investiga-tions might be undertaken through theme-based work or case studies (for example, looking at a popular text, and analysing reviews, audience ratings, texts subsequently influenced by it, and so on). Such an approach could also help counter the problem in Cultural Studies of relatively sophisticated syn-chronic analysis (of the codes of modern culture) coupled with only crude and reductionist versions of history (as 'necessary background', 'earlier developments', and so on). The published work of Raymond Williams shows in an exemplary way the depth of insight which can be gained through in-depth historical analysis.[9] Regrettably, however, although Williams's work has been influential in Cultural Studies as practised in Britain, North America and Australia, so far it has had relatively little impact on EFL-related British Studies, whose own historical accounts often remain damagingly foreshortened.

CONCLUSIONS

The study orientation I am advocating here carries British Cultural Studies some way beyond its current remit. Such

studies, even in this revised perspective, could hardly be confined to investigations of an area-specific kind. The value of the current resurgence of interest in British Cultural Studies, if it is to have one, lies as much in drawing on students' own cultural awareness as a basis for intercultural dialogue and cultural exchange as in knowledge about Britain in particular. Students' motives for taking British Cultural Studies – in those cases where motivation can really be said to stretch beyond institutional compulsion – are, after all, less likely to be found in Anglophilia (or some sort of 'integrative motivation') than in a kind of contrastive cultural curiosity. Cross-cultural interest should accordingly be welcomed, even if general procedures of contrastive method cannot easily be formulated because each contrastive pair of cultures requires a slightly different mode of study.

It is worth returning, finally, to the explanation I offered at the outset for current interest in British Cultural Studies: that (taking over this function from English Literature) the field provides an important 'culture component' for English language teaching.

If links with EFL are an essential aspect of the field, then it is important that the relationship between cultural study and English language study is adequately specified. Roughly speaking, there are two main possibilities. The first is what might be called 'target culture' studies (by analogy with the phrase 'target language'); in such studies, the object of study is the specifics of the particular culture. The second possibility is what might be called 'culture in language' studies; in such studies, by contrast, the chosen culture serves to illustrate *how language and other media work* in representing particular ways of living. In either of these cases, British Cultural Studies as currently practised appears problematic.

If British Cultural Studies is viewed as a 'target-culture' discipline, then there appear to be serious shortcomings as regards its development of active or performative skills as opposed to comprehension skills. Where priority is given to studying a notional *content* of cultural references (for example, by offering a substantive gloss for the Boat Race, pigeon racing or race relations), an assumption is effectively made that students want primarily to understand British speakers and their meanings – and so be assimilated into 'typical' British social relations – rather than actively contributing to cultural

dialogue by also speaking about their own cultural experience. What might be called the 'culture phrasebook' design of such courses assigns to students primarily a consumer role; at worst, such courses realize potential for cultural 'dialogue' inherent in British Studies only in the limited sense of including students (as visiting foreigners) within a slightly patronizing hospitality of the home culture.

If, on the other hand, British Cultural Studies is viewed less as what I have called 'target-culture' studies than as an attempt to establish close, methodological links between language study and cultural analysis, then there is little reason for the curriculum focus to be on Britain in particular. A more international perspective would reflect the changing world use of English and acknowledge a reduced sense of British cultural 'ownership' of the language. Such a reorientation would also have practical advantages: EFL students are as likely to visit Australia, the USA or other English-using societies as they are to visit Britain, and will in any case want to be able to use their English to talk with people who will never visit an English-using society at all.

My own view, for what it is worth, is that the centre of gravity of 'British Cultural Studies' should indeed move away from its recently reinforced focus on British society. Instead, the field could explore a far wider range of English-using cultures. Fresh emphasis in British Cultural Studies on negotiating a relationship between EFL and issues of cultural content is timely and welcome. But that impetus should not be simply directed towards academic commodification of British culture for export. Few people will take such an approach seriously for long, in any case; and British Cultural Studies of this kind would quickly come to be seen as merely a new insularity or piece of market-led opportunism.

Consider the literature teaching analogy once more in this context. In the study of English literature, the changing geography of the English language is slowly shifting emphasis away from exclusive study of an English national literary canon towards interest also in the new literatures in English. Correspondingly, I would suggest, priority in British Cultural Studies should be less on celebrating a constructed version of 'Britishness' than on looking, analytically, at how discourse in the English language conveys specific cultural meanings and values *in and across all those cultures where the language is regularly used.*

Such a curriculum emphasis would almost certainly enjoy less favour with funding agencies in Britain than a British Cultural Studies of the 'batting for Britain' type. In any case what would be needed is really a new kind of study, which might be better called 'cultural understanding of language'. By investigating how allusions work and how cultural information is encoded in discourse and activated in interpretation, such study would link EFL with cultural contexts which are often (but not exclusively) British. The classroom processes I have identified above could be carried out in and for any English-using culture, as well as in comparison *between* English-using cultures. Such a culturally referential framework might then be equally of interest to a Swedish businessperson in conversation with a Nigerian, a Chinese student listening to Voice of America, or a Brazilian reading a novel in English by an Indian.[10] No clear model for such studies yet exists. But such work needs to develop, if British Cultural Studies is to be more than the relaying of specialized British intellectual traditions of self-analysis or a flagrant act of self-promotion. The latter, regrettably, would amount to little more than a crude effort to fly the flag in the form of a cultural wraparound for English language teaching.

Notes

1 There is so much material now commercially available that a very substantial bibliography would be required to give any real sense of its scope and variety. A representative (and pedagogically useful) example of an expository textbook is Oakland (1995).

2 A collected 'reader' which gives a sense of the development and breadth of contemporary cultural studies in Britain and the United States is During (1993). Care needs to be taken with such readers, however, because of the fundamental reshaping and dehistoricization of the field which tends to take place in the process of selection and editing.

3 A clear, guide to discourse analysis is Brown and Yule (1983). The concept of 'communicative competence', developed initially by Dell Hymes, is introduced and explained in Saville-Troike (1982), a work of general relevance to connections between linguistic and cultural behaviour.

4 The notion of 'thick description', which has become central to ethnographic and other qualitative research approaches, originates

in the writing of Clifford Geertz (1973). For a general introduction to ethnographic method, see Hammersley and Atkinson (1995).

5 Political and legal topics need not be abstract or uninteresting to students. An interesting case study might be developed, for example, around British legal concepts of individual freedom, especially freedom of speech. Descriptive or theoretical work (based on popular but authoritative legal arguments such as those presented in Robertson (1989) and Lee (1990)) can be combined with selective reading or viewing of works contested in the celebrated cases analysed. And there are almost endless other possibilities.

6 A concise overview of audience research within contemporary British media industries is Kent (1994). A critical overview of this rapidly changing field of study, presented alongside reports of his own research, is Morley (1992). A complex and suggestive theoretical framework for analysing patterns in social taste is proposed in Bourdieu (1986).

7 The 'ecology' metaphor employed here has been modified from its more specific use by David Barton to describe the environment of potential reading materials by which we are surrounded during the acquisition of literacy; see Barton (1994). For a general introduction to literacy, with extensive reference to the British situation, see Levine (1986); for a critical account of established approaches to literacy, outlining what have come to be called the New Literacy Studies, see Street (1984; 1995).

8 See Dan Sperber (1996). The general perspective is developed in his earlier *On Anthropological Knowledge* (1985); the technical sense of 'relevance' in Sperber's framework is explained in Sperber and Wilson (1986).

9 See especially Raymond Williams (1973, 1980).

10 The changing geography of the English language is vividly described and well illustrated in McCrum, Cran and MacNeil (1986). A more academically linguistic introduction to issues raised by world Englishes is Kachru (1982).

References

Barton, David, *Literacy: An Introduction to the Ecology of Written Language* (Oxford: Blackwell, 1994)

Bourdieu, Pierre, *Distinction: A Social Critique of the Judgement of Taste* (London: Routledge, 1986)

Brown, Gillian and Yule, George, *Discourse Analysis* (Cambridge: Cambridge University Press, 1983)

During, Simon (ed.), *The Cultural Studies Reader* (London: Routledge, 1993)

Geertz, Clifford, 'Thick Description: Toward an Interpretive Theory of Culture', in *The Interpretation of Cultures* (New York: Basic Books, 1973), pp. 3–30

Hammersley, Martyn and Atkinson, Paul, *Ethnography: Principles in Practice*, (London: Routledge, 1995)

Kachru, Braj (ed.), *The Other Tongue: English across Cultures* (Oxford: Pergamon, 1982)

Kent, Raymond (ed.), *Measuring Media Audiences* (London: Routledge, 1994)

Lee, Simon, *The Cost of Free Speech* (London: Faber & Faber, 1990)

Levine, Kenneth, *The Social Context of Literacy* (London: Routledge, 1986)

McCrum, Robert, Cran, William, and MacNeil, Robert, *The Story of English* (London: Faber & Faber and BBC Publications, 1986)

Morley, David *Television, Audiences and Cultural Studies* (London: Routledge, 1992)

Oakland, John, *British Civilization: An Introduction* (London: Routledge, 1995)

Robertson, Geoffrey, *Freedom, the Individual and the Law* (Harmondsworth: Penguin, 1989)

Saville-Troike, Muriel, *The Ethnography of Communication: An Introduction* (Oxford: Blackwell, 1982)

Sperber, Dan, *On Anthropological Knowledge* (Cambridge: Cambridge University Press, 1985)

Sperber, Dan, *Explaining Culture: A Naturalistic Approach* (Oxford: Blackwell, 1996)

Sperber, Dan and Wilson, Deirdre, *Relevance: Communication and Cognition* (Oxford: Blackwell, 1986)

Street, Brian V., *Literacy in Theory and Practice* (Cambridge: Cambridge University Press, 1984)

Street, Brian V., *Social Literacies: Critical Approaches to Literacy in Development, Ethnography and Education* (London: Routledge, 1995)

Williams, Raymond, *The Country and the City* (London: Chatto & Windus, 1973)

Williams, Raymond, *Problems in Materialism and Culture* (London: Verso, 1980)

3

British Studies: an educational perspective

CHRISTOPHER BRUMFIT

Introduction

This chapter explores the educational background to the rise of interest in 'British Studies'. I examine some tensions between arguments for a nationally based curriculum area and for teaching as an emancipatory activity, and then consider such issues in the light of recent approaches to research on the curriculum. Finally, I consider the teacher's role as mediator in an attempt to define the most appropriate methodological stance for an inevitably contentious subject area.

First, though, it may be helpful to express some of the concerns that many teachers feel about the new interest in this field. The concept 'British Studies' raises a number of problems for educators, particularly those brought up within the liberal tradition that has dominated intellectual thinking in the second half of the twentieth century. The generation that was educated in the years after the Second World War acquired a number of tacit assumptions that proved highly productive in the optimistic period of international regeneration, but which are severely challenged by the pessimism underlying contemporary conservative culture. Among these assumptions was a belief in the power of formal education to overcome the fundamental problems of poverty, ignorance and disease, and (in the strongest version) to create a peace-loving and creative

community of egalitarian altruists. Such naïve hopes required a liberation from the local loyalties that had led us all to two world wars, to bureaucratic tyranny and racist dogma. Education was internationalist, optimistic, mildly anti-wealth and suspicious of national governments unless they were engaged in freedom struggles against the major imperial powers.

This picture may be a stereotype, but it is by no means a caricature. In the 1960s volunteers from the 'developed' world poured into 'developing' countries to teach in schools and universities, and do their bit to dismantle their own empires, or (as with the Peace Corps) to undermine others'. In Africa and Asia national ideologies were promoted, as a means of overcoming more local loyalties, usually paying lip-service to some form of socialism, each aiming at greater independence, greater equality, greater international anti-imperialist collaboration, and (though less explicitly stated) greater power over their own destinies. Conservative prime ministers welcomed the winds of change, and nations like South Africa which resisted were consigned if not to the dustbins of history at least to those of the United Nations. And central to the realization of these goals was the education system, designed to a Western European pattern, senior-staffed by Western-trained teachers or by imported Western expatriates (frequently written as 'ex-patriots', as indeed they often were), superimposed on the vast traditional network of ordinary people's cultural relations, with which it scarcely interacted at all.

Nor was this model solely a response to the fragmenting twentieth-century empires: it drew on a long-standing European tradition. Nationalism, emancipation and increased educational provision had contributed massively to the collapse of the European empires following the First World War, and to earlier nineteenth-century freedom movements (see Hobsbawm, 1962: 164–71). The rhetoric of the succeeding power configurations, whether for the Communist International or for the League of Nations, reinforced beliefs that the wider the collaboration, the safer the world would become.

Teachers were the minor missionaries of this process. What they did to their pupils in Europe, their pupils did to theirs in turn, both at home and abroad. Education and progress rode together, hand in hand.

It is easy to ridicule this model, for the conflict between these internationalist aspirations and nationalist *Realpolitik* was plain to see. But it offered a potent ideal to education: an opportunity, it seemed, to contribute to the improvement of the world both by overcoming petty nationalisms and by advancing equality between nations. Ironically for Western exponents of this view, the substantial shift in economic power away from the West, arising from the oil crisis of the early 1970s, coincided with (and perhaps contributed to) the popularization of the conservative and the post-modernist critiques of such optimistic hopes. But these criticisms were increasingly questioned as the 1980s ended, and the aspirations of the 1960s may prove to have worn better than their critics anticipated. For, while not entirely disinterested, the cause was certainly not ignoble.

Children's lives *were* sometimes saved, the negative effects of technology *were* sometimes mitigated, tyrannies *were* sometimes defeated (even if others arose). However, the side-effects of the free-market economies springing from the right-wing critique (which was perhaps allowed to develop more aggressively by the acceptance of impotence implicit in the cultural relativism that was central to the Left's critique), had been the predictable emergence of virulent nationalist movements. And their ideologies will inevitably conflict with pluralistic tendencies in mass communication, air travel and increased educational opportunity.

While we cannot avoid sharing the disappointment at the continuing poverty, the continuing violence and instability of the countries for which a generation of professionals worked (it seemed) so hard, it is difficult now to accept that intervention by professionals was the problem rather than the response. The World Bank has been increasingly attacked for its insensitive implementation of monetarist policies, and the pressures of major crises in Africa, Europe and the Middle East force social intervention back into the centre of the West's agenda.

In such an atmosphere the competing ideologies, the post-1945 left-liberal consensus explicitly opposed by Thatcherism and the monetarist identification of democracy with the free market espoused by the Right, are engaged in a more equal struggle than they were a decade ago. Education once again has international relevance. The universal subject, the emphasis on what is shared by human beings rather than the

cultural oppositions that create difference, is again important. As universality has been abandoned for particularity, trans-national loyalties have become parochial or ethnic, and the negative effects are visible in each day's newspapers.

Thus any discussion of the teaching (or learning) of British culture poses acute ideological problems. If we are being asked to accept the ethnic or cultural reductionism of the 1980s embedded in the curriculum in the form of nationalist studies, we need to examine our principles with great care, for it would be easy to slip into triumphalism in an effort to simplify and clarify complex historical processes for learners. On the other hand, if we are in fact responding to a demand by offering a set of values that can be defended in terms of universal needs, we have a responsibility to make as valuable a contribution as we can. Either way, since we are considering a curriculum area, we are obliged to relate its justification to broad educational concerns. In the rest of this chapter, I shall consider the implications of educational research for a responsible role for British Studies, and particularly for teaching methodology.

Britishness in a liberal perspective

The educational assumptions attributed to the 1960s reflect a view of British culture, a view based on a confident political and social tradition. In this tradition Britain's most distinctive contribution is a willingness to wash its dirty linen in public (because of a self-confident pride in the effort to improve through public and accountable criticism), and a civic life that values incorruptibility, public service and lack of concern for personal gain. At its best it risks priggishness, at its worst hypocrisy; but it incorporates ideals that were popularly and justifiably celebrated by atheoretical libertarian writers from Milton and Fielding to Orwell. If the worth of such values for British Studies now appears less self-evident than it might have done in the past (and such assertions are notably absent in discussion of the area), it is because British Studies are being promoted when the concept of 'Britishness' is much disputed. Since 1979 a government, elected by a minority of voters, explicitly repudiated compromise and national consensus and produced a unilateral assertion of what national values should be (see, for example successive disputes over History and

English Language in the National Curriculum for schools).
Consequently, discussions of British Studies that recognize the
historical changes underlying contemporary arguments cannot
avoid consideration of the relationship between national iden-
tity and oppositional politics.

In addition to these concerns, internal to Britain, there are
concerns about the international context. Promotion of British
Studies has developed at a time when assertions of national
values against supranational groupings have become politically
significant in several parts of the world. 'National' here becomes
defined as ethnic, set against governmental, as in the break up
of Yugoslavia, Czechoslovakia and the USSR. But 'British' is
supranational in the same sense as those countries were. What
makes Britishness defensible if the others are not?

Because of the complexity of such problems, it is easiest to
take the view that there is a market for British Studies, and
there is a legal entity, Britain, and to offer no more than
description and analysis. Hence we have the eclectic sets of
materials recommended by interested agencies (the 1991 Brit-
ish Council list of library materials includes books on art,
economics, education, geography, language, law, literature,
politics, science, religion, sport and theatre along with customs,
food, monarchy, television and other less weighty topics). This
is Britain as a set of given facts, or as an organism, but not
Britain as something in which to believe. Yet a set of given facts
does not constitute a serious curriculum area. Without a
carefully thought-through teaching methodology, such an ap-
proach risks being no more than intellectual tourism, or high-
grade stereotyping.

Any serious curriculum analysis forces us to ask 'What is this
field of study for?', and that takes us back to the ironies of our
earlier discussion. If we teach values as 'givens', how do we
distinguish ourselves from the most reactionary 'blood, lan-
guage and soil' nationalism? If we teach values as 'process', we
have to locate ourselves in a critical spirit within or outside the
national and nationalist values referred to above.

So there is a fundamental irony that we cannot escape. If
we approach teaching about Britain in a cautious, liberal,
consensus-seeking manner, looking for what is best for civi-
lization, and defending approaches because they are as right as
we can make them, not because they are British, we are in

direct conflict with both internal and external ideologies. We can no longer defend this view as a product of a particular British tradition (popularly, the myth that 'this was what we fought the Second World War about'; academically, a pragmatic, sceptical and reformist philosophical and social tradition incorporating Locke, Mill and Popper, as well as Wilberforce, Gaskell, Orwell, Beveridge *et al.*). Yet we can only teach what we are, and when we devise procedures, design curricula, and define new courses, we cannot avoid questioning and problematizing 'Britishness' if we belong to an academic British tradition. Perhaps the only way to proceed is to be explicit about this paradox.

Key curriculum concepts

British Studies is a curriculum innovation which has been developed outside the mainstream of British education by practitioners who have not usually been closely involved in the debates in Britain of the past twenty years on the nature of the curriculum. It is therefore worth briefly describing some of these issues, for they have direct relevance to questions about British Studies which are central to our discussion.

Much formal education has not in the past seen the *content* of education as problematic. Subject material might be adjusted and updated, but the range of subject areas, the generally accepted knowledge associated with each subject, and the hierarchy of prestigious areas essential for social advance is not typically questioned except in periods of crisis. Nevertheless, curriculum discussion may be directed to a range of different goals. Skilbeck (1976) discusses *classical humanist, reconstructionist* and *progressivist* ideologies. Each of these places emphasis on a different aspect of the educational process. *Classical humanism* emphasizes the knowledge and content inherited from the past, *reconstructionism* the needs of society for social improvement, and *progressivism* the development of individual potential in all its diversity. Golby (1989) develops Skilbeck's categories to include several different curriculum traditions. He calls the tradition that is concerned with implementation of an allegedly agreed and uncontentious body of knowledge *technocratic*, links it to *reconstructionism*, and argues that the British National Curriculum (introduced for England and Wales by the Education Act of

1988) combines *humanist* and *technocratic* assumptions. He calls for a new *cultural analysis* curriculum which draws on recent understanding of educational sociology. This approach, which Golby only sketches out very briefly, reflects a substantial shift in academic thinking about education, arising from experiences of the 1960s and 1970s.

In Britain, partly as a result of the major structural re-adjustment caused by the introduction of comprehensive, rather than selective, secondary schooling in the 1960s, many curriculum assumptions previously taken for granted were isolated, examined and probed during the 1970s and 1980s. A key text in this process was Michael F.D. Young's edited collection *Knowledge and Control*, published in 1971. In this book a number of contributors questioned, with varying degrees of polemic, the beliefs about the stability and neutrality of the knowledge that schools made available to learners. For many in British education, this offered the first serious engagement with postmodernist ideas that had been emerging throughout Europe in the decades following the Second World War. But it also pushed discussion of the curriculum away from a prescriptive and confident assertion of what the adult world *ought* to be doing to those in receipt of compulsory schooling towards a more serious sociological concern with current practices as they were realized through action in classrooms, and the processes by which knowledge was filtered through the education system to learners. This shift marked a striking departure from the concerns about the different forms of knowledge of philosophers of education like Hirst (1974), who were interested in structures that were independent of social context; it was also distinct from the curricular traditions of psychological schools such as behaviourism, as in Bloom's (1956) taxonomy of knowledge, skill and affective elements in the curriculum. As Hammersley and Hargreaves (1983) point out, the new sociology of education encouraged suspicion of too clean and rationalist an approach to the curriculum, and a greater recognition of 'the unavoidable daily "messiness" of teaching' (p.4).

Following this shift in academic educational interest, a number of commentators have examined the processes of social construction: the history and sociology of school and university subjects (generally, see Becher, 1989; for English, Doyle, 1989,

Protherough, 1989, Evans, 1993; for modern languages, Evans, 1988). Similarly, curriculum practice has been re-examined (Hammersley and Hargreaves, 1983). From the technocratic view of the curriculum as essentially an administrative issue, perspectives shifted to a concern with its unobserved working processes – a shift reflected in metaphors like 'the hidden curriculum' and references to the curriculum as 'the secret garden' (Lawton, 1979).

The technological tradition of curriculum discussion concentrated on key structural issues, of scope and coverage, of ordering, of aims and objectives. The sociological approach was concerned far more with processes and behaviour rather than plans and specifications. But the two approaches are inevitably complementary. Without a structure and demarcation, there is no field within which to behave, and educational institutions, being institutions, inevitably produce statements for planning and administrative purposes. Such statements cannot avoid questions of structure and coverage.

Objectives for particular student groups

The curriculum issues referred to in the previous section raise a number of questions for 'British Studies', which can be related to the traditions discussed there. On the one hand, we need to consider the prime objectives of the subject: are we exposing students to a liberal-humanist perspective, Britain as part of a particular tradition in Western civilization, Britain at its most humane? Are we using Britain as an instrument in social reconstruction, the basis of free markets, the bastion of democracy? Are we providing an example of a particular form of constantly deconstructing, constantly criticizing and analysing, constantly problematizing approach to cultural phenomena, in which it is the academic approach that is distinctively British, rather than the content, which is incidentally British, but really need not be? On the other hand, we need to consider the internal structure and organization of material to be included: how much are we concerned with 'knowledge about Britain'? How explicitly are we concerned with affective factors, encouraging students to admire and respect Britain? Are there skills that we would expect students of British Studies to

acquire? What should be the scope and coverage of the course? In what sense can there be progression? What are the appropriate modes of assessment?

Answers to these questions are crucially dependent on the needs of particular groups of students. Yet the educational issue cannot be reduced to any simple identification of topics with student interests or anticipated needs. In a recent issue of the British Council's newsletter *British Studies Now,* Montgomery (1993) contrasts the concern with British institutions characteristic of German *Landeskunde* and French *civilisation* courses with the cultural analysis approach inspired by the work of the Centre for Contemporary Cultural Studies at Birmingham University. This is a similar contrast to that advanced by Golby between technocratic/humanist and cultural analysis curricula. Yet, in the context of British Studies, the latter approach is developing a methodology which still requires decisions to be made about which aspects of British life to concentrate on, and consequently a selection of 'institutions' for investigation. If the choice of institutions results in a sociology of British society becoming the subject of investigation, potential students will presumably be those who need to understand the nature of contemporary life in Britain. If the choice is more historically or institutionally based, there is still a choice to be made between 'typical' institutions, and those events, such as literary or scientific achievements, that have held their place in contemporary interest because of the value that subsequent generations have placed upon them. Thus we have a matrix:

	'Typical'	'Valued'
Past	e.g. Henry Mayhew; Mass Observation	e.g. Isaac Newton; Virginia Woolf
Present	e.g. Private schools; Leisure pursuits	e.g. Tom Stoppard?; Thatcherism?

But as the entries for the present illustrate at once, decisions about what to include immediately raise questions of whose values are being promoted by the selection of topics for study.

While there may be a general educated consensus on major events, intellectual movements and significant individuals in the past (though, of course, the debate on 'the canon' is specifically about the contentiousness of such claims for consensus), no such agreement is likely about contemporary social phenomena.

This disagreement is only partly a matter of distance. Montgomery comments that outside Britain institutional study is valued, while inside cultural analysis is preferred. Certainly, for many learners, Britain is in some sense a 'given' culture which needs describing, while inside Britain individuals are engaged in the sometimes painful process of creating Britain through struggle. But while curricular decisions made by insiders will reflect participant ideologies in a different way from those made by outsiders, both will be claiming typicality, for both will be selecting significant items from a much wider range of possible choices. Nevertheless, this difference in perspective raises serious questions for foreign learners who are taught by British teachers. Participants in the culture will inevitably present an insider, and partisan, view which foreign teachers of British Studies may hope to avoid.

Montgomery, however, sees the two approaches more neutrally as options for any teachers, and attempts to find a principled way of relating their two sets of concerns. He sees such a way in the study of language as a social institution. Variation according to user is, he suggests, variation of identity, identified particularly by class, gender and region. Variation according to use is more closely tied in to institutions. The study of dialectal variation will contribute to a concern for cultural analysis, while institutional analysis will be supported by a concern for genres and registers. But this is to associate both approaches with the data as 'given' while proponents of the cultural studies approach often have a more fundamental agenda, associated with the critical discourse movement (Fairclough, 1989). For such advocates of cultural studies, part of the teacher's role is to expose the power relations underlying varying social discourses, and to show the workings of competition and political manoeuvre that underlie apparently innocent linguistic and social relationships. Again, the tension between ideological stance and a body of content shows itself.

British Studies as a curriculum area

It will be clear from previous discussion that any curriculum area will simultaneously show some characteristics of all earlier traditions. Institutional constraints in education are strong, and however radical teachers wish to be, they are forced by their professional environment to operate within unavoidable constraints. Among these are the following:

1 a selection has to be made from the mass of possible subject matter;
2 the process of teaching and learning requires that the selection is given some organizing principle(s) to enable learners to come to grips with it at all;
3 criteria for the selection and organization will include explicit (or, frequently, implicit) goals for the learners to achieve; these goals must reflect a realistic assessment of what learners bring to the study at the beginning: if they do not the curriculum will be so unrealistic that it will be doomed to failure;
4 failure to make the processes in 1–3 above explicit to teachers will result in wasted effort and inefficient organization.

It is striking how little discussion of learning issues actually appears in accounts of British Studies. Yet our understanding of processes of learning is now both sophisticated and sensitive to variation caused by variables such as age, cultural expectations and previous experience of learning. A number of key points about processes of learning can be made from the experience of formal education in the past. First, learners construct their own meanings by a process of engagement with appropriate data. They must, therefore, be offered opportunities to interact with data. Second, their construction of effective meaning depends on being able to integrate their new understanding with the sets of categories they are already using to deal with previous experience. Thus learning depends on interaction between the new and the old. Because of this, the procedures used in teaching, and the selection of issues for study will need to recognize not only motivating and appropriate material, but means of integrating comprehension of Britain with the knowledge and understanding that students already have.

This brings us to a key paradox. Most discussion of British Studies has concentrated on ways and means of 'presenting' one or other of the many possible critical perspectives on Britain. Yet unless we are able to clarify exactly what kind of study activity a particular course is practising, and how this relates to the previous understanding of the learners, the presentation risks being educationally ineffective. It seems to be widely agreed, as Dunn (1994) remarks, 'that the "Studies" part of the title has come, over the last twenty years, to be understood as a code for interdisciplinarity' (p.11), but, as he points out, there may have been a retreat into traditional discipline structures. However, it is not so much the discipline structure that is likely to pose educational problems; most subjects, and particularly social studies, become interdisciplinary when they are taught to relatively inexperienced learners. Rather, it is the difficulty of relating the classroom processes called upon by teachers to the knowledge and experience of the learners. Understanding such knowledge and experience will cause us to examine the obvious issues of how to connect knowledge of British constitutional structures, scientific and literary history or sporting practices with learners' knowledge of their own countries. It also enables us to explore the relationship between critical approaches expected by British-based teachers and those expected of learners at home, and the epistemologies that learners take for granted (knowledge as authoritative fact *versus* knowledge as best available hypothesis *versus* knowledge as vested interest of the powerful, to stereotype some contemporary positions). It also forces us to take into account the relationship between the skills and practices for the consideration of cultures that learners have already acquired and those needed for British Studies. All three of these general areas are of course closely bound up with each other in ways that are culturally grounded, and difficult to analyse, so it is scarcely surprising if the solution is often a tendency to rely on the content and to slide past other issues with eyes averted.

The most sophisticated attempt to deal with these other aspects is described in the work of Michael Byram (his published works from Byram, 1990, to Byram and Morgan, 1994, and references in those, will give a full picture of his work). He started with a concern for the role of culture in foreign language learning, but his studies have far wider implications, because

of his interest in developing students' abilities to analyse and comment on culture, both in their own and in the foreign environment. Nevertheless, turning learners into ethnographers in their own right is not an easy option on courses in which overseas travel is unavailable, so modified versions of cultural sensitization will be necessary on many courses. What makes Byram's approach significant, though, is the central role of learners' understanding of their own cultures. The main way through most of the paradoxes that have been identified in this paper seems to be a recognition that British Studies must in the end be a comparative activity.

Once the specification of what learners can be expected to understand already about their own culture has been completed, the traditional concerns of technological curriculum design become primarily administrative issues, relating to resources, time and space. But that first specification has wide implications. It will suggest, for example, the extent to which the British Studies curriculum should concentrate on a historical approach, perhaps drawing upon liberal-humanist assumptions of quality and value, or on a contemporary analysis, either 'critical' or sociological-descriptive. It will suggest, of course, the extent to which artistic, scientific, economic or popular culture may be prominent, and it will indicate realistic approaches to assessment (where relevant), student participation and teaching mode.

Yet to describe the curriculum task in this way is not to deny the importance of the individual teachers. The educational principles discussed in this chapter provide a background for what is always, in the last resort, a personal relationship between teacher and taught. Such a relationship depends upon the teacher feeling that the approach adopted is not just appropriate to the learners, but honest to the teacher's beliefs. Consequently, whatever understanding derives from the kinds of analysis referred to here must be modified by careful interaction with the teacher's own expectations. At the same time, as I have tried to argue here, the teaching role when dealing with British Studies is subject to ideological and attitudinal tensions which other subjects such as language and literature possess in a much more muted form. For British native-culture teachers, some of these problems may disappear if they can always teach and plan jointly with a local person.

But many of them are inherent in the subject, and constitute both its risks and its challenges.

References

Becher, T., *Academic Tribes and Territories* (Milton Keynes: Open University Press, 1989)

Bloom, B., *Taxonomy of Educational Objectives* (Harlow: Longman, 1956)

British Council, *Core Lists of Library Material: British Studies* (London: The British Council, 1991)

Byram, M., 'Foreign Language Teaching and Young People's Perceptions of Other Cultures', in B. Harrison (ed.), op. cit., pp.76–87

Byram, M. and Morgan, C., *Teaching-and-Learning Language-and-Culture* (Clevedon: Multilingual Matters, 1994)

Doyle, B., *English and Englishness* (London: Routledge, 1989)

Dunn, T., 'The "British" in British Studies', *British Studies Now*, vol. 4, 1994, pp.11–12

Evans, C., *Language People: The Experience of Teaching and Learning Modern Languages in British Universities* (Milton Keynes: Open University Press, 1988)

Evans, C., *English People: The Experience of Teaching and Learning English in British Universities* (Milton Keynes: Open University Press, 1993)

Fairclough, N., *Language and Power* (Harlow: Longman, 1989)

Golby, M., 'Curriculum Traditions', in B. Moon, P. Murphy and J. Raynor (eds) op. cit., pp.29–42

Hammersley, M. and Hargreaves, A. (eds), *Curriculum Practice: Some Sociological Case Studies* (London: The Falmer Press, 1983)

Harrison, B. (ed.), *Culture and the Language Classroom*, ELT Documents 133 (Basingstoke: Modern English Publications/Macmillan, 1990)

Hirst, P., *Knowledge and the Currriculum* (London: Routledge and Kegan Paul, 1974)

Hobsbawm, E.J., *The Age of Revolution* (London: Sphere Books, 1962)

Lawton, D., *The End of the Secret Garden? A Study in the Politics of the Curriculum*, Inaugural Lecture, 15 November 1978 (London: University of London Institute of Education, 1979)

Montgomery, M., 'Institutions and Discourse', *British Studies Now*, July, 1993, pp.2–3

Moon, B., Murphy, P. and Raynor, J. (eds), *Policies for the Curriculum* (London: Hodder & Stoughton, 1989)

Protherough, R., *Students of English* (London: Routledge, 1989)

Skilbeck, M., *Culture, Ideology and Knowledge*, Open University Course E203, Unit 3 (Milton Keynes: Open University Press, 1976)

Young, M.F.D. (ed.), *Knowledge and Control* (London: Routledge and Kegan Paul, 1971)

4

Cultural Studies and foreign language teaching

MICHAEL BYRAM

British cultures, or any others, can be studied by those who are native to them or by outsiders, but there are fundamental differences between the two perspectives, one of which is the question of language. Where those studying the culture of a specific social group speak 'the same' language as those who are 'natives' of the group, they have much easier access. For example, even though the language of a teacher studying the culture of the medical profession, or of a British teacher studying the culture of American teachers, is not identical with the language of the natives of the culture in question, the overlap is considerable. On the other hand, where the students of a culture have access to it through a foreign language, there arise quite different and difficult issues. And here, too, there are degrees of difference, from, for example, access to British cultures for a speaker of French or German to the perspectives facing a speaker of Chinese or Japanese. The complexity of access comprises differences in linguistic structures and distances between cultures.

My intention in this chapter is to consider the study of cultures from the perspectives of the foreign language learner and teacher. It is important to do so for several reasons. First, there is a growing concern within foreign language teaching (FLT) with the ways in which language learning is related to

cultural learning, indicated by phrases such as 'cultural aware-
ness' and 'intercultural learning'. Yet this concern has not
been explicitly related to the developments in Cultural Studies
(Kramsch, 1993). On the other hand, those who define and
discuss Cultural Studies rarely show any awareness of how the
study of cultures, for many learners, is a study of foreign
cultures through the medium of foreign languages, the learners
in question being essentially language learners.

A second issue is that Cultural Studies in some cases is taught
as part of a course for teachers of foreign languages, either at
the beginning of their career or as part of their further
professional development in mid-career. The study of British
cultures is often part of the training of teachers of English as a
foreign language. For these students the relationship between
Cultural Studies and language teaching is important not only as
part of their own learning process but with respect to their
methods of teaching language and culture to others.

A third issue raised by the link with FLT is the question of
different stages or levels of learning. Foreign students of British
cultures may be at quite different levels in language acquisition;
they may also be at different stages of personal development –
from the primary school pupil to the postgraduate student; they
may also have quite different purposes and opportunities for
learning – from professional contacts in Britain on a regular
basis to a certainty that they will never visit Britain during or
after their course of study.

Before considering this relationship between Cultural Studies
(CS) – a term I shall use generically – and FLT, I shall need to
identify some significant contextual issues in FLT, and to
suggest a model of language learner competences with respect
to cultural learning.

Issues in foreign language teaching

This is not the place to review the history of different ap-
proaches within FLT to the relationship between language and
culture. It is long and complex because of different traditions
in various countries (Stern, 1983; Buttjes, 1988). More briefly,
there are a number of current debates relevant to the question
of cultural studies and foreign language teaching.

The purposes of FLT vary according to the context and the

learners involved. Where FLT is part of general education at
school or university, the educational aims may be part of a
liberal tradition of increasing understanding of the world, of
creating positive attitudes towards speakers of other languages,
of furthering the personal and social development of the
individual. In other circumstances a language may be learnt for
specific professional purposes. In both cases the language in
question is often spoken in a number of countries and cultures,
and teachers and learners are faced with a choice of which
country/countries to study closely. On the other hand, it is
sometimes argued that learning for specific vocational pur-
poses, such as working in an oilfield, is 'culture-free', not
related to any particular country.

A related issue is the case of the *lingua franca* – notably English
– where the purpose of learning may primarily be to use the
language to speak with other non-native speakers. Does there
need to be a link with one of the countries where English is
spoken? Can English be taught free of any context, or can the
language be acquired in the context of and referring to
learners' own environment? This same point is sometimes
carried over into the debate about the aims of language
learning. It can be argued that the methodology of teaching
should emphasize the way in which the ability to communicate
with others is generalizable, rather than concentrating on any
one culture – even the culture of the learners' own environment
– in all its complexity. One way of doing this is to introduce
topics which are of 'universal' significance in all cultures, with
an emphasis on the commonalities rather than the variations.
Such an approach contrasts with a selection of topics which are
peculiar to a given culture and which characterize its unique-
ness for the language learner.

Finally, there is the question of learning processes. Although
there are developed theories of foreign language acquisition
which take account of learners' age and level of competence
(Singleton, 1989), a similar concern with theories of cultural
learning is only just beginning (Melde, 1987; Baumgratz-Gangl,
1990; Byram and Morgan, 1994). The teacher must never-
theless be aware that teaching and learning aims which include
'understanding', 'tolerance', 'empathy' and related notions
presuppose a psychological readiness in learners which may be
age-dependent, may be influenced by social factors, may be

furthered or even inhibited by exposure to a foreign culture and language. Methods of teaching foreign cultures and languages range from analytical study from within the security of learners' own culture and language to experiential learning through classroom immersion or an extended stay in another country. Yet the methods are seldom expressly related to theories of learning and the nature of the learners in question.

Against this background of issues, it is possible to attempt to define the 'socio-cultural competence' which language learners need as part of an 'intercultural communicative competence' (Byram and Zarate, 1994). My definition is based on the concept of the 'intercultural speaker': the foreign language learner as a social actor whose interaction with others is coloured by the social identities he/she brings to communication situations and how those identities are perceived by other speakers of the language, both natives and non-natives. There are four dimensions to socio-cultural competence:

- *savoir-être*: an affective capacity to relinquish ethnocentric attitudes towards and perceptions of otherness and a cognitive ability to establish and maintain a relationship between native cultures and foreign cultures;
- *savoir-apprendre*: an ability to produce and operate an interpretative system with which to gain insight into hitherto unknown cultural meanings, beliefs and practices, in either a familiar or a new language and culture;
- *savoirs*: a system of cultural references which structures the implicit and explicit knowledge acquired in the course of linguistic and cultural learning, and which takes into account the specific needs of the learner in his/her interaction with speakers of the foreign language. The notion of 'intercultural speaker' presupposes that this system of references incorporates native-speaker perspectives – not academic disciplinary knowledge – and an awareness of the relationship with foreign-speaker perspectives on the issue in question; and
- *savoir-faire*: a capacity to integrate *savoir-être, savoir-apprendre* and *savoirs* in specific situations of bicultural contact, that is, between the culture(s) of the learner and of the target language

It will be evident that this definition focuses as much on the process of communication as upon the acquired platform of

knowledge and skills upon which communication takes place. The intercultural speaker is always a mediator between his/her own cultures and others present in the situation, and must be constantly able to interpret and re-interpret (*savoir-apprendre*) the cultural phenomena implicit or explicit in the communication. One source on which the intercultural speaker draws is the *savoirs* already acquired, the knowledge of cultural phenomena as experienced by other speakers, to which he/she is constantly adding as he/she continues to learn the culture and language. Language and culture learning never stops.

This definition of socio-cultural competence was developed with reference to the Western European context where the mobility of citizens is a policy aim and already a reality. The study of British cultures also has its origins within Britain and Western Europe and this is the context for the following pages, in which I shall compare and contrast the processes of cultural studies and foreign language teaching. It is not my intention at this point to extend the argument to the global context, although I am aware of the rapid extension of the study of British cultures comparable to the spread of the teaching of English as a foreign language.

Cultural Studies

Whereas we have seen that FLT is concerned with processes of communication, CS for learners of foreign languages (and our particular concern is the study of British cultures) is focused on processes of analysis and criticism. Thus, CS practitioners establish a corpus of texts, not in order to create a canon but to provide learners with an 'object' which they can analyse, criticize and deconstruct. This will be the means towards a better understanding of (part of) a society and will challenge and modify learners' existing understanding. The principal aim of CS is to enable learners to develop a more nuanced view of a country and society whose language they are learning. At the same time they acquire the means of working on other texts from the same or other countries and the interest and willingness to do so; this contributes to their general education.

The texts under study are not merely juxtaposed elements of a corpus, for it is an important dimension of CS that texts are understood and analysed as interrelated. The deconstruction

of intertextuality and the analysis of shared meanings within and between texts is carried out in order to clarify the values and beliefs which are held by members of a society or at least by a cultural group within a society. It is thus the group which is the ultimate concern of CS, even though analysis begins with the texts of individuals. Though owing allegiance to no single discipline, CS draws upon sociology and sociological disciplines such as political sciences and history because it attempts to enable learners to reach generalizable understanding of a society and its constituent groups.

A significant dimension of CS is that it introduces learners to foreign societies and therefore to ways of feeling, thinking, believing and acting which are not merely different from their own individual ways but are alien to the ways into which they have been socialized and which are therefore part of their identity. The process of working on texts involves an understanding of otherness which implicitly challenges their taken-for-granted perceptions of themselves and their world, simultaneously requires a reassessment of their perceptions of a specific society, and introduces the issues of cultural relativity. Implicit challenges become explicit when CS includes comparison – that is, non-evaluative juxtaposition and relativization – either informally in the course of teaching and learning, or formally as part of the syllabuses and curriculum. Formal comparison is seldom found in CS, however, and it is not possible, without specific research, to know what role informal comparison plays.

A related issue is more prominent in the debate about CS: the nature of CS when taught at an institution within the country in question and when taught in another country, usually the native country of the learners involved. First, there are practical issues of what materials and methods are feasible in each case. Learners resident in the country can carry out their own investigations more easily, while those elsewhere have to rely on texts made available indirectly or, at best, in the form of telemedia such as satellite television or e-mail.

Whether in the country or elsewhere, learners may be taught by natives of the language and country, or by non-natives of their own or other origins. It is likely that they will have more of the former if resident in the country and therefore have more opportunity to hear informal 'insider' perspectives whatever

the perspective taken in the formal curriculum. For those resident, such opportunities are multiplied through their inter-action with people outside the classroom. This interaction may be more significant than the classroom for certain aspects of experiential learning which are not thematized or theorized in CS discourse. Indeed, CS theory pays little or no attention to learning processes as such, and appears to assume only cognit-ive models of learning, in common with much university-level teaching.

Theory about 'insider' and 'outsider' perspectives, from native or non-native teachers and curriculum planners, is confined to discussion of critical perspective and models of analysis. For example, the distinctiveness of the new German *Journal for the Study of British Cultures* is that it provides an outside perspective from a specific tradition of CS and *Landeskunde*.

Seen from an FLT perspective, CS has therefore a number of areas which need to be addressed. CS does not work with explicit learning theories, or with issues of adapting methods to particular age-groups. It does not address issues of affective and moral development in the face of challenges to learners' social identity when they are confronted with otherness in the classroom or, just as significantly, in the hidden curriculum of the informal learning experiences of residence in the country. CS discourse does not, furthermore, include discussion of teaching methods and learning styles appropriate to different kinds of classroom interaction in different environments inside or outside the country in question.

Second, many if not all learners in CS classes are studying CS as part of vocational as well as general education – to be teachers, international businesspeople, diplomats, and so on – where they will find themselves acting as mediators between cultures, as 'intercultural speakers'. Teachers in particular have the task of introducing other learners to a new culture and simultaneously enabling those learners in turn to become communcatively competent across cultural boundaries. In so far as CS claims to contribute to these vocational aims, it should treat intercultural issues explicitly and should enable learners to understand and manage problems of intercultural com-munication. A significant part of this contribution to inter-cultural understanding would be made by teaching which involves a comparative methodology dealing with differences

and similarities in culture-specific values, beliefs and shared meanings.

A third problem, from an FLT perspective, is that CS does not relate its approaches to language learning. Although CS is concerned, in textual analysis, with the ways in which language embodies the subject matter of CS, there is insufficient regard to the fact that the language in question is foreign to some of the students. Analysis and acquisition for these students may be simultaneous processes, and the acquisition is not simply an extension of a native-speaker competence, but rather a further development of an intercultural, non-native competence. CS needs to develop appropriate methods for this specific learning situation. Even advanced students are not native speakers, and are continuing to acquire the language – new structures, new genres, new vocabulary – as they study new aspects of a culture.

The cultural dimension of foreign language teaching

As indicated above, the primary objective of FLT is to enable learners to communicate using a foreign language, in different ways and with native and non-native speakers according to the context of their learning. Recent attention to the cultural dimension has arisen in part from a recognition that communication in a foreign language can lead merely to encoding of learners' own culture-specific meanings which are not necessarily comprehensible to other speakers of the language, for whom it carries *their* culture-specific meanings and connotations. Learners, therefore, need a 'cultural awareness'. This enables them to anticipate cross-cultural communication problems because they are conscious of culture-specific meanings, of the cultural identities of their interlocutors and of how their own cultural identity and shared meanings are perceived by their interlocutors, influencing the process of communication and interaction. Cultural awareness thus involves a reflexive aspect, a questioning of learners' cultural identity and a relativization of their naturalized, taken-for-granted values, beliefs and actions. It also involves a comparative methodology which, through juxtaposition, facilitates understanding of others, of foreign cultural values, beliefs and practices. Through this development of the primary objective of successful communication, FLT also

claims to realize general educational aims: the understanding of otherness and of self, and the acquisition or development of positive attitudes towards speakers of other languages.

Given the emphasis on communication, FLT focuses on the individual as a social actor who needs a range of skills – linguistic, non-verbal, social – as well as specific knowledge of a country and society (*savoirs*) and the capacity to extend that knowledge in new communication situations (*savoir-apprendre*). Any generalized knowledge learners have provides a framework, a system of references, within which particular interactions can take place successfully. The knowledge framework is that to which native speakers refer, implicitly or explicitly, rather than the ideology beneath it, of which they remain unaware. Foreign language learners become interpreters of the frameworks of their interlocutors, and of their own framework for their interlocutors; they are 'intercultural speakers' of a language, mediators between two frameworks and the cultural practices which take place within them. In the initial stages of learning in particular, the framework is provided as a given, as a normative factor in communication, rather than as the object for critical analysis and deconstruction which is the focus of CS. Whereas CS strives for a critical understanding of the shared meanings and underlying ideologies of a social group, FLT prepares learners for interaction with individuals, one of whose communication characteristics is their social identity and associated system of references.

From a CS viewpoint, FLT does not put sufficient emphasis on *critical* understanding based on analysis and deconstruction. FLT theorists do not, with some exceptions (Melde, 1987; Doyé, 1993; Zarate, 1986; Kramsch, 1993), take an analytical approach but simply expect that comparison by juxtaposition will lead to consciousness-raising and 'awareness', which are insufficiently defined. The notion of 'empathy' in particular, which is considered a basis for successful communication, is uncritical and normative. Learners are expected to accept and understand the viewpoint and experience of the other, not to take a critical, analytical stance. It is, therefore, not surprising but nevertheless regrettable that FLT theorists and practitioners do not engage with CS and are not represented in CS debate and writing (Kramsch, 1993).

Furthermore, the system of references or framework of knowledge that FLT provides for learners is seldom theoretically well founded and is often merely a listing of surface, behavioural phenomena – even when related to underlying common human experiences. The significant factors in the life of a society are the ideologies which determine its values and influence the direction of its development and change. Communication in the language(s) and culture(s) of that society is dependent on apprehension of the ideologies, not the adoption of surface behaviour. If FLT is to claim a general educational aim of extending learners' critical understanding of social phenomena in their own and foreign countries, it needs to take more seriously the methods and contents of study proposed by CS, and to develop appropriate learning theories and teaching methods to ensure a proper integration with the skills and knowledge comprising intercultural communicative competence.

Relating Cultural Studies and foreign language teaching

It would be possible for CS and FLT to continue to develop independently; there is no necessary connection, even with respect to CS for students of foreign languages and cultures, and the study of cultures by native speakers will doubtless follow its own path. This also raises another set of issues, not to be pursued here, namely the relationship between CS for native and non-native speakers.

We have seen that CS for foreign language students would benefit from closer attention to theories of linguistic and cultural learning. Although CS is usually taught at higher-education levels, an exclusive concern with cognitive analysis presupposing a capacity in learners to deal with abstract concepts does not give due regard to the affective power of cultural identity even for older learners. When CS presents learners with interpretations of reality, and options for social action, that are different or even contradictory to those which learners take for granted as given and natural, then the CS teacher should be aware of the nature of the challenge to learners' understandings of their culture and identity.

On the other hand, CS demonstrates that notions of 'cultural

awareness' and 'empathy' have to be re-examined. Although 'intercultural speakers' need a system of references, those who select and present knowledge of another culture should take account of fundamental phenomena revealed by CS, not just the surface phenomena offered as context to the language being learnt. CS shows that such knowledge should include critical appraisal of the phenomena, rather than an unquestioning empathy with native speakers' understandings of their culture and identity. It is only through *critical* cultural awareness that FLT can claim to contribute to learners' general education and development. This applies, furthermore, to all levels of FLT, at school or higher education, even though the pedagogy must also take account of other factors such as stage of personal development and range of linguistic competence (see Byram *et al*, 1994, for examples).

In the perspective of our definition of socio-cultural competence, the function of CS for foreign language learners at all levels is contributory: CS provides learners with some of the knowledge and skills required to communicate successfully. The contribution is significant because it takes FLT beyond training, into education or *Bildung*, to use the German word (Klippel, 1994, p.55). Where learners are being educated as 'professional linguists' – that is, not only functioning success-fully as individuals but facilitating communication for others, as interpreters, teachers, international business managers – they need an additional dimension: a theoretical understanding of cross-cultural communication and of the competence re-quired to achieve it.

A form of CS which is based on a theoretically sustained integration of linguistic learning and critical cultural analysis and which includes a comparative, reflexive dimension in its methodology would be a substantial contributory discipline to the education of professional linguists. It would provide them with an in-depth understanding of the framework within which cross-cultural communication takes place, and, just as importantly, the means to extend the framework in new communication. It would, above all, offer linguists an identity in critical cultural studies – whereas in alternative traditions they are invited to become literary critics or theoretical lin-guists – and such an identity would be a central factor in their profession. Thus, although I have suggested there is no

necessary relationship between cultural studies and the study of British cultures on the one hand, and foreign language learning and English as foreign language on the other, there are many advantages for each in the relationship becoming closer and more explicit.

REFERENCES

Baumgratz-Gangl, G., *Persönlichkeitsentwicklung und Fremdsprachenerwerb* (Paderborn: Schöningh, 1990)

Buttjes, D., 'Landeskunde-Didaktik und landeskundliches Curriculum', in K.-R. Bausch *et al.* (eds) *Handbuch Fremdsprachenunterricht* (Tübingen: Franke, 1988)

Byram, M. and Morgan, C. (eds) *Teaching-and-Learning Language-and-Culture* (Clevedon: Multilingual Matters, 1994)

Byram, M. and Zarate, G., 'Definitions, Objectives and Assessment of Socio-cultural Competence', Paper for the Council of Europe Education Committee, Strasbourg, Mimeo, 1994

Doyé, P., 'Neuere Konzepte der Fremdsprachenerziehung und ihre Bedeutung für die Schulbuchkritik', in M. Byram (ed.), *Germany: Its Representation in Textbooks for Teaching German in Great Britain* (Frankfurt am Main: Diesterweg, 1993)

Klippel, F., 'Cultural Aspects in Foreign Language Teaching', *Journal for the Study of British Cultures*, vol. 1, no. 1, 1994, pp.49–61

Kramsch, C., 'The Cultural Component of Language Teaching', Keynote Lecture delivered at the International Association of Applied Linguistics, Amsterdam, August 1993

Melde, W., *Zur Integration von Landeskunde und Kommunikation im Fremdsprachenunterricht* (Tübingen: Gunter Narr, 1987)

Singleton, D., *Language Acquisition. The Age Factor* (Clevedon: Multilingual Matters, 1989)

Stern, H.H., *Fundamental Concepts in Language Teaching* (Oxford: OUP, 1983)

Zarate, G., *Enseigner une culture étrangère* (Paris: Hachette, 1986)

5

Fictional maps of Britain
DAVID PUNTER

The situational problem

This is a chapter about teaching modern British fiction, and
about British Cultural Studies. But this conjunction already
poses a pedagogic and indeed theoretical problem. Are we to
speak of teaching fiction in the *context* of British Cultural
Studies; or are we to speak of teaching fiction as an *aid* to the
more general study of British culture?

It will, I hope, immediately be seen that this specific problem
is a wider version of a pedagogic difficulty which comes up
throughout the range of 'literary education'.[1] We might put it
in various ways: for example, when teaching texts – and
especially, perhaps, prose fiction – where is the privileged site
of discussion? What value are we to place on surrounding
information? Is there any way in which we can speak of those
vexed terms 'text' and 'context' without falling back on the
ancient habit of treating 'history' as mere 'background', back-
ground to some purer aesthetic encounter?

British Cultural Studies, I take it, is a discipline which is
designed – or is being gradually designed in practice – specifi-
cally for teaching outside Britain; but again, one can see this
as only a variant of a problem which is becoming endemic
within British tertiary institutions themselves: as the (in any
case fictional) assumption that the 'average student' is a 17-year-

old school-leaver dissolves under the pressure of wider access, so the problem of which knowledges should count as intellectual gifts, skills or achievements becomes more acute.[2]

It is in this respect, perhaps, that the term 'comparative', which will appear several more times in this chapter, should first make its appearance, for there is a sense in which all learning in literature is comparative: such learning, even at the most basic level of encounters with texts which we have not read before, is always comparative in the sense that it challenges us to compare a textual experience with our own life experiences. In support of this hypothesis, there is no need to fall into the trap of asserting a rigid dichotomy between 'text' and 'life'; we may choose to assert on theoretical grounds that 'life experience' is itself a category comprised from previous textual immersion, of whatever kind, but the comparative aspect still exists and, indeed, predominates; without it there would be no levers available to us whereby we might make sense of the text or begin the work of interpretation.

British Cultural Studies, then, confronts us in the literary context with a particular form of this problem; but this opens also on to further questions about what British Cultural Studies is. There are two things, it seems to me, that, despite terminological similarities, it is *not* – or at least, which it should not be if it is to make the widest and deepest contribution in its many contexts.

It is not, in the first place, 'cultural studies' in the broadest sense of that term. It does not seek merely to take the general framework of cultural studies – whether we see this anthropologically, sociologically, psychoanalytically[3] – and perfect a version of this 'assemblage' – to use Deleuze and Guattari's term[4] – fit for specific consumption. Among other things, this would risk insult – and the risk of insult is again a point to which I shall return – for there are, all too obviously, other, non-English language traditions of cultural studies which provide frameworks at least equally valid to that which we may use, and the very people on whom British Cultural Studies is most frequently targeted – academics, schoolteachers, an informed general public – will be the most familiar with these frameworks.[5]

In the second place, it is not the study or relaying of that particular form of cultural approach which we may refer to as

the 'British school' of cultural studies: I am thinking of the tradition which moves from Raymond Williams and Richard Hoggart through Stuart Hall to the work of the Birmingham Centre for Contemporary Cultural Studies.[6] It may well be that we would wish to see this as a sub-discipline in its own right; but to be properly situated within British Cultural Studies, this British intellectual tradition would itself have to be situated within a broader frame. In fact, if one thinks back to Perry Anderson's crucial but now inevitably dated essay 'Components of the National Culture',[7] one can see that one of the lines one would need to follow in order to update Anderson's findings about the shape of the British intellectual tradition would be precisely the inclusion and location of this sub-discipline as well, unavailable, of course, for inspection by Anderson since he was writing precisely *within* its moment of emergence.

British Cultural Studies, I would argue, differs from these disciplines in many ways: for the purpose of this chapter, I want to highlight one of them, which is the necessity within British Cultural Studies of providing maps. In the broadest context, of course, British Cultural Studies and the agencies which provide and foster it are already elements in a map, a map which also includes other, nationally diverse, agencies which are in some sense providing a parallel service – the United States Information Service, the Goethe Institute, and so forth. But in a more important sense, the proper business of comparison, of matching previously held and experienced notions of British culture against a chosen and developed teaching schedule, can be envisaged throughout as the comparison between one map and another; and it should immediately be obvious that the question of priority here is highly problematic. The map which we may carry with us and seek to promulgate when we teach British Cultural Studies overseas may well have the virtues of being the product and distillation of immersed experience, but it may also have the vice of an inability to question, or see beyond, the very cultural co-ordinates within ourselves which have produced our map. The maps held in the mind by our students may, through all sorts of difficulties of resourcing, appear to us inadequate or dated; but they will also, necessarily, have the 'virtue of alienation' – in other words, that which to us may seem obvious will not be obvious to others, and the very

questioning which this provokes may well prove to be the most important linchpin of comparative, collaborative study.[8] Maps have margins and they have centres, but the real imaginative springboard can frequently come when we notice that these centres and margins are differently placed according to our own, native or non-native, experiences and traditions.

Towards a psychology of British Cultural Studies

In order to learn, it is necessary to feel safe. This is not directly to say that the imagination can only flourish under conditions of safety: in small children the imagination flourishes everywhere, but the shape of its development, its relation to experiences in the world, will differ sharply according to early conditions of safety or otherwise. It would be crude but accurate to distinguish between two types of imagination, the 'dark imagination' which will flourish where needs for containment and safety are not met, and the contents of which will consist largely of replayings and elaborations of fantasies of damage, and the 'bright imagination' which will grow when external conditions are 'good enough' to allow exploration without an omnipresent fear of destruction.

These points seem self-evident to me; what is also interesting, if we move through another twist of reflexivity, is that they probably do so only because I am British, and the language I have used in the paragraph above is the language of the British School of Psychoanalysis;[9] its key terms would not be respected or even understood by other analytic schools, let alone other varieties of psychology and psychiatry. However, if we can accept that terminology for a moment, then I think we can expand on it to draw out a further problem in British Cultural Studies, which tends to be as psychologically under-theorized as our pedagogic activities so usually are.

For in the provision of British Cultural Studies it is vital to provide a safe enough base to encourage the imagination; only through such imagination can we properly begin to see the 'other maps' held by the people with whom we are working, only through the illumination of imagination can they glimpse the shape of our maps, see their bright and dark areas. But the ever-enduring problem with containment is that it slides

rapidly into a dependency model;[10] and, of course, this danger is vastly over-determined by the question of language. We may all, teachers and students, take it as a conscious or unconscious axiom that a culture can best and most fittingly be described in the terms *and in the language* of the culture being described; and thus the native holders of that language will automatically be inserted in the position of discursive privilege, be seen as at the centre of the map.

Yet what position do we as practitioners actually occupy *vis-à-vis* the culture which we are trying to relay? In so far as we are usually academics in the humanities, then our own position will most normatively be a dissenting one[11] (or, if you prefer, dissent will have taken its place in our individual evolution into teachers of the humanities[12]); therefore the map we present may well be fractured from the start, and it may be our task to reflect on and manifest these fractures – a difficult thing to do, partly because it is never easy to wash the family's dirty linen in front of an audience of strangers.

At its most acute, we have to deal here with residues of British imperialism, both within ourselves and within any national group of students. Nothing is innocent: there are international contexts in which British culture is a more apparently desired object than the US equivalent, but this may only be because of British imperial impotence;[13] a wish for Shakespeare and the 'British heritage' may or may not sell many British manufacturing products; it certainly will not affect the sales of Coca-Cola. But what is crucial here, I think, is to grasp the salient fact that we are all post-colonials now. Post-colonialism is not a constellation to be held only within the so-called Third World; it is a global movement – not in the sense of a political movement, but a movement of the collective psyche – and everything we say and do takes its place within the decolonizing context; which is in turn to talk again about dependency and rebellion against dependency.

Teaching and learning situations will necessarily enact, re-enact, perhaps 'act out' these issues. Again, we are looking here at a point that, seen from one angle, pertains very particularly to British Cultural Studies; but seen from another, it underlies and striates all our pedagogy, even the 'pedagogy of the oppressed',[14] in that learners are psychologically likely to view the teacher as arriving on the scene with an always mixed

message, a message of gift and withholding: on the one hand, she/he says, here is the object of desire which I want to share with you, transmit to you, of which I wish you to become co-owner with me; on the other, here is the object of desire, and I am going to withhold it from you because you are not able to be masters of it fully; at the end of the day I shall not have shared my knowledge at all but merely enabled you to experience the depths of your incomprehension.[15]

Post-war British fiction: a course

I make these points not because I have immediate solutions to the problems they present; indeed, the only 'solution' available is through reflexivity and the ability to work experientially within the contexts as (over-)determined.[16] But I do suggest that thinking on maps, and especially on the *multiplicity* of maps, may at least at the metaphorical level provide a useful key to our choices of text and method, and at the same time encourage an approach to British Cultural Studies which takes the business of comparison seriously and which puts into question the notion of a privileged site of discourse – always, of course, within the unavoidable limitations which belong to the pedagogic situation.

I should like now briefly to describe a course in post-war British fiction, one which has a great deal to do with the presentation and comparison of maps. My purpose in describing it is to suggest that it is fully possible to combine in a course an attention to a wide range of modern writers with the provision of a set of 'pictures of Britain'; to combine an interest in 'literariness' with an approach to the culture within which the texts are situated; and to do this by focusing on the texts through specific features and contradictions in British culture. The course is text based, and obviously requires that time be available to read the texts concerned. The materials are as follows:

John Braine, *Room at the Top* (1957)
Graham Greene, *Brighton Rock* (1938)
Iris Murdoch, *The Bell* (1958)
William Golding, *The Spire* (1964)
John Fowles, *The Magus* (1965)
Doris Lessing, *Shikasta* (1979)

Russell Hoban, *Riddley Walker* (1980)
Salman Rushdie, *Shame* (1983)
Angela Carter, *Nights at the Circus* (1984)
Joan Riley, *The Unbelonging* (1985)
J.G. Ballard, *Empire of the Sun* (1985)
Kazuo Ishiguro, *The Remains of the Day* (1989)

The course follows post-war chronology, with one obvious exception, which is the inclusion and location of Graham Greene's *Brighton Rock*, which is included and located as it is for various reasons, which I shall mention below.

The course begins with John Braine's *Room at the Top*[17] because this text provides an opportunity to talk about major issues in post-war Britain, and also to introduce two crucial mappings: the map of Britain as geographically divided and the map of class. The novel raises the general issue of where 'the top' might be supposed to be: it also introduces what one might call an 'insider's Britain', from one particular angle, a Britain, or perhaps one might better say an England, which barely needs to be explained to 'outsiders', and this opens on to a whole set of issues about the 'national literature' – by whom it is supposed to be read and interpreted, what its national and international parameters are supposed to be, and thence, of course, into theoretical issues about narrative position, seen all the time not as purely theoretical but as having a relation, however complex, with the 'nation' and its view of itself.[18]

The move back to *Brighton Rock* is for two principal reasons: the importance of introducing Greene,[19] who clearly has maps of his own to deliver, and the comparable need to situate the post-war world against its pre-war counterpart. *Brighton Rock* fuses these requirements, while offering another, London- and Brighton-based, geography of England, as with Braine's, replete with 'insider' discourse and imagery; it can also provide a useful repertory of what we might call 'gangster capitalism', an economic form increasingly familiar from South America and Africa to China. There are points about religion to be made here, too: the recognized image of Britain in terms of the Church/State linkage can be relativized by bringing out the significance of Catholic identity within the British context, a perception very necessary if one is to respond to the need to understand something of the 'Irish problem'.

Iris Murdoch's *The Bell* [20] pursues the religious issues, with a more distinctly modern inflection. Alongside the novels, essential reading for the course is Arthur Marwick's essay, 'A Social History of Britain 1945–1983',[21] and the change from a world of religious certainties, however embattled, to a world of religion as one form of exploration among others coincides neatly with the transition year, 1958, which, Marwick claims, heralds the epoch of the 'cultural revolution'. Murdoch clearly also signals a move away from the masculist power structures which predominate in Braine and Greene, and thus introduces a different mapping, more based on gender, which will become more significant in later texts.

Golding's *The Spire*[22] brings into focus, it seems to me, an entirely different map, different again geographically, but different also historically, and enables the posing of some important questons about national self-construction. The previous three novels have been set in the present: what does it mean, we might ask, to look into remote regions of history for an image-bank with which to deal with everyday issues? – for I assume that the crises of belief which Golding discusses are hardly restricted to the Middle Ages, or to Salisbury. At the theoretical level, *The Spire* brings into focus some of the problems of first-person narrative, but in a British Cultural Studies context the important thing will not be to pursue these issues at a theoretical level but rather to try to share experiences of what the secrecy and reticence necessarily held within the apparent overtness of first-person narration might signify in the context of cross-cultural communication.[23]

John Fowles's *The Magus*[24] is, or was, the icon of an age: if there was indeed a cultural revolution in Britain in the 1960s, then this is as likely a place from which to interpret that revolution as any, and this despite, or perhaps precisely because of, its largely overseas location. Indeed, what we might begin to deal with here is the very question of the 'exotic', and its relation to the post-colonial,[25] for one of the motifs which runs through *The Magus* is of a type of revenge; the image offered is of a wider world – symbolically also a more civilized and longer-lasting world – where the norms of British culture cannot last for very long. One might say that, writ large, *The Magus* is about British incomprehension, about the transformation of the

assured traveller and explorer into a bewildered and paranoid subject who largely fails to grasp the subtlety and sophistication of what is going on around him – and the use there of 'him', of course, can simultaneously return us to the problems of gendered writing.

If *The Spire* has taken us into a distinctively British past, and *The Magus* exposed us to the perils of Britishness in a wider international context, then Doris Lessing's *Shikasta*[26] opens us to the future, and at the same time throws a further light on the cultural revolution in its reliance on a certain trope of youth as the world's salvation. Again the position of Britain within a wider geographical ambience is predominant: the text further invites a consideration of a question too infrequently aired, namely, how the national self-image is constructed not only by its myths of the past but by its images of the future – if it has one. Although the central terrain of *Shikasta* appears to be occupied by a conflict between the planet Earth and other galactic entities, we might also want to probe the extent to which this is in fact modelled on a hidden version of Britain at the mercy of superior national powers.

Russell Hoban's *Riddley Walker*[27] is a difficult text to read; nevertheless, it is to date the most convincing version of a British post-nuclear future, and perhaps – and this is also grist to the mill – all the more telling in that it was not written by somebody British. The geographical map is strictly limited, to the area around Canterbury; this catches up at once the arguments about religion mentioned above, and also the question about the future as a pressure upon the present national myth. Most astonishingly, the novel creates a new language, or rather reassembles the shards of an outmoded national language in a new and brutalized form; obviously there are ways in which almost any national culture can relate to the issues and problems thus addressed.

In Salman Rushdie's *Shame*,[28] the question of geography – maps of the world, boundaries and borders, maps of the psyche, topographies of the inner world – is throughout paramount; this is a novel which, above all, is about maps, and also about the impossibility of centring, decentring, marginalizing in a realm where – again geographically and psychically – all is in flux, where artificial borders have created a world in which

there is no possibility of being fully at home. To include a book by Rushdie on the course is, of course, to provide a host of other signals: about censorship, about British multiculturalism, about danger, about conflict between the self-image of the British and what actually exists within the nation, about democracy and its limitations.

Angela Carter's *Nights at the Circus*[29] occupies a curiously analogous position: if Rushdie is Britain's most significant literary *cause célèbre*, then Carter currently figures as Britain's most studied author, and it will be useful to enquire into the roots of this peculiar but commercially limited 'popularity'. *Nights at the Circus* (which we might also call 'Room at the Big Top') takes us on to magical terrain, as has Rushdie: but the magic in the 'magical realism' is here of quite a different kind, and again we need to look at the gender difference, at the importance of the state apparatus in Rushdie's text, an apparatus which Carter can blithely disavow, even in the course of forming another crucial 'fable for our time'.

Joan Riley's *The Unbelonging*,[30] probably, but unjustly, the least-known novel on this list, is a savage and depressive story of a West Indian girl's upbringing in London; it concludes with a devastating account of how such transplantation can result in a total homelessness, which is compounded by, or perhaps is the very image of, the abuse which Hyacinth also suffers. What we are talking about here, as in the entire discourse of abuse with all its political and therapeutic ramifications, are hidden histories, hidden geographies: not, perhaps, the maps neatly laid out on the surface, but the whole issue of how the generations find it impossible to free themselves one from another, so that problems deeply rooted in the (familial, national) past become the substance of present perversions.

J.G. Ballard's *Empire of the Sun*[31] takes us again, in a sense, abroad; it also takes us back to the Second World War and its aftermath, providing a salutary reminder of how the imagery of that war has continued to be active in the collective imagination. Here we come directly up against issues of imperialism and counter-imperialism which are more difficult to trace in 'domestic' fiction, and simultaneously up against a root of madness. For the doubts that surround Ballard's narrator can be used as a lever to prise apart all narration as a series of attempts to recount a tale of damage, of abuse, which can never

fully surface, never be fully mapped; at the same time the very immersion of Ballard's narrator in a world far from Britain can help us to realize the various international meanings of 'being British', albeit in this case under the most extreme of conditions.

Kazuo Ishiguro's *The Remains of the Day*[32] brings us up against a final series of problems. By whom is the nation's identity defined? What is the source of narrative involvement, immersion or estrangement? How can it be that Ishiguro's style reminded so many critics of Jane Austen? What does the myth of reticence, reserve, self-abnegation, the whole construct of class subservience which Ishiguro so faithfully adumbrates mean in a current British context – in other words, how much of Britain's past has been laid to rest amid the changes of the last forty years, how much is still alive and strong, still playing itself out in habits of political conservatism and, to use that oft-repeated but still crucially important term, social deference?[33]

Maps, then, I hope we have here in plenty, and contradictions between maps, which will give rise to questioning, investigation, comparison. What is also important and, I hope, evident about this choice of texts is that, of their writers, very few could or would wish to claim a centrality in terms of the white/male/Protestant monolith which often passes for British culture overseas. What we have here instead is a succession of maps which do not fit one with another, of perceptions from the fringes or borders, relativizations of a governing ethos which, if rethought aright, would reveal simultaneously the strength and weakness, the endurance and fragility, of the bonds which hold together the diverse British *cultures* represented in these texts behind the façade of a single culture.

Theoretical frames

What we have here for presentation, then, is not a culture but cultures, not a monolith but a complex interwebbing of different cultural axes – and, of course, there are many others which are not approached within the context of this course. Most glaring among the omissions is any sustained reference to Britain's own regionalisms, to the Welsh, Scottish and Irish dimensions of the field. There are, to paraphrase the title of Seamus Heaney's excellent article on recent poetry, many

'Britains of the mind':[34] here are only some of them, but there are plenty more which could be added on, and within the teaching and learning situation many other texts might appear which evidence these further maps. Apart from these regional and national considerations, one text that I have omitted from this course, because I did not want more than a single text by one author, is Hoban's *The Lion of Boaz-Jachin and Jachin-Boaz* (1973), which could well serve as an Ur-text about maps, and also about the complex interplay and succession of realism, fantasy and magic realism that I hope the texts themselves as given go some way to evidencing.

My point here is to locate the 'comparatism' *within the field*. There is no point at all in presenting to a learning group a monolithic picture of Britain and saying, in effect, is your own country like or not like this? Apart from any other considerations, this is, I would contend, not how our own national culture appears to ourselves. But if we can say that, within the carapace of 'our' culture, there are these divergences, these asymmetries, these dominant, residual and emerging patterns, then there is something to hang on to, a sense of change which will always have its echo, its replication, within any other process of cultural formation and transformation.

National myths are always also supranational myths: it is never enough to say that one country figures in such-and-such a way, because in doing so it also, more or less consciously, figures the 'rest of the world' (important phrase) in such-and-such ways too – always as other, but with a wide diversity of stances of otherness. In this sense, I would want to return full circle to some of my comments at the beginning of this chapter. It will be clear that I do not think it correct or useful to consider British Cultural Studies as a fully theorizable discipline in its own right: but I do think that the development and experience of British Cultural Studies – which is, after all, at least as much a practice as a discipline – will have a great deal to say to the theorists.

If I were to take one particular instance of this potential dialogue, I would begin from Deleuze and Guattari's figure of the 'nomad', who, according to them, stands for all which resists the state apparatus and the war machine.[35] There is no space here for me to justify this claim, but I believe that the real figure which offers that resistance, but in a far less

predetermined and conscious a way than the idealized 'nomad' of our desert dreams, is the refugee: and I could now start to run through the texts again, demonstrating the extent to which they hinge on the figure of the refugee – across international borders, but also across the borders of the mind and in the enduring figure of the internal exile.

What this might suggest to us is that, in the business of communicating about and across different cultures, we can no longer rely either (naturally) on stereotype or, more importantly, on the simple dismantling of stereotype: instead it is axiomatic that we deal seriously in difference, internal difference, in, if you like, a practical deconstruction in which we are able to exhibit our national myths, neither in a mood of celebration nor in a mood of cynicism, but as objects for attention. In a simpler world, we could pretend – and have in the past pretended – that this could be achieved through an assumption of neutrality; it is clear that this will no longer do, and that in order to balance the various myths and counter-myths we have at our disposal we must try to show their wealth and diversity and to encourage students to make what they will of this discourse of difference and *aporia*.

Another way of putting this is to suggest that the task of all cultural and intercultural studies now has become to problematize the notion of authority: who is it, we might fairly ask, who has the authority to promulgate this or that version of what it might be like to be British? And here we see, as it were, the other side of the relation between fiction and cultural studies: for we might claim that in fictions – in, that is, relatively free-standing imaginative constructs – we see the very image of the free flow of authority and power which British Cultural Studies should be trying to encourage.

In conclusion, I want to return to the dilemma from which I began: namely, the problem of what one is doing in suggesting that fictions can provide 'evidence'. The answer to this, I think, can be sought in one direction and one direction only: through experience and analysis of how they are read. The 'same' novel may be (and is) read as a linguistic textbook; as a piece of evidence about daily life in a particular culture; as a self-sufficient formal artefact; as a manifestation of a personal and/or cultural imagination. It is indeed possible that the world is nothing but text; but if that is true, then we must

reinterpret 'text' as meaning 'text-as-received'. I am not at all sure that reception theory in itself deals with this, because reception theory aspires to be a science of the ideal reader; when one is adrift in a sea of real readers, from many different backgrounds and with many disparate competences, then the position becomes altogether less clear; and, at the same time, all the more replete with meanings, with incompatible maps, with the materials for a comparison which is always – and presumably always will be – on the verge, the margin, of being made.

Notes

1 See Ben Knights, *From Reader to Reader: Theory, Text and Practice in the Study Group* (London: Harvester Wheatsheaf, 1992), esp. pp.10–40.

2 See Michel Foucault, *The Archaeology of Knowledge* (London: Tavistock Press, 1972), pp.56–63.

3 Or we may choose to base our classifications on those offered by Raymond Williams in *The Long Revolution* (Harmondsworth: Penguin, 1961), pp.57 ff.

4 See Gilles Deleuze and Félix Guattari, *A Thousand Plateaus: Capitalism and Schizophrenia*, transl. B. Massumi (London: Athlone Press, 1988), pp.71–4.

5 I am thinking here in particular of the varied audiences encouraged by the British Council in Belgrade.

6 See Peter F. Murphy, 'Cultural Studies as Praxis: A Working Paper', *College Literature*, 1992, pp.31–43.

7 Perry Anderson, 'Components of the National Culture', in A. Cockburn and R. Blackburn (eds), *Student Power: Problems, Diagnosis, Action* (Harmondsworth: Penguin, 1969), pp.214–84.

8 This is an argument which has been developed in successive workshops organized by the British Council for academics from the former German Democratic Republic.

9 See, for example, D.W. Winnicott, *Human Nature* (London: Free Association Books, 1988), pp.99–115.

10 See, for example, Melanie Klein, 'On the Sense of Loneliness' (1963), in *Envy and Gratitude, and Other Works 1946–1963*, (ed.) H. Segal (London: The Hogarth Press, 1975), p.311.

11 See B. Ollman and E. Vernoff (eds), *The Left Academy: Marxist Scholarship on American Campuses*, (New York: McGraw-Hill, 1982), esp. pp.166–201.

12 See Colin Evans, *English People: The Experience of Teaching and Learning*

English in British Universities (Milton Keynes: Open University Press, 1993), pp.19–34.

13 I am thinking here of my experiences of British Cultural Studies in China.

14 See Paolo Freire, *Pedagogy of the Oppressed*, transl. B. Ramos (London: Sheed and Ward, 1972).

15 See Knights, op. cit., pp.33–40.

16 The major model I have in mind here is the work of the Development of University English Teaching Project (DUET); see Colin Evans (ed.), *Developing University English Teaching: An Inter-disciplinary Approach to Humanities Teaching at University Level*, (Lewiston: Edwin Mellon Press, 1995).

17 John Braine (1922–86): *Room at the Top* (1957); *The Vodi* (1959); *Life at the Top* (1962); *Stay with Me till Morning* (1970). I shall give a similar list of selected novels for each of the writers mentioned.

18 On this issue see Benedict Anderson, *Imagined Communities: Reflections on the Origins and Spread of Nationalism* (London: Verso, 1991), pp.3–7.

19 Graham Greene (1904–91): *Stamboul Train* (1932); *Brighton Rock* (1938); *The Power and the Glory* (1940); *The Heart of the Matter* (1948); *The Quiet American* (1955); *Our Man in Havana* (1958); *The Comedians* (1966).

20 Iris Murdoch (1919–): *Under the Net* (1954); *The Sandcastle* (1957); *The Bell* (1958); *A Severed Head* (1961); *The Nice and the Good* (1968); *The Sea, the Sea* (1978); *Nuns and Soldiers* (1980).

21 Arthur Marwick, 'A Social History of Britain 1945–1983', in David Punter (ed.) *Introduction to Contemporary Cultural Studies* (London: Longman, 1986), pp.19–46.

22 William Golding (1911–93): *Lord of the Flies* (1954); *The Inheritors* (1955); *Pincher Martin* (1956); *Free Fall* (1960); *The Spire* (1964); *The Pyramid* (1967); *To the Ends of the Earth: A Sea Trilogy* (1992).

23 See, for example, Wayne C. Booth, *The Rhetoric of Fiction* (Chicago: University of Chicago Press, 1961), pp. 149ff.

24 John Fowles (1926–): *The Collector* (1963); *The Magus* (1965); *The French Lieutenant's Woman* (1969); *Daniel Martin* (1977); *A Maggot* (1985).

25 See Edward Said, *Orientalism* (London: Routledge, 1978), pp.58–61.

26 Doris Lessing (1919–): *Martha Quest* (1952); *The Golden Notebook* (1962); *Shikasta* (1979); *The Sentimental Agents* (1983); *The Good Terrorist* (1985); *The Fifth Child* (1988).

27 Russell Hoban (1925–): *The Lion of Boaz-Jachin and Jachin-Boaz* (1973); *Kleinzeit* (1974); *Turtle Diary* (1975); *Riddley Walker* (1980); *Pilgermann* (1983); *The Medusa Frequency* (1987).

28 Salman Rushdie (1947–): *Grimus* (1975); *Midnight's Children* (1981); *Shame* (1983); *The Satanic Verses* (1988).

29 Angela Carter (1940–92): *The Magic Toyshop* (1967); *Several Per-

ceptions (1968); *The Passion of New Eve* (1977); *Nights at the Circus* (1984); *Wise Children* (1991).

30 Joan Riley: *The Unbelonging* (1985); *Waiting in the Twilight* (1987); *Romance* (1988); *A Kindness to the Children* (1992).

31 J.G. Ballard (1930–): *The Drowned World* (1962); *The Drought* (1965); *The Crystal World* (1966); *Crash* (1973); *Concrete Island* (1974); *Empire of the Sun* (1984); *The Kindness of Women* (1991).

32 Kazuo Ishiguro (1954–): *A Pale View of Hills* (1982); *An Artist of the Floating World* (1986); *The Remains of the Day* (1989).

33 See Marwick, in Punter (ed.), pp.26–7.

34 See Seamus Heaney, 'Englands of the Mind', in *Preoccupations: Selected Prose 1968–1978* (London: Faber & Faber, 1980), pp.150–69.

35 See Deleuze and Guattari, pp.351–423.

Part 2

6

Dedefining Scotland
ROBERT CRAWFORD

My aim in writing this chapter is to guide readers towards some of the more interesting recent developments in Scottish Studies, often drawing attention to works where they will learn much more about Scotland's history, culture and traditions. At the same time as surveying the direction in which Scottish Studies have developed of late, and advocating future directions, I am writing consciously as a poet and critic with particular commitments to the cultural life of my country, and a special concern with literature. This means that I shall concentrate on some aspects of culture more than others, and that what follows is a survey which is at times close to being a manifesto.

Modern Scotland, like modern England, is a nation, but not a state. Implicitly or explicitly, this position obsesses many who study Scottish culture and politics. The fact that before 1603 Scotland was a separate kingdom, and that until 1707 it had its own parliament in Edinburgh, tends to intensify the obsession. An impressive majority of Scottish voters now vote for parties which support Scotland having democratic control of its own affairs, though only a minority of those voters support independence from the rest of the United Kingdom. A concern with, and a perceived need to assert, national identity characterize many aspects of Scottish life.

So, for instance, Scotland's banks continue to produce their

own notes, though, of course, Scotland does not have its own currency. The established church, the Church of Scotland, is Presbyterian. Scots Law differs significantly from the law of England, being often more akin to continental legal systems based on Roman Law. Scotland's educational system is broader-based than that of England, and, both at school and university level, offers a different structure. A sometimes confident but often anxious emphasis on national difference was mocked by the nationalist poet Hugh MacDiarmid in 'A Drunk Man Looks at the Thistle' (1926) where he ridiculed those who complain about minutiae such as the use of the word 'England' where the 'United Kingdom' is meant, yet a bristling at trifles continues to be significant in a modern Scotland which is often regarded by London-based companies (such as the BBC) as a 'region' rather than a nation.

Scotland, however, is in little danger of lapsing into mere regional status. It has too high an international profile for that. This profile was developed, to a considerable degree, through European Romanticism, the result of which is that several widely recognized and sometimes conflicting constructions of Scotland are on offer. So, for instance, Scotland has always been a good supplier of savages. Tacitus in his *Agricola* presented the Caledonian noble savage Calgacus to Roman Europe. Napoleonic Europe thrilled to the exploits of the Ossianic Highlanders, out-Homering Homer's heroes. Dr Johnson, faithfully recorded by his Scottish biographer James Boswell, maintained that much might be made of a young Scotchman, if he be caught young. Even today, Glasgow, a predominantly douce, middle-class city, remains for many imaginations the territory of the urban savage now popularly portrayed as BBC television's Scottish 'heidbanger', Rab C. Nesbitt.

Yet Scotland is also Britain's brainbox. Aberdeen for a long time had as many universities as England. James Watt, Alexander Graham Bell, John Logie Baird – Scots invented modernity from logarithms to the steamship, from television to radar. They were doctors and dominies, missionaries and mechanical engineers. Even if assumptions about the long history of widespread Scottish literacy have been dented, the dream of Scotland as a land of education persists. The world expects Scotland to do its duty as misty, kilted realm of romance, but also as canny, Calvinist knowledge base. Flora

MacDonald takes tea with Adam Smith; John Knox offers Bonnie Prince Charlie a scone.

The more one scrutinizes Scottish myths, and the culture that gave rise to them, the more the apparent contradictions multiply. Robert Burns provides a focal point. He is the often republican libertine who becomes the icon of a respectable Presbyterian monarchy. He is the widely read, socially adept, calculating individual who achieves star status by being welcomed as a naïve peasant. Robert Burns, like Scotland, is where extremes meet.

It was to try to explain the constant meeting of extremes in Scottish culture that theorists, particularly the belletristic Professor G. Gregory Smith in his book *Scottish Literature: Character and Influence* (1919), came up with the abstruse-sounding term 'Caledonian Antisyzygy'. Seized on by Hugh MacDiarmid in the 1920s, the idea was that Scottish culture (especially literature) relied on producing energy by bringing together clashing opposites in the way that a medieval cathedral sculptor might place a grinning gargoyle beside a saint. This theory fits various well-known Scottish books such as Robert Louis Stevenson's *Dr Jekyll and Mr Hyde* (1886). It also fits other Scottish productions like MacDiarmid's own poems, or like Edinburgh, where the Old Town with craggy tenements and dark vennels confronts the eighteenth-century New Town with its expansive Georgian squares. Ultimately, though, this theory becomes a straitjacket, a one-size-fits-all explanation into which everything Scottish gets squashed in an endless search for opposites and doubles. Scottish culture, even at the level of myth, is more diverse and complex than that. Scotland has more than two faces.

A lot of modern thought has tried to seek out ideas of 'Scottishness' which would hold true of the culture in general. In literature an example of this would be Kurt Wittig's *The Scottish Tradition in Literature* (1958; republished 1978), a book whose blurb argues that 'nobody can fully enjoy Scottish literature until he learns to interpret it primarily in terms of its own inherent values' which are 'essentially Scottish'. Such constricting essentialism is obvious also in some of the more extreme movements, such as Scottish Watch (scorned by the Scottish National Party), one of whose members spoke recently of preserving 'Scottishness' and worried that the replacing of

Scottish people by English people in Scotland was a 'final solution to the Scottish problem, more or less, in UK terms.'[1] In fact the English-born represent about 8 per cent of Scotland's population. Those who feel passionately that Scottish culture is being eroded or who lack confidence in the ability of Scotland to persist often seek essentialist definitions of Scottishness which do not stand up to close scrutiny and which tend to freeze the culture rather than allowing scope for variation and development.

Nevertheless, the search for consistency or at least identifiably Scottish cultural attributes has led in recent decades, and particularly in the last ten years, to several totalizing and impressive examinations of Scottish history and culture. These surveys have both reflected and encouraged cultural self-confidence and must be of interest to students of Scotland or of Britain in general. The 1960s and 1970s saw the publication of multivolume histories of Scotland by the Edinburgh publisher Oliver & Boyd and by the London publisher Edward Arnold, but it was the modern social history written by a St Andrews-based Englishman Professor T.C. Smout which brought Scottish history to the widest audience. In 1968 William Ferguson, writing the Oliver & Boyd history's fourth volume, complained about books such as C.L. Mowat's *Britain Between the Wars, 1918–40* (1955) and A.F. Havighurst's *Twentieth Century Britain* (2nd edn, 1966) which 'do not consider Scotland', so that 'Little help is to be found in general histories of England or Britain (the precise title usually makes little difference to the contents).'[2] This familiar complaint about English historians treating Britain as England might be mirrored by the tendency for the most important Scottish authors to be incorporated in 'English Literature', with the rest being ignored – an ironic position since the university subject of 'English Literature' can be viewed as a Scottish invention. Looking from the end of the twentieth century, however, it can be seen that multivolume histories such as the one in which Ferguson was writing, along with T.C. Smout's *A History of the Scottish People 1560–1830* (1969), his *A Century of the Scottish People 1830–1950* (1986), and Michael Lynch's *Scotland: A New History* (1991) have so changed the intellectual climate that Scottish history has become more widely read and discussed.[3] Partly this has been helped by the contemporary penchant for the mar-

ginal, an intellectual fashion which has been of benefit to Scotland, though in it lies the danger of creating a postmodern version of the old 'Celtic fringe' idea. If one examines a work such as Linda Colley's prize-winning *Britons: Forging the Nation 1707–1837* (1992), it is obvious that one of the book's strengths is the way it sees how important Scotland and the Scots were in the development of the British state (not to be confused with the English nation). It may be that the growth of Post-colonial Studies will also direct more attention to Scotland's considerable part in the colonial experience – for the most part as colonizer. It is largely the importance of the Scottish contribution which has ensured that we speak of the British empire, rather than the English empire. The development of colonial and post-colonial investigations as part of British Studies cannot afford to ignore the Scots, and is likely to enrich perception of Scottish culture by reminding us how much Scotland has been shaped by, and has helped to shape, nations other than its immediate neighbour.

Work of confident consolidation in Scottish historiography, represented most impressively by Michael Lynch's *Scotland: A New History*, is paralleled by the recent work in literary, art historical and musical scholarship. Maurice Lindsay's 1977 one-volume *History of Scottish Literature*, the first such large-scale totalizing volume for almost three-quarters of a century, was followed by Roderick Watson's *The Literature of Scotland* (1984) which broke new ground in its panoptic view of Scottish writing in English, Scots and Gaelic. The four-volume, multi-author *History of Scottish Literature*, produced in 1987–8 under the general editorship of Cairns Craig, gave literary historians a work to match those earlier multivolume series which dealt with Scottish history.

Paralleling these totalizing literary histories, two particularly notable works of scholarship attempted in the early 1990s to present panoptic surveys of Scottish art and music. Duncan Macmillan's *Scottish Art 1460–1990* (1990) presents art in terms of a 'flow of exchanges', but is confident that 'Scottish art proves itself to have a continuous and distinct identity as part of the European tradition.'[4] This emphasis on an identifiable Scottishness that is to be seen in the light of European tradition, rather than simply aligned with English culture, is present also in John Purser's *Scotland's Music* (1992) whose subtitle, *A History*

of the Traditional and Classical Music of Scotland from Early Times to the Present Day reinforces its aim of being a totalizing project that presents an 'overall picture' which sets Scottish music in a European, not just a British context: 'As a long established nation in Europe, musically prolific and distinctive, Scotland has an outstanding claim on our attention.'[5] This viewing of Scotland in a European frame has a lengthy and respectable history. Commentators have long pointed not only to the culture of medieval Scotland but to the European pre-eminence of the sixteenth-century Latinist George Buchanan, to the part played by Scotland in the Enlightenment and in nineteenth-century Romanticism. Nevertheless, a view of Scotland as European, rather than simply British, has been particularly prominent of late in several areas of scholarly and creative work, as seen, for example, in the anthologies *European Poetry in Scotland* (1989) edited by Duncan Glen and Peter France, and *European Poetry in Gaelic* (1990) edited by Derick Thomson. Though not all of the authors and editors just named would regard themselves as nationalists, their work frequently corresponds to the emphasis plain in the 'Scotland in Europe' slogan adopted by the Scottish National Party in the late 1980s and early 1990s, and which helped to win that party considerable success in 1994's European elections. This cultural and political emphasis on a country which views itself (or wishes to view itself) as confidently European may be seen in part at least as a way of outflanking Anglocentric pressures within the British state, and as a device to celebrate Scotland's aloofness from the prevailing politics of Westminster under both Margaret Thatcher and John Major, neither of whom emerged as a jubilant European. It is hard to imagine 'England in Europe' making much headway as a persuasive political slogan south of the Scottish border.

The subject of this chapter is Scottish Studies, not Scottish politics, but it would be foolhardy to pretend that the two can be kept separate. Indeed, it is noticeable that the upsurge in the production of totalizing histories of Scottish literature, art and music – striving to give a wholeness to the Scottish experience in these fields – has come during a period in which Scotland has striven for, but failed to find, a complete expression of its political identity. Though a 1979 referendum almost gave Scotland its own legislative assembly within the

British state, the British government's insistence that this constitutional change would require not a simple majority of Scottish voters but a 'yes' vote by at least 40 per cent of all on the electoral roll in Scotland meant that, despite a majority vote for devolution, the Scottish assembly planned for Edinburgh never materialized. Since 1979, though the vast majority of Scottish voters have favoured a legislative assembly, and though the Conservatives have few MPs north of the border, the Conservative majority at Westminster at successive elections has ensured the blocking of moves for Scottish self-government. At times this has encouraged a tendency for culture, particularly literature, to take on an overtly or covertly political role. Though it would be foolish to believe that all Scottish writing was defiantly political, or that all Scottish political writing was nationalist in its orientation, there are clear instances where this is so. For instance, the poet Edwin Morgan has said of his 1984 collection *Sonnets from Scotland* that:

It began with the idea of writing one or two, I think as a kind of reaction, probably, to the failure of the Referendum to give Scotland political devolution and any idea of a Scottish Assembly. I think at that time there was a sense of a kind of gap, a hiatus, a numbness in Scottish thinking. There had been such a build-up towards the possibility of not independence, obviously, but some kind of Assembly, and I think lots of people had felt that really it was going to happen. It didn't happen, of course, and there was this great deflation. But the deflation led to (not just in myself but in other people too) a great deal of thinking about it, not necessarily picking over what had gone wrong. I think there was a kind of 'Nevertheless' feeling. We hadn't got our Assembly, and everything seemed to have gone back to square one as it were, but. And it was the but that seemed to be important. I had very strong feelings about Scotland at that time and wanted perhaps to put something down that would make this 'Nevertheless' feeling quite palpable and tangible. Although there's only one of the sonnets about the Referendum itself and the sense of deflation, nevertheless the whole thing is meant to be related to that. It's a kind of comeback, an attempt to show that Scotland was there, was alive and kicking, that people were living there, were thinking and feeling about it and were going

to go on writing about it even if political change was at that
time certainly pretty unlikely. It was just a kind of desire to
show that Scotland was there and that one mustn't write it off
just because the Assembly had not come into being.[6]

I quote this at length because it clearly articulates a cultural
politics often felt to be implicit in the work of a number of
Scottish figures in the period. Significantly, in *Dream State: The
New Scottish Poets* (1994) it is Edwin Morgan whom the anthol-
ogist Daniel O'Rourke sees as the most important influence on
the poets of the generation born in the later 1950s and 1960s.
Morgan is also interesting in being at once a scholar and critic
of Scottish culture, in such books as his essays *Crossing the Border*,
as well as a creative writer. The poet Douglas Dunn, now a
Professor at St Andrews University where he directs the St
Andrews Scottish Studies Institute (SASSI), is another such
figure. Morgan's *Sonnets from Scotland*, ranging from prehistory
to science-fiction, is yet a further 'totalizing' view of Scottish
culture, which might be set beside the work of historians and
cultural historians such as Roderick Watson, John Purser and
Duncan Macmillan. All of them seem concerned with present-
ing a full-length portrait of Scotland and her culture which can
be seen as designed to bolster a sense of national identity, and
a perceived continuity of 'Scottishness'. Again, in Morgan's
work there is a clear 'European' edge seen most obviously,
though not solely, in his fluent work as a translator from
Russian, Hungarian, French, German, Italian and other Euro-
pean languages.

Including celebrations of scientific as well as literary figures,
Sonnets from Scotland also indicates an important direction in
which totalizing visions of Scottish culture have headed: the
interdisciplinary. While, for instance, the writings on art his-
tory and on music by Duncan Macmillan and John Purser show
a keen awareness of literature, other recent volumes have
attempted to portray Scottish culture more fully 'in the round'.
The first of these is David Daiches's *Companion to Scottish Culture*
(1981), a multi-author A–Z republished by Polygon in 1993.
The second, edited by the active nationalist P.H. Scott, is
Scotland: A Concise Cultural History (1993), and is introduced by
its editor as 'the first on the subject which is intended to be read
straight through'. In the same introduction, Scott complains

that Scottish culture has suffered 'denigration' both inside and outside Scotland, so that 'It is possible to go through from a Scottish education at all levels from nursery school to a postgraduate degree and emerge in almost complete ignorance of Scotland's outstanding contribution to civilisation.' Despite a salutary increase in the incidence in the teaching of Scottish topics, this remains the case, and Scott makes the perceptive statement that 'It is astonishing, but perhaps symptomatic of the effects of denigration, that hardly any attempt has been made before to study Scottish culture as a whole.'[7] Again, Scott is surely correct. Though, like John Purser, he has university connections, Scott is an example of the Scottish scholar whose work is done outside the academic institutions, and his complaints must stand as a reproach to these institutions which, with few exceptions, have been slow to develop an integrated view of Scottish culture in the round. The distinguished School of Scottish Studies at Edinburgh University, for example, has concentrated on folklore studies. Only recently and (ironically) at the very time when Scott's volume was being written have integrated degrees in Scottish Studies been developed. At St Andrews University, for instance, both undergraduate and postgraduate students study core interdisciplinary modules and build round these a programme selected from a menu of courses in Scottish literature, art history and history. As yet, however, even these degrees (conceived *ab initio* as interdisciplinary) lack substantial elements in such areas as divinity and popular culture. What is striking is that the newer Scottish Studies degrees at the universities of Glasgow, Stirling, St Andrews and elsewhere also tend to present a totalizing picture of Scottish culture that is in keeping with many of the most significant recent publications. It should be stressed that not all of these publications come from the walls of academia. Though writers such as Purser and Scott have university connections, they are not professional academics. Scottish Studies have been furthered by scholars working both inside and outside academic institutions and, as is often the case, each at times has too little respect for the other.

Between them, these writers, academics and commentators may be said to have established what one might see as an intellectual infrastructure for the culture of a future Scotland with democratic control of its own affairs. In such areas as

painting, music and literature, as well as in the broader field of history, there exist substantial overviews of what constitutes a distinctive and continuing Scottish tradition. Writing in a period when it seems only a matter of time before Scotland achieves at least some measure of devolution, I think it is important that Scots have confidence in their more democratic future and their possession of charted cultural traditions. Indeed, I would go as far as to say that in the near- to medium-term Scotland can assume that it will gain greater control of its affairs, and that it is the job of intellectuals not so much to produce further totalizing views of Scottish culture, not to define Scotland and Scottishness, but to dedefine them.

I write this convinced that we owe a debt to the totalizing views of Scottish culture recently produced, but convinced also that part of the strength of any modern national identity must lie in fluidity. To go on attempting to define Scottishness and Scottish tradition is to risk the production of an oppressively monolithic notion. Having achieved a sufficient measure of cultural self-definition, and standing on the brink of greater political autonomy, Scotland needs not the pursuit of some elusive *echt* Scottishness, but requires many reminders of its protean and plural past, present and future.

In this context, as I have argued elsewhere, the work of Mikhail Bakhtin may be of some use since it allows us to conceive of identity in terms of an ongoing (and, by nature, fluid) dialogue, rather than in terms of a fixed and unchanging monologue.[8] Scotland, then, alters according to its relations with the rest of the world, not least the rest of Britain, changing and being changed by interaction with other cultures and communities. More than that, Scotland itself is dynamic, authored through an internal polyphonic process. That authoring involves a variety of languages (not least English, Scots and Gaelic) and their attendant traditions; it involves an ongoing regional interaction between parts of Scotland as different as Glasgow and the Outer Hebrides, St Andrews and Dundee. Scotland is also a complexly and shiftingly gendered construct. Work by the American Jude Burkhauser on Glasgow women artists, by Leah Leneman on Scottish women's suffrage, and by Douglas Gifford and Dorothy McMillan, general editors of Edinburgh University Press's *History of Scottish Women's Writing* (forthcoming), all serves to remind us of ways in which Scottish

history and culture have often been crudely phallocentric.[9] Part of the work of dedefining Scotland will be to combat notions of macho and sentimental Scottishness furthered by older brands of whisky-and-fags Burns-suppering. Many Scots might find it hard to name six famous Scottish women who didn't have their heads chopped off.

As if to emphasize this need for a new pluralism in Scottish Studies, one that gives full range to variety, and little scope for essentialism, the term 'Scotlands' is finding increasing favour north of the border. Emphasizing open-ness and fluidity rather than any sort of narrow emphasis on nationalistic purity, *Scotlands* is the title of a new interdisciplinary journal of Scottish Studies with editors in Scotland, North America and New Zealand, which lays the emphasis on the plural identity of the nation. 'Scotlands' is also a word used by the anthologist Daniel O'Rourke. For him it expresses the pluralist visions not only of the young poets but of composers, artists and other cultural figures. Certainly the 'Scotlands' approach suits the syncret-izing *brio* of much recent Scottish writing and painting. Old-style nationalism tended to produce narrow, holier-than-thou definitions of Scottishness ('Scottish poetry in Scots is more Scottish than Scottish poetry in English'). The new pluralism is both more imaginatively generous and better suited to the Harris in which remote crofts are visited by Abdul's Mobile Shop or the Glasgow in which at least some of the Bangladeshis vote SNP.

This new pluralism of 'Scotlands', however, isn't mere political correctness or slick postmodern pick 'n' mix. It reflects an awareness (seen in the corpus of Raeburn's portraits or in the novels of Scott) that Scotland is and has long been a multicultural, multilingual society. Gaelic-speaking Scotland, Scots-speaking Scotland and English-speaking Scotland have co-existed for centuries. There are only 80,000 Gaelic speakers today, yet several of the most internationally recognized Scot-tish symbols are strongly linked to Gaelic culture. Few Scots have no imaginative investment in the Gaelic world, even though they do not speak its language.

Again, few English-speaking Scots would want to renounce Burns, or MacDiarmid's best poetry. Even among today's fiercest champions of the Scots language there is no suggestion that we should round up speakers of English. Scotland is

growing more content with its Scotlands, and is coming to see that pluralism is richly rooted in its culture. It's meaningless to argue whether Robert Adam was more Scottish than Charles Rennie Mackintosh, or whether Stornoway is more Scottish than Largs. There are many Scotlands. This cultural proliferation is a source of fertility and strength.

The Scots' awareness of centuries of linguistic and cultural pluralism is rarely consciously articulated; but it is deeply felt. There are some clear parallels with the cultures of Ireland and Wales. Yet in England, which has no equivalent of Gaelic, and whose Bard did not obviously write in dialect, there is less of a deep sense of native linguistic and cultural pluralism. Anglo-Saxon and Norman French are too far in the past; Cantonese and Urdu seem comparatively recent. It is easy to sketch English culture so as to exclude the Channel Islands; much harder to sketch Scottish culture so as to exclude the Hebrides. Glasgow is aware of Lewis in a way that London is not aware of the Isle of Man. All this supports the idea of a plural Scottish identity as something deeply ingrained in Scottish culture, if not always articulated fully. Part of this wider, 'dedefined' rather than restrictingly defined or redefined Scottish identity would take the form of an acknowledgement that many Scots have favoured (and continue to favour) integration in Britain. Scotland does not speak with one voice, and it would be a dangerous position if it did.

So, in recent centuries much of Scottish cultural energy has been directed towards the maintenance not simply of a Scottish but of a fully British ethos in which Scotland can play its part. Scott's novels, the *Encyclopedia Britannica*, Sir John Reith's BBC – all these are Scottish-rooted institutions geared to presenting Britishness that was significantly more than Englishness. Yet Scottish culture today often suggests that such classic Britishness is a thing of the past. Perhaps John Buchan (whose chaps' old-fashionedness we can still relish) was the last *British* writer. His hero Richard Hannay, a Scots-born Rhodesian Anglophile, is the champion of the British empire. But it is hard to think today of what could be confidently called 'British' culture rather than English or Scottish culture. Certainly it is the Scottish nationalist MacDiarmid rather than British Buchan who is the crucial twentieth-century Scottish literary intellectual. Alasdair Gray, the leading novelist in contemporary

Scotland, produced at the time of the 1992 election a small book entitled *Why Scots Should Rule Scotland.*

While some of the most prominent mid-century Scottish cultural figures – Muriel Spark, Sean Connery, Karl Miller – left Scotland for various reasons, there may be today a greater feeling of native self-confidence which helps keep (or even re-patriate) Scottish talent. Painters like Alison Watt and Lesley Banks seem confidently domiciled in Scotland. Young poets such as Kathleen Jamie and Don Paterson move easily betwen Scotland and the wider world. These figures, like the composer James MacMillan, look and travel abroad. They seem happier with Scotlands than with any purist's Wee Scotland. They are Scottish-international in outlook.

Scottish culture seems to have moved into a post-British phase. If Scots wanted to run Britain in the eighteenth century, and to run the empire in the nineteenth, in the twentieth century they seem, more reasonably, to want to run Scotland. Culturally, they have already declared independence. It seems inevitable that where the imagineers and voters have led, the politicians and the civil servants will follow. At such a juncture, having helped to define a new Scotland, it is time for artists and students of Scottish culture both in Scotland and beyond to go on with that complicating, enriching, and necessary work of 'dedefinition' which will ensure that no definition of 'Scottish-ness' becomes oppressively monolithic and that Scotland, which looks about to achieve a substantial measure of auto-nomy with the next change of government, remains imagi-natively and intellectually freed-up – supplied with many visions of itself as well as many ways of looking at, engaging with, and being perceived by an increasingly interested world beyond. There are already centres for Scottish Studies as far apart as Germany, Canada, and New Zealand. If the growing internationalization of British Studies directs more non-Scottish attention to Scotland, then it will be performing a service beneficial to Scottish Studies, in further multiplying perspectives on Scotland, enriching it by dedefinition.

Notes

1 Ian Sutherland, speaking to Michael Ignatieff on *The Late Show* ('A Different Country'), BBC2, 13 June 1994.

2 William Ferguson, *Scotland: 1689 to the Present* (Edinburgh: Oliver & Boyd, 1968), p.425.

3 For full details of the recent works of Scottish Studies mentioned in this article, and of other useful books, see sections A and B of my *Literature in Twentieth-Century Scotland: A Select Bibliography* (London: The British Council, 1995).

4 Duncan Macmillan, *Scottish Art 1460–1990* (Edinburgh: Mainstream, 1990), p.8.

5 John Purser, *Scotland's Music* (Edinburgh: Mainstream, 1992), pp.11 and 20.

6 Edwin Morgan, *Nothing Not Giving Messages: Reflections on Work and Life*, (ed.) H. Whyte (Edinburgh: Polygon, 1990), p.141.

7 P.H. Scott, *Scotland: A Concise Cultural History* (Edinburgh: Mainstream, 1993), pp.10, 12, and 13.

8 Robert Crawford, 'Bakhtin and Scotlands', *Scotlands*, issue 1, 1994.

9 Jude Burkhauser (ed.) *'Glasgow Girls': Women in Art and Design 1880–1920* (Edinburgh: Canongate, 1990); Leah Leneman, *A Guid Cause: The Women's Suffrage Movement in Scotland* (Aberdeen: Aberdeen University Press, 1991); Douglas Gifford and Dorothy McMillan (eds), *A History of Scottish Women's Writing* (Edinburgh: Edinburgh University Press, forthcoming).

Cymru or Wales?: explorations in a divided sensibility

KATIE GRAMICH

> Britishness is a mask. Beneath it there is only one nation, England.[1]

Although the publicly announced beliefs of the eminent Anglo-Welsh poet R.S. Thomas cannot generally be held to be shared by the majority of his compatriots, his rejection of the term 'British' is by no means extremist or unrepresentative in the Welsh context. Surveys have shown that the majority of people who live in Wales, even in the most Anglicized or border regions, will identify themselves as 'Welsh' rather than as 'British'. The proportion of Welsh speakers who reject the designation 'British' is, predictably, higher than that of non-Welsh speakers. Nevertheless, the willingness to be identified as 'British' is not dependent on linguistic factors only, but is strongly linked to the geographical territory inhabited by a given group. This fact has led one sociologist, Denis Balsom,[2] to construct a 'Three-Wales Model' of the country, based on his analysis of survey questions on language and perceptions of identity. The model posits a tripartite division of the country into territories designated as follows: 'British Wales', 'Welsh Wales', and 'Y Fro Gymraeg' (the mainly Welsh-speaking area). In this study, the designation 'British' is evidently used to indicate an attenuated sense of a distinctively Welsh identity, as the statistics quoted in the study show. The territory covered by 'British Wales' is, in the main, a wide border country, which might be expected to exhibit the division of identity which the habitation of a border implies. Nevertheless, this rather negative usage of the term 'British' in the Welsh context is not universally accepted, even in Wales. Some scholars, such as the historians Dai Smith and Linda Colley, accord a much more

positive image to the term 'British'; in his influential study
Wales! Wales? (1984) Smith argues persuasively that the Welsh
in the present century are characterized by a dual sensibility,
one 'Welsh', one 'British', and to deny the existence of that
duality is to deny the validity of 'the historical experience of
unity found in the description of themselves as "British" by
working people in strikes, unions, depression and war'.[3] The
focus on 'working people' is, of course, not accidental; Smith's
view may be taken as a fairly typical left-wing internationalist
one not dissimilar to that of the English historian Eric Hobs-
bawm, although in Smith's case obviously owing something to
the socialist ethos of his Rhondda background. As such, his
view is utterly opposed to that of the Welsh Nationalist, R.S.
Thomas, although the official Welsh nationalist party, Plaid
Cymru, is nowadays a thoroughly socialist and European-
focused institution. It was not always thus.

Indeed, it was not always thus in many ways. Welsh hostility
towards the notion of Britishness is bound up with the per-
ceived and real hegemony of England within the British state,
and also with the legacy or burden of empire. It is in the latter
context that Welsh duality becomes truly schizophrenic. It is,
of course, not a new idea that the Celtic countries: Wales,
Scotland and Ireland, were in fact the first British colonies;
historical and cultural similarities in their situations and those
of more overtly colonized places, such as the Caribbean, tend
to support this contention. It is, however, a highly sensitive area
of discourse for, as Ned Thomas has pointed out in his study
of Derek Walcott,[4] Wales was also, as part of Britain, a
colonizer, and therefore a participant in the oppression of other
peoples. This means that it is potentially insulting to allege that
Wales, too, is a colony: compared with the enormity of slavery,
the oppression of Wales has been a paltry thing. But it is still
going on. Other casualties of Empire can have a post-colonial
culture; what can we really claim to have in Wales except a
colonial one?

Arguably, the political test of the Welsh divided sensibility
came in 1979, with the Devolution Referendum in Wales,
which received a resounding no vote from the Welsh; on the
face of it, this could be interpreted as the British identity
overcoming the distinctively Welsh identity. Many nationalists
went into mourning; others lashed out at what they perceived

as their compatriots' cowardice. A book such as *Diwedd Prydeindod* (*The End of Britishness*) (1981) by the former leader of Plaid Cymru, Gwynfor Evans, is, it seems to me, a direct result of the Devolution debâcle, and constitutes a virulent and eloquent attack on Britishness, on the Labour Party in Wales, and on Neil Kinnock in particular! Evans's words sound remarkably similar to those of R.S. Thomas:

> Beth yw Prydeindod? Y peth cyntaf i'w sylweddoli yw mai gair arall ydyw am Seisnigrwydd; gair gwleidyddol, a gododd o fodolaeth gwladwriaeth Brydeinig, sy'n ymestyn Seisnigrwydd dros fywyd y Cymry, y Sgotiaid, a'r Gwyddelod.Os gofynnir beth yw'r gwahaniaeth rhwng diwylliant Seisnig a diwylliant Prydeinig sylweddolir nad oes ddim gwahaniaeth. Yr un ydynt. Yr iaith Brydeinig yw'r iaith Saesneg. Addysg Brydeinig yw addysg Saesneg. Teledu Prydeinig yw teledu Saesneg. Y wasg Brydeinig yw'r wasg Saesneg. Y Goron Brydeinig yw'r Goron Seisnig, a brenhines Prydain yw brenhines Lloegr. Cyfansoddiad Prydain yw'r hyn a alwai Dicey, y prif awdurdod arno, 'the English constitution'. Y Senedd Brydeinig yw'r hyn a elwir yn nheitl cyfrol awdurdodol Kenneth Mackenzie, *The English Parliament*. Yr iaith Saesneg yw'r unig iaith a ganiateir yn honno. Nid oes cyfraith Brydeinig – dim ond cyfraith Seisnig a Sgotaidd. Seisnigrwydd ydyw Prydeindod.[5]

(What is Britishness? The first thing to realize is that it is another word for Englishness; it is a political word which arose from the existence of the British state and which extends Englishness over the lives of the Welsh, the Scots and the Irish. If one asks what the difference is between English culture and British culture one realizes that there is no difference. They are the same. The British language is the English language. British education is English education. British television is English television. The British Press is the English Press. The British Crown is the English Crown, and the Queen of Britain is the Queen of England. The British Constitution is called by Dicey, the main authority on the subject, 'the English Constitution'. The British Parliament is that which is termed in Kenneth Mackenzie's authoritative book, *The English Parliament*.The English language is the only language it is permitted to speak there. There is no British

Law – there is only English and Scottish Law. Britishness is Englishness.)

If Gwynfor Evans and R.S. Thomas sound extreme in their positions, it is perhaps mainly because they are making overt political statements and averring their commitment to a particular definition of Welsh identity. Historians who oppose nationalism in whatever form and adopt a so-called constructivist view of identity, particularly cultural identity, tend to conceal their politics beneath a coat of rationality and liberalism. It has become a truism that cultural identity is a construct, a projection, an invention, to use the term preferred by Hobsbawm.[6] This constructivist view of identity and tradition has largely displaced the essentialist view, but it is important to remember that the Hobsbawmian model is not ideologically neutral. It reveals a fairly crude English left-wing bias against all forms of nationalism, which tend to make their initial political appeal in essentialist terms.

At the opening of his recent polemical essay *Cymru or Wales?*, R.S. Thomas states:

> We are familiar in life with the tyranny of 'either or'. There are certain combative people who try to corner us by asking: 'Which is it, yes or no; black or white?' It can also be the ploy of simplistic persons. 'Come on,' they urge, 'it must be one or the other'; whereas more astute people realise how many shades of grey there can be between black and white. Nevertheless, I chose my title because I cannot in this context see a third or fourth condition. Cymru or Wales; there is nothing between.[7]

In the typically contrary and perhaps mischievous way which is characteristic of him, R.S. Thomas thus calls into question the validity of binary thought while making it fundamental to his argument! We see also that between 1985 and 1992 R.S. Thomas's political stance has become more radical: no longer does he feel it necessary to discredit the notion of British identity – now he goes much further by claiming that the only truly Welsh identity is that of the Cymro or Cymraes – the Welsh speaker. As he says: 'To those of us who speak the Welsh language, that is *Cymraeg*, there is no such entity as Wales. This land in which we live is *Cymru*.'[8]

There are many kinds of division in Welsh cultural and political life. Even such an early commentator as the twelfth-century writer Gerallt Gymro (Giraldus Cambrensis) remarked upon the internal divisiveness of the Welsh, lamenting, since he was partly Welsh himself, 'If they would be inseparable, they would be insuperable.'[9] Some, like Dai Smith, see the main division as being between Welsh and British identities but, as R.S. Thomas's comments show, there are perhaps more funda-mental self-divisions than that in the Welsh psyche, colonized and historically conditioned as it is. In my view, the most damaging split is that between what Balsom calls 'Welsh Wales' and 'Y Fro Gymraeg'; there is a great deal of hostility and suspicion on both sides. While the inhabitants of Y Fro Gymraeg (including R.S. Thomas, though few are as extreme as him) tend to regard the Anglo-Welsh of the Valleys as not truly Welsh, the Anglo-Welsh tend to be indignant at this aspersion, reiterating their Welsh identity and hardening themselves against the Welsh language. It must be said, though, that active hostility towards the language in the south is less common today than, say, twenty years ago, although there are still areas, such as South Pembrokeshire, where the Welsh language is regarded by many as something quite alien and, indeed, irrelevant.

Binary oppositions of all kinds tend to be discredited and dissolved in post-Structuralist theory. Obviously we can see the strategic importance of such a practice in, for example, feminist theory, where the binary oppositions which have functioned as the buttresses of the patriarchal system of oppression are deliberately smashed. To return to a dialectical way of thinking may therefore appear wilfully naïve or reactionary. At first sight, though, the cultural situation of Wales does seem in-eluctably divided: north versus south, Welsh versus English, town versus country, industry versus agriculture, chapel versus pub, and so on. Such dualism seems to pervade Welsh culture: is it apparent or real? Edward Said has argued[10] that binary oppositions are a prerequisite of imperialist thought, since the latter needs the idea of the Other in order to sustain and extend its power. I suggest that it might be possible to apply this argument to Wales: the reason that the binary model is still so strong in Wales is that it is still a colonized country, subject to imperialist ways of thinking.

Yet there is room for dissent and subversion within that

colonial scheme: in Wales a revitalized literary culture in both languages is currently destabilizing the old binary order. Movement outside one's own language group is often a way of reforging one's literary identity, of reinventing it, if you will. Arguably, this process is going on at the moment in avant-garde Welsh literature, such as the novels of Robin Llywelyn,[11] which draw heavily upon German and Irish models, as well as the native Welsh tradition. R.S. Thomas has taken the Welsh to task for their obsession with ancient history; we are a people given to 'warming our hands at the red past',[12] but it could be argued that turning our backs on it or, worse, shrugging our shoulders over it, is a recipe for cultural destitution. Moreover, as Ned Thomas has pointed out:

> the suppressed group carries within it the sense of history; it cannot but feel the pressure of historical movement, historical direction. While the comfortable, adjusted social group can live in the present, we have to live in the past and in the future for the consciousness of suppression has implicit in it the notion of liberation and emergence.[13]

Experimental works like those of the contemporary novelists Robin Llywelyn, Mihangel Morgan, Wiliam Owen Roberts, Angharad Tomos and Chris Meredith, the dramatist Ed Thomas, and the poets Gillian Clarke, Menna Elfyn and Gwyneth Lewis, show that awareness of cultural tradition need not necessarily be essentialist or conservative. But nor is that tradition monolithic or homogeneous; each of the authors mentioned projects a different configuration of cultural identity and these configurations, in turn, constitute not binary opposites but a series of intersecting circles, like fish scales, whose scintillations and iridescence are a more apt metaphor of Welsh identity than any bald binary model. *Pace* R.S. Thomas, Wales does exist, as does Cymru, both within and outside that invented institution Britain. As Dai Smith puts it, 'Wales is a singular noun but a plural experience.'[14]

I have mentioned above a number of Welsh writers whose creative work is in English, including R.S. Thomas himself: these writers used to be given the label Anglo-Welsh, but most have now rejected that term, for 'hyphenisation is betrayal'.[15] Despite R.S.Thomas's self-flagellating derogation of the Anglo-Welsh, these writers bear witness in an inventive and often

defiant way to the experience of cultural dispossession. It could be argued that Welsh writing in English is a literature of internal exile or a deterritorialized literature, but it obviously differs from other writings that are usually described in this way – such as Persian literature written by exiles in the United States, for example – in that these Welsh writers are ostensibly at home and writing in their mother tongue. And yet many have expressed a sense of loss and of self-alienation, as in this bitter poem by R.S. Thomas:

> Why must I write so?
> I'm Welsh, see:
> A real Cymro,
> Peat in my veins.
> I was born late;
> She claimed me,
> Brought me up nice,
> No hardship;
> Only the one loss,
> I can't speak my own
> Language – *Iesu*,
> All those good words;
> And I outside them,
> Picking up alms
> From blonde strangers.[16]

Even when such writers learn Welsh, as R.S. Thomas has done, there is a residual sense of having been cheated and of having missed out. Again, it is only fair to add that this poet's anguish is not exactly representative; a poet like Gillian Clarke, for example, is much more likely to be celebratory than angst-ridden, as evidenced in her acclaimed recent collection *The King of Britain's Daughter*[17] (Clarke is moreover reclaiming Britain here for the Welsh). Interestingly, Welsh speakers, as an embattled minority (just under 20 per cent of the population), can also feel like exiles in a land which is becoming over-whelmingly Anglicized, even in the most remote areas. R.S. Thomas, again, testifies to this: 'I live in Llŷn, where . . . English is hardly ever used by my friends and neighbours in their daily association with me and one another. But to move far is to be haunted by the spectre of the ghetto. It is possible to be an exile in one's own country and to receive short shrift, too.'[18]

Hitherto, I have been quoting mainly from male authors' views of Wales, and perhaps this is apt since stereotypical views of Wales and of Welsh cultural identity are overwhelmingly male, indeed macho. The historian Deirdre Beddoe put her finger on it in 1986 when she wrote: 'Welsh women are culturally invisible.'[19] The very frequency with which Beddoe's words have been quoted in the past dozen years or so suggests that the situation is changing. A recent collection of feminist essays, *Our Sisters' Land: The Changing Identities of Women in Wales* (1994) is an eloquent testimony to the growth of feminism within Wales, which has often gone hand in hand with the Welsh language campaign. One of the contributors, Menna Elfyn, who is regarded by many as the foremost contemporary poet in the Welsh language, states the following:

> Searching for wholeness in a world that marginalizes and divides one into Welsh, woman, poet, requires a great deal of questioning and contemplation. Those who speak Welsh and have tried to live their lives through their mother tongue will perhaps be able to recognize how similar their situation is to that of 'woman'. Both groups are relegated to second-class citizenship, yet both are now struggling to transform the system which tries to disempower them.[20]

It is perhaps a sign of culturally changed times that Elfyn's contribution to this fine volume also includes one of her poems translated into English by none other than R.S. Thomas himself. It seems that, for many of these writers, the notion of Britain is an irrelevance which is superseded by much more powerful bonds of attachment, such as the sisterhood of international feminism, or the Green movement, or even a re-invigorated, feminized Christianity.

While the poets have their own agenda, the historians tend, on the whole, to pay more attention to Britishness, perhaps partly because they are aware of the history of the term itself, which was originally and surprisingly the property of the Welsh. As Gwyn Alf Williams puts it: 'We Welsh look like being the Last of the British. There is some logic in this. We were, after all, the First.'[21]

Indeed, if we glance at a compilation such as Meic Stephens's *A Most Peculiar People: Quotations about Wales and the Welsh*, we see that the first use of 'Welshman' is, tellingly, in the *Anglo-Saxon*

Chronicle. Before this, and also continuing right up to the nineteenth century in some contexts, references to the Welsh are to the 'Britons'. The first entry, from Julius Caesar's *Commentarii de Bello Gallico* (51 BC) refers to the 'Britons,' that is the Welsh. Some Celtophiles have become quite irate at the perceived spoliation of the term 'British' from its rightful owners, the Welsh: witness the fulminations of J.R.R. Tolkien:

> In modern England the usage [of 'British'] has become disastrously confused by the maleficent interference of the Government with the usual object of Governments: uniformity. The misuse of 'British' begins after the union of the crowns of England and Scotland, when in a quite unnecessary desire for a common name the English were officially deprived of their Englishry and the Welsh of their claim to be the chief inheritors of the title British.[22]

Gwyn Alf Williams's well-known assertion that 'the Welsh make and remake Wales' over and over again throughout the centuries and will continue to do so 'if they want to'[23] manages to be both a memorable statement of the constructivist view of national identity and a strongly nationalistic challenge. Williams, moreover, suggests that 'Welsh identity has constantly renewed itself by anchoring itself in variant forms of Britishness.'[24] Linda Colley seems to assent to this when she says in her book *Britons: Forging the Nation 1707–1837* that 'we can plausibly regard Great Britain as an invented nation superimposed, if only for a while, onto much older alignments and loyalties.'[25] However, Colley tends to present this fusion as a consummation devoutly to be wished, and a benefit to all concerned. The Welsh feminist critic, Jane Aaron, questions this in her essay 'Seduction and Betrayal: Wales in Women's Fiction 1785–1810', which concludes that in these fictional representations of the Anglicization process:

> The Welsh peasantry is bereft by the seduction and removal of its nobility; that nobility, for all that it gains in increased power and status through its incorporation into the English establishment, is itself in imminent danger of being irretrievably alienated from its roots in the mother country.[26]

Alluding back to one of the texts she analyses, Elizabeth Gunning's 1797 novel *The Orphans of Snowdon*, Aaron concludes

that 'Both groups [Welsh peasantry and gentry] are, in a sense, orphaned by the historical development they are undergoing.'[27] Aaron is here adopting a different metaphor for the Welsh condition, which has generally been described in the past – mainly by male writers – as a state of physical mutilation, 'a torn consciousness',[28] in Ned Thomas's words. English commentators understandably tend to regard the imposition of English as an immeasurable gain for the colonized; this may seem to be a dated assertion, applicable to Matthew Arnold but not to twentieth-century Englishmen, who are surely more enlightened? E.J. Hobsbawm's 1989 work *Nations and Nationalism since 1780* reveals clearly that the spirit of Arnold is by no means dead: not only does Hobsbawm quote the notorious 1847 Blue Books Report on the state of education in Wales as if its denunciation of the inadequacies of the Welsh language were historically accurate, but he suggests that 'Welsh language enthusiasts . . . are even now devising Cymric place names for places which never had any until today.'[29] The elegance of the snub is in the very choice of the word 'enthusiast'!

Such 'enthusiasts', mainly members of Cymdeithas yr Iaith Gymraeg (The Welsh Language Society) have won notable victories in the thirty years of their existence. One of the most significant was the founding of a Welsh language television channel, S4C, in the 1980s. By 1995, however, 'Y Sianel' (The Channel) had become the focus of debate and disillusionment, despite the fact that it is run from within Wales by and ostensibly for Welsh speakers. Many Welsh people are by now wringing hands and quoting Yeats: 'Was it for this . . .?' It is by no means unusual to find on a particular evening, while Channel 4 is screening, for example, *Out*, a gay and lesbian magazine programme, that S4C is showing *Rasus*, 'a series about trotting' that is, horse-races, presented by a farmer-turned-TV personality, Dai Jones. True, *Out* may be shown later on S4C, but much, much later: after midnight, to be precise. Is it fair to draw some conclusions from this? The Welsh language programming on S4C tends to target a middle-aged audience with distinctly low-brow tastes and strong agricultural interests, politically incorrect and culturally undiscriminating. *Noson Lawen*, for instance, is a typical light-entertainment programme which is sadly amateurish, stars entertainers who tend to be well over fifty, and thrives on

humour of sexual innuendo and the most unregenerate sexism.
The innuendo is not even sophisticated enough to be camp.
Often, programmes of this nature are broadcast when popular
feminist programmes featuring Germaine Greer and her like
are being seen on Channel 4. The assumption on S4C, despite
evidence to the contrary, seems to be that Welsh women are
not interested in feminism, that it is something alien and
English. Similarly, gay and lesbian people, it is assumed, are
unlikely to be Welsh speaking, so programmes targeted at this
audience may be relegated to the early hours of the morning.
(One of the essays in *Our Sisters' Land*, 'Welsh Lesbian Feminist:
A Contradiction in Terms?' by Roni Crwydren,[30] confirms the
prevalence of such homophobic prejudice.) One might also
suspect that this timing is a veiled censorship: consigning
potentially 'corrupting' sexual material to a very safe time-slot,
when all the good, Welsh-speaking *werin* (folk) will certainly be
tucked up with their hot-water bottles, if not with their Bibles.

Watching S4C is a strange, disorienting experience because
the Welsh programmes are constantly interrupted by English
advertisements. *Dysgwr y Flwyddyn* (*Welsh Learner of the Year*), a
worthy and mildly engaging programme broadcast annually on
S4C, shows interviews with admirable and enthusiastic indi-
viduals who have mastered the language and speak eloquently
about the need to foster the Welsh language and its culture;
suddenly their words may be unceremoniously drowned by an
urgent announcement: 'Toilet Duck is back!'

The problem is, partly, that there is only one Welsh language
channel. What if there were only one English language channel
in Britain? It would no doubt consist entirely of soap operas,
game and quiz shows and 'light entertainment', the Engish
equivalent of *Noson Lawen* but slicker and blander, with bigger
prizes and better make-up.

And what about the 80 per cent of Welsh people who don't
speak Welsh? S4C certainly makes no attempt to speak to them;
its English programmes are no different from those shown on
English channels. There are very few programmes on the BBC
or ITV which are specifically aimed at a Welsh audience.
Sometimes there are even bizarre anomalies: for example,
series of plays by contemporary Welsh authors being shown on
HTV West but not on HTV Wales. The *Radio Times* has a
special edition covering the West and Wales; programmes for

the West Country are invariably listed first, followed by those for Wales. One wonders what the rationale for this might be. Alphabetical order has evidently been abandoned in favour of a more politically advantageous order. Are there more viewers in the West Country, so that precedence is given to the majority? Or are English viewers simply more important than Welsh ones, at least to an editor sitting comfortably in Wood Lane, W12? The titles of Welsh programmes on S4C are, moreover, often hilariously misspelt by the *Radio Times*; it seems to have particular difficulty with the circumflex sometimes found over Welsh vowels, for example 'Pêl-Droed' (Football) is invariably rendered by the *Radio Times* as 'Pjl-Droed'.

As the above comments show, the invisibility of Wales as a separate cultural, if not a political, entity is a constant source of annoyance to the Welsh. Much of R.S. Thomas's polemic in *Cymru or Wales?* is devoted to cataloguing outrageous instances of Welsh servility in the face of English ignorance or superciliousness.

One thing which tends to diminish the notion of Wales as a separate entity is the ubiquitous practice of combining England and Wales together as a single unit, which it is all too easy to abbreviate conveniently by omitting the second element. We are still little further forward than the Edwardian *Encyclopaedia Britannica* entry: 'For Wales, see England.'[31] Even the television weather reports speak of meteorological conditions in 'EnglandandWales', while virtually all government statistics also cover the same strange territory. Never, never is this land called 'WalesandEngland', not even in the weather reports where it might make logical sense: most of our weather seems to come from the west, reaching Wales first, but the rain is always deemed to fall on 'EnglandandWales'.

The invisibility of Wales as a separate place is also gallingly evident in the rest of Europe. In Germany, for instance, GroßBritannien and England are usually taken to be synonyms; while in Spain, Inglaterra similarly covers the whole of the British Isles, despite the fact that there is a perfectly good Spanish term for Wales, el país de Gales. Many Welsh people, I'm sure, have, like myself, had the guilt-inducing experience of calling themselves British, just to avoid the complications of having to explain again where and what Wales is. Sometimes, in European countries like Spain and France which have

oppressed and increasingly militant ethnic groups, such as the Basques and the Bretons, it is simply not wise to labour the point of a distinctly Welsh identity. Nevertheless, in the context of teaching British Studies abroad, there is much to be said for drawing parallels between the Welsh within Britain and the experience of minority cultures within the 'home' state. A consideration of the condition of Wales could also be incorporated into an exploration of the break up of empire, the experience of colonization and decolonization. As Ned Thomas has shown in his study of the poetry of Derek Walcott from a distinctively Welsh perspective, there is much to be gained from examining literary parallels among colonial and post-colonial texts from different territories, and these parallels are not confined to the thematic level but extend also to fundamental similarities in the use and strategic abuse of language.

The current relative lack of understanding of Wales in continental Europe is, however, as nothing compared with English ignorance of Wales and Welsh culture, which is often quite startling, considering our uncomfortable proximity to each other. British Studies courses focusing on Wales, Scotland and Ireland should be pioneered in English schools; English schoolchildren should automatically be offered the opportunity of learning Welsh and Gaelic at GCSE and A Level. But at present this is an idle fantasy; its realization would perhaps entail the recreation and redefinition of 'Britain' as a cultural and political entity.

In the past, American commentators, such as T.S. Eliot, have often been more appreciative of Celtic difference, but nevertheless reveal their Anglocentricity by viewing what the Celt possesses as a potential contribution to English culture:

> It would be no gain whatever for English culture, for the Welsh, Scots and Irish to become indistinguishable from Englishmen – what *would* happen, of course, is that we should all become indistinguishable featureless 'Britons', at a lower level of culture than any of the separate regions. On the contrary, it is of great advantage for English culture to be constantly influenced from Scotland, Ireland and Wales.[32]

There is no doubt that English culture has been enormously influenced by Scotland, Ireland and Wales, but that is the proper subject of enquiry for English scholars or, possibly,

scholars in British Studies. Welsh Studies must turn its attention to itself initially and not to the ways it has infiltrated neighbouring cultures. Of course, if R.S. Thomas is right, there is no such thing as Welsh Studies, since Wales no longer exists. But few would agree with Thomas's position: the culture of Wales *is* diverse, and does not consist solely of the Welsh language and literary tradition. There is more than the language to distinguish us, although many feel that the situation of the language is now so critical that the only honourable role that Welsh Studies can play is as 'a stepping-stone back to the vernacular'.[33]

Notes

1 R.S. Thomas, 'Undod', the J.R. Jones Memorial Lecture, 9 December 1985: translated as 'Unity' by K. Gramich, *Planet*, vol. 70 (Aug/Sept 1988), pp. 29–42; also reprinted in *R.S. Thomas: Selected Prose*, ed. Sandra Anstey (Bridgend: Seren Books, 1995), pp.143–58.

2 Denis Balsom, 'The Three-Wales Model', in John Osmond (ed.), *The National Question Again: Welsh Political Identity in the 1980s* (Llandysul: Gomer Press, 1985), pp.1–17.

3 Dai Smith, *Wales! Wales?* (London: Allen & Unwin, 1984), p.168.

4 Ned Thomas, *Derek Walcott: Bardd yr Ynysoedd/Poet of the Islands* (Cardiff: Welsh Arts Council, 1980).

5 Gwynfor Evans, *Diwedd Prydeindod* (Talybont: Y Lolfa, 1981), p. 13 (my translation).

6 Eric Hobsbawm and Terence Ranger (eds), *The Invention of Tradition* (Cambridge: Cambridge University Press, 1983).

7 R.S. Thomas, *Cymru or Wales?* (Llandysul: Gomer Press, 1992), p. 5.

8 Ibid., p. 6.

9 Giraldus Cambrensis, *Descriptio Kambriae* (1193), quoted in Meic Stephens (ed.), *A Most Peculiar People: Quotations about Wales and the Welsh* (Cardiff: University of Wales Press, 1992), p.7.

10 Edward Said, *Orientalism: Western Conceptions of the Orient* (London: Routledge, 1978).

11 Robin Llywelyn, *Seren Wen ar Gefndir Gwyn* (Llandysul: Gomer Press, 1992); *O'r Harbwr Gwag i'r Cefnfor Gwyn* (Llandysul: Gomer Press, 1994). *From Empty Harbour to White Ocean*, the author's translation of the latter novel, has recently been published by Parthian. Of the other Welsh language writers mentioned later only the work of William Owen Roberts has been translated into English: his novel *Y Pla* is available in English translation, as *Pestilence*, and in German

as *Der schwarze Tod*, published by List Verlag, Munich. A Dutch translation is currently being prepared. Angharad Tomos's novel *Si hei lwli* is being translated into German at present. For the work of Menna Elfyn, see note 20 below. Chris Meredith, Ed Thomas and Gillian Clarke publish their work in English, and texts are readily available. Seren Books publish Meredith's and Thomas's works, Carcanet publish Clarke's. Gwyneth Lewis's first collection of poems in English, *Parables and Faxes*, was recently published by Bloodaxe.

12 R.S. Thomas, 'Welsh History' in *Collected Poems 1945–1990* (London: Dent, 1993), p.36.

13 Ned Thomas, *The Welsh Extremist: Modern Welsh Politics, Literature and Society* (Talybont: Y Lolfa, 1991), p.121.

14 Dai Smith, op. cit., p.1.

15 R.S. Thomas, *Cymru or Wales?*, op. cit., p.30.

16 R.S. Thomas 'Welsh', in *Welsh Airs* (Llandysul: Gomer Press, 1987), p.19.

17 Gillian Clarke, *The King of Britain's Daughter* (Manchester: Carcanet Press, 1993).

18 R.S. Thomas, *Cymru or Wales?*, op. cit., p.28.

19 Deirdre Beddoe, 'Images of Welsh Women', in Tony Curtis (ed.), *Wales: The Imagined Nation* (Bridgend: Seren, 1986), p.227.

20 Menna Elfyn, 'Writing is a Bird in Hand', in Jane Aaron, Teresa Rees, Sandra Betts and Moira Vincentelli (eds), *Our Sisters' Land: The Changing Identities of Women in Wales* (Cardiff: University of Wales Press, 1994), p.284. Menna Elfyn has published two bilingual volumes, namely *Eucalyptus* (Gomer Press) and *Cell Angel* (Bloodaxe).

21 Gwyn Alf Williams, *The Welsh in their History* (London: Croom Helm,1982), p.190.

22 J.R.R. Tolkien, 'English and Welsh' in *Angles and Britons* (1963) quoted in Meic Stephens op. cit., p.133.

23 Gwyn Alf Williams, *When was Wales?* (Harmondsworth: Penguin, 1985), p.304.

24 Gwyn Alf Williams, *The Welsh in their History*, op. cit., p.194.

25 Linda Colley, *Britons: Forging the Nation 1707–1837* (New Haven: Yale University Press, 1992), p.5.

26 Jane Aaron, 'Seduction and Betrayal: Wales in Women's Fiction 1785–1810', *Women's Writing*, vol. 1, no. 1, 1994, p.74.

27 Ibid.

28 Ned Thomas, *The Welsh Extremist*, op. cit., p.123.

29 E.J. Hobsbawm, *Nations and Nationalism since 1780* (Cambridge: Cambridge University Press, 1990), p.112.

30 Aaron *et al.*, *Our Sisters' Land*, op. cit., pp.294–300.
31 Meic Stephens, op. cit., p.70.
32 T.S. Eliot, 'Unity and Diversity: the Region', in *Notes Towards the Definition of Culture* (1948), quoted in Meic Stephens, op. cit., p.109.
33 R.S. Thomas, *Cymru or Wales?*, op. cit., p.30.

8

A view of the present state of Irish Studies

SABINA SHARKEY

Introduction

In broaching the subject of Irish Studies I would like to begin by suggesting that there is neither a global concept nor a single canon available to us. Instead, we are working with emerging formations which map out the terrain in specific ways. We can probably agree that what constitutes Irish Studies in Ireland is different from what constitutes it in Britain, in European academic institutions, in America, Australia and other parts of the Irish diaspora. Just as any syllabus or canon formation can be usefully examined rather than unthinkingly adopted, so too the differences between what constitutes Irish Studies in these disparate areas are in themselves an interesting object of enquiry. While there are relational links and significant overlap in terms of subject area and methodology, it is highly question-able whether we can attempt to extract any skeletal, essentialist core of Irish Studies.

From other contributions to this volume, the reader may notice that there are many variables affecting Cultural Studies. Different histories in terms of disciplinary or interdisciplinary developments need to be addressed as do the specific relations of the various learning constituencies. We have seen that there is no authoritative consensus regarding what constitutes either Cultural Studies or British Cultural Studies. Proponents of

Cultural Studies have deliberately resisted demands for defini-
tion, preferring instead to proclaim it a process-orientated
activity. British Cultural Studies can also be viewed in a similar
way. So, too, can Irish Studies, where the object of study is the
construct we term 'Ireland'.

This chapter is delimited in two ways: first I make no attempt
to define Irish Studies and, second, I focus on the geographic
areas of which I have most direct experience: Ireland and, more
recently, Britain. The chapter should be viewed within a
dialogue or conversation about what constitutes Irish Studies.
My contribution will be to offer some thoughts about the
development of Irish Studies in Ireland, and then more par-
ticularly in Britain, with a consideration en route of its relation
to Cultural Studies and, more specifically, to British Cultural
Studies.

Irish Studies in Ireland

In Ireland the area of Irish Studies has frequently been
collapsed into the teaching of Irish language (*An Gaeilge*, known
in translation as Gaelic) or of literature in Gaelic or English.
This highly specific interpretation is hardly surprising within a
community of learning where component areas of the study of
Ireland were traditionally taught within single disciplines such
as Irish history, economics or literature. More recently how-
ever, and particularly from the 1980s onwards, a more multi-
disciplinary approach has also developed, as exemplified by key
pioneering texts such as Brown (1985), Bartlett *et al.* (eds),
(1988) and Kearney (ed.) (1988). Influenced by contemporary
developments in critical and cultural studies, this newer focus
has benefited both nationally and internationally from a degree
of border traffic between disciplines and from acknowledging
a plurality of Irelands.

Irish Studies in Britain

In the past there have been almost notoriously two strands of
Irish historiography in Britain, an Irish tradition produced
predominantly by and for an internal community, and another
by and for an external, hostile grouping with designs upon Irish
terrain. The latter tradition, generally considered British and

colonialist, is regarded as having been inaugurated by Giraldus Cambrensis (Gerald of Wales) in the twelfth century. At various stages up to the last century these two strands ran in uneasy parallel making consistent attempts to ignore one another but being nonetheless connected in their processes of selection and representation. In recent times there has been some recognition of the interrelationship between the two strands, in contrast with earlier insularities. These days it is not as easy as it once was for an Englishman to be represented as an SUL (stiff upper-lip) of pure Anglo-Saxon origin nor can the Irishman be paraded as pure, dreaming Celt. The old habit of mutual dismissal of the Other is being replaced. Thus in British Studies the role of Ireland in the construction of aspects of Britishness has begun to receive attention while the influence of Britain in the maintenance of aspects of Irish identity is considered within Irish Studies. Given that we have here a sense of discursive as well as geographic proximity, it is not altogether surprising that Irish Studies as developed in Ireland and Britain share some salient features. In many cases, for example, the study has been developed through an expansion from a base in Irish literary studies to include elements of sociology, political science and history. However, the differences resulting from the subject's location in a British context need further clarification.

In Ireland the constituent disciplines were anchored locally, refracted through a lens that made Ireland the locus of enquiry. In Britain, likewise, local refractions have resulted in a British-centred focus within economics, history, sociology or literary studies. With the term *British* under contemporary scrutiny, we are beginning to have a sense of how categories such as Scots, Welsh or Irish within or adjacent to Britain were constructed in order to advantage the dominant group. Part of what is being attempted by Irish Studies in Britain is a process of recognition and reappraisal of past inequities. Strategies of incorporation and enforced assimilation within certain disciplines have resulted in widespread ignorance about Ireland. For example, the traditional canon of English literature can be found to include Swift, Edgeworth, Joyce, Yeats, Beckett and, more recently, Seamus Heaney. When an author such as Heaney is still alive, the opportunity to demur a little presents itself. His response to inclusion in an anthology entitled *The Penguin Book of*

Contemporary British *Poetry* (my emphasis) is stated in 'An Open Letter' (1983):

> I hate to bite
> Hands that led me to the limelight
> In the Penguin book, I regret
> The awkwardness.
> But British, no, the name's not right
> Yours Truly, Seamus.

Canon formation of the older empire-building sort produced a fine display of writers depicted as DWEMs (dead white English males) regardless of their origins or allegiances. However, suppressing difference in this way resulted in aspects of these incorporated authors' works being played down in the interests of incorporation into the canon. In other disciplines Ireland was presented in fairly static ways, looked at only as a problem area for territorial governance in political history for example, or ignored because of the operation of constructed disciplinary paradigms. Though the Irish are the second largest (largest if one includes Northern Irish) and the oldest ethnic minority community in Britain, Hickman and Walters (1995) have noted their consistent absence from many areas of sociological enquiry into the constituent communities of Britain.

This leads to the evident conclusion that the Irish will not feature much in any statistical enquiry if they are not included as a category for the process of data collection in the first place. Where they have no profile, then both their needs and their contribution to the community can be ignored. Their agency can be discredited and their statements about the needs of vulnerable sections of their community such as the elderly, homeless or the mentally ill can be decried on the basis that there is no research to support any claims of special needs. Omission at the broadest levels, such as in the collection and interpretation of government census records, to the more specific, as in the take-up of statutory services at local level in Britain, has resulted in the Irish becoming an invisible minority. On the subject of patterns of migration, which is of key interest to Irish Studies both inside and outside Ireland, Hickman and Walters note that a Whiggish assimilationist approach has been the traditional way in which sociologists have until recently approached the phenomenon and history of

Irish migration to Britain. This has resulted in a failure to study these phenomena, and in consequence the Irish in Britain appear inconsequential (Hickman and Walters, 1995, p.6). Against these studied indifferences and constructed invisibilities which have too often characterized British treatment of Ireland, Irish Studies in Britain is based upon an interdisciplinary programme which invites reappraisals of the past.

Being different . . .

The study of aspects of Ireland and Irish culture in Britain is a minority subject located within a culture that has oscillated between habits of ignorance and of incorporation. This has reproduced a climate of denial with regard to Ireland, offering merely a trajectory of assimilation to a British culture which has traditionally discredited what it terms 'Irish'. The history of the emergence of Irish Studies in Britain therefore involves issues of visibility and the pioneering agents of this history are worth noting. The Irish in Britain are a long resident, if not established, community, and Irish Studies has been a subject which has evolved in recent decades as part of their struggle against the dominant narratives (Hillyard, 1993; Curtis, 1984a and 1984b). The formal recognition of Irish Studies as an area of study, within A Level programmes and tertiary institutions (as well as extra-murally), has arisen in large part from the efforts of these Irish community groups since the 1960s. Their demand for, and organized delivery of, Irish Studies at extramural level created a foundation in Britain upon which the more recent programmes were developed. Here Irish Studies seems to share a similar history to the establishment of Cultural Studies in post-war Britain, where the impetus began within Workers' Educational Associations and the adult education sector generally and where, as the subject gained increased recognition, it soon also developed within academic contexts. One can now study for a diploma, undergraduate degree or an MA in a multidisciplinary Irish Studies programme within British universities. Additionally, some single-subject areas, such as History or English, now offer integral units specializing in Ireland.

Claiming a space: how to 'be' in this context?

Raising this question indicates another major difference between Irish Studies as developed in Ireland and outside. In Ireland the student may also pursue aspects of identity and examine behavioural patterns, and he/she does so from a context other than that of the study of a constituted minority subject. However, Irish Studies in Britain, as a minority and previously disregarded subject, faces the dilemma of how to avoid defensive positioning. It is important to face up to this dilemma, if Irish Studies is to be a *study* and not a missionary activity.

Or how not to be?

Listing

It seems to me that there are three potentially disabling positions for Irish Studies. The first is straightforward and involves defensive listing activities and canon formations. The usefulness of reappropriating Joyce, Wilde and Beckett from the English canon merely to produce an equivalent mapping of GIWs (great Irish writers) is questionable. The work of contemporary Irish cultural producers may be studied in terms other than those involved in mimicking the outdated modes of literary and cultural imperialisms. Historically, one may wish to consider these artists' relations to traditional genres and forms of expression, initially from within their particular locale. But what is *not* interesting about writers like Roddy Doyle, Mary Dorcey or Eavan Boland, filmmakers like Neil Jordan, mixed media artist Anne Tallentire or musicians such as Shane McGowan or Sinéad O'Connor is that they can be listed as so many great Irish personae who can 'prove' to 'outsiders' how gifted, clever or musical the Irish are. That they often articulate something about an Irish condition or culture may be interesting and it is for this reason rather than for the unreconstructed joys of chauvinism that we might direct ourselves to their music and art.

The Hoggart effect

The second self-defeating position bears some relation to the first, again in a context where it sites Irish Studies in a dialogue conducted in the main not within that community, but with one that is in part external and, until recently, antipathetic. A similar predicament has been faced by other groupings within Britain of course. There is the dilemma exemplified in a text such as Richard Hoggart's *The Uses of Literacy* (1957). This Ur-text of British Cultural Studies simultaneously aims to document, celebrate and interpret/explain an English working-class regional community for a differently constituted readership. The discontinuity between the subject material and the readership might be described by the title of one of Hoggart's own chapters, 'Us and Them'. In the space between us and them, the authorial function decodes for a readership in whom is invested the powers of cultural validation. 'Us' with the help of the narrator quickly learn to appreciate 'them', and 'they' are all the more improved by this act of recognition. The social historian E.P. Thompson's work on the English working class (1963) is seen as a project undertaken to rescue that group from 'the enormous condescension of posterity'. But, of course, there is also the condescension of the present to negotiate. How does one write about or teach a previously overlooked area without compromising either the material or the reader/learner? While *proud* of one's own identity group, one can still subscribe to dominant values which disadvantage it by choosing implicitly to recognize another group as the present arbiters of (more or better) value. This is what might be termed the Hoggart effect.

Blarney and all that

The third danger which can beset Irish Studies, particularly in the current climate of a new interest in, indeed almost a vogue for, Irish popular and high culture, is assenting to other static representations, particularly to positive stereotyping. Who has not heard that the Irish are a nation of talkers, or heard about their gift of the gab, blarney, the Terry Wogan factor, or encountered our great wordsmiths – Yeats, Joyce and Beckett, who work the language to breaking point and then revive it in eloquent, elegiac silences: 'Ireland's revenge', poor Ireland

starved into poetry? Brian Friel is a contemporary Northern Irish dramatist and a founder member of the influential Field Day Theatre Group. In his plays of the early 1980s he explores the allure of this sort of positive stereotyping while also investigating how it obfuscates other aspects of power relations, denies other forms of communication and how it may be resisted. *Translations* (1981), is set in the hedge-school of an imaginary townland of Baile Beag/Ballybeg, an Irish speaking community in Co. Donegal in 1833. There is an interesting exchange between Yolland, a British lieutenant posted there to aid the execution of a British official Ordnance Survey, and Hugh, the ageing village schoolmaster and poet. The survey involves Anglicizing place names (the subtext here being that this exercise in translation and cartography will aid in the regulation of the territory if not in its appropriation and reallocation). While engaged in the process, Yolland responds less like a colonial administrator than an enthusiast for all things local. He attempts to learn the language, admires the hedge schools and is impressed by the erudition of members of the community versed in Latin and Greek as well as Gaelic. But Hugh's response (*Translations*, p.42) to Yolland's compliment that the language is 'rich and ornate' is wry:

Hugh Indeed Lieutenant. A rich language. A rich literature. You'll find sir that certain cultures expend on their vocabularies and syntax acquisitive energies and ostentations entirely lacking in their material lives. I suppose you could call us a spiritual people.

Friel's schoolteacher is grappling with positive stereotyping here. The poet does not declaim; Hugh's resistance to interiorizing or performing the stereotype (as stage Irishmen have obligingly done from time to time) moves him to sarcasm instead. This is not directed solely at Yolland, a fairly easy target, but is also caustically self-critical in presenting a local facility with a language 'full of the mythologies of fantasy and hope and self deception – a syntax opulent with tomorrows. It is our response to mud cabins and a diet of potatoes; our only method of replying to . . . inevitabilities' (p.42). In the context of the play, under the discreet cloak of the term 'inevitabilities', lies the brute enormity of a British presence in Ireland, clearly acknowledged by Hugh but lightly glossed over since Yolland

is seen as a rather atypical cog in the colonial administration. From Hugh's perspective linguistic prowess may be charming but is hardly a consolation prize for powerlessness elsewhere and to be complimented on it by agents implicated in the disempowering is a regular impertinence. On that basis alone, the stereotyping, though apparently complimentary, needs disavowal.

In noting that Hugh's comment is also appositely self-critical it should be said that Friel's play, first produced in 1971, provides a riposte to some aspects of stage Irishry integral to a post-1937 Irish state. As if working to blueprint stereotypes provided by folklorists and conservationists, these formulations of Irish people were reproduced as positive representations and role models, even though they were often anti-modernist, nativist, sometimes chauvinist figures. These in turn contributed to the state's provision of essentially conservative social legislation and language policy (Sharkey, 1995). What Hugh the schoolmaster says of a language and civilization in the process of dying could also be applied to this attempted stasis: 'And it can happen . . . that a civilisation can be imprisoned in a linguistic contour which no longer matches the landscape of fact' (*Translations*, p.43). In Ireland, for a number of decades, the landscape was changing, criss-crossed by telegraph poles and TV aerials and studded with multinational industrial units whose owners enjoyed tax-free incentives. But rather than acknowledge secularism, modernity, international capitalism and multicultural phenomena within a linguistic contour, 'positive' stereoptypes of an essentially rural, pastoral and naïve community were adhered to instead. This nativist, postcolonial period, from the 1930s through to the late 1960s, is worthy of considerable attention. But to return here to the issues of defensiveness and stasis, whatever the positive stereotyping or wherever its provenance, it warrants scrutiny not consolidation within Irish Studies.

Getting beyond Begorrah

Let us assume provisionally that we manage to break free from the potential straits of defensive stereotyping, listing and related activities and set out to pursue a subject of study that will not automatically be part of an attempt at assimilation.

Part of the agenda then within Irish Studies might rather be to ask the question as to what types of knowledge about Ireland have been previously and are presently in circulation amidst specific groups in different constituencies and communities, in Ireland, Britain and elsewhere. In Britain the subjects and agents of study may be a group of mixed constituency. To begin with, there are various sections of Irish in Britain. These range from women who are now reaching pensionable age whose working lives have been predominantly part time in service industries, who have raised second-generation families and whose social lives are often formed around parish networks in their urban environments, to the new wave of highly qualified younger women in a range of professions with disposable incomes and active social lives which bear no relation at all to a local urban parish. It also includes the Ulster, Protestant unionists (who to their occasional irritation are generally seen as *Irish* in Britain just the same) and the single young homeless men who are living in increasing numbers on English city streets.

Having considered the diversity of the resident Irish community in Britain, one may also investigate the interaction between Irish people and other national groups in Britain, a subject that has begun to be studied in areas such as Scottish Studies. From the plantations of Scots in seventeenth-century Ulster to the class allegiances and sectarianism which bind and divide Irish from Scots neighbours in contemporary Scotland, the historical relations of the host community to the migrant group can be studied, while remaining aware that Scotland, too, is a heterogeneous and hybrid entity (Maley, 1994, p.80). The interrelations between nationalities and ethnic groups within Britain, whether in the labour force, in trades and professions such as building and nursing or in other social institutions, are all under-researched areas. A high proportion of Irish women wed Afro-Caribbean partners and the experience of this section of the Irish community and that of their mixed-race children, within local communities and within general state systems such as the educational system, are also largely unrecorded. In other words, by getting beyond the begorrah factor imposed upon and sometimes internalized by those who study subjects pertaining to Ireland, Irish Studies can be undertaken, as can the study of any culture, as a process

which is relational rather than ethnically absolutist (Gilroy, 1993, p.24).

Mapping the relational field of Irish Studies

While any number of outline programmes of Irish Studies are potentially available to the student, I would like to introduce some elements which I currently include in my mapping of the terrain. In terms of representations there are a number of available readings.

Post-colonial and other revisionist readings

At present, valuable work is being carried out in the process of national demythologizing, uprooting fixed stereotypes. Noting a refusal to buy into a representation of the Irish as museum artefacts or theme park personae, for commodification either at home or abroad, contemporary academics have been concerned to analyse these refusals. Most crucially writers such as Deane (1991), Eagleton (1995), Gibbons (1988) and Lloyd (1993) have identified these developments in contemporary cultural activity as post-colonial. Other aspects of contemporary historical study termed revisionist have provided valuable contributions by Boyce (1991) and Foster (1993). Sometimes where historical analysis questions received versions of political history in Ireland, this has become known as revisionism within the discipline of history. However, it is worth bearing in mind that there are many forms of revisionist history in process in Ireland: cultural and social history (Brown, 1985; Cairns and Richards, 1988; Carlson, 1990; Curtis, 1984a, 1984b; Curtis et al., 1987; Kearney, 1988); labour history (Connolly, 1910; Gray, 1985; Keogh, 1982); and gender history (Luddy and Murphy, 1989; Luddy, 1995a, 1995b; MacCurtain and O'Corrain, 1978; Mac-Curtain and O'Dowd, 1991; Walter, 1989; Ward, 1983) to name a few. Within interdisciplinary Irish Studies the term 'revisionist' refers to the various ways in which the dominant narratives about Ireland, including those produced within the ideology of the Irish as well as the British state, at historically specific points, are subject to deconstruction. Much of Irish Studies, from post-colonial to gender studies, is a revisionist practice.

A revisionist consideration / case study?

As an example of the process of reappraisal integral to Irish Studies, we can consider the way in which, in general, the failure of multiculturalism in Ireland up to the 1970s was perceived to result from nationalist and national hegemonies. The lack of secularization was attributed to a chauvinism on the part of nationalist politicians which fused the elements of Catholicism, Gaelic ideology and Conservatism into an essentialist notion of Irishness. The resulting impact on social legislation and culture has been well documented by critical and cultural commentators (Brown, 1985; Connelly, 1993; Curtis, 1987; Farrell, 1988; Scannell, 1988; Sharkey, 1993a), and there is a well-established consensus that the agency accorded to the Catholic Church in Irish politics retarded processes of modernization and of liberal pluralism. Though this is irrefutable, it is also to be recognized as presenting an incomplete picture, offering only a partial representation of Irish society. First, it can be stated that a strain of Christian fundamentalism has always been present in other Christian denominations in Ireland. This is why in areas such as Northern Ireland, although they are linked to Britain under the Union, social legislation has differed on a range of issues from limiting abortion rights to the regulation of public houses and children's playgrounds. These differences were directly linked to Northern Protestant, Presbyterian and Methodist influence.

Second, in Ireland as a whole, legislation generated by nascent Christian fundamentalism was often considerably at odds with cultural practice and was frequently unenforceable. But, enforceable or not, such legislation was offensive in itself to many and was circumvented by large numbers from all the constituent communities in Ireland. This may be stressed because in previous representations of 'Southern' Catholic/ nationalist hegemony, it was assumed that the intervention of the state, particularly in the regulation of the family, was injurious to the tiny minority Protestant community alone and that the Catholics there were willing recipients, indeed celebrants, of this paternalistic and pietistic authoritarianism. Quite unproblematically, this previous account assumed that the majority culture in the Republic was a univocal, homogeneous group. Irish Studies now, while resisting wholesale

acceptance of this dominant narrative, corrects the former erasure of the opposition to nativist hegemony from within the Catholic community in the Republic and restores to visibility the agency of those who resisted the state (among whom we can include women, lesbian and gay and working-class movements; see Conroy Jackson, 1986; Prendeville, 1988).

Women and gender issues

For women in particular, post-colonial Ireland has attracted a degree of critical attention. Gender stereotypes have tended to fix women in fairly easily identifiable and negative ways. It is arguable that the ways in which women were perceived, with a view to their containment and a need to regiment and police their activities, in particular their sexual agencies, provide an eloquent gloss on the failure of the Irish state after 1937 to attain a post-colonial status, aligning it with the nativist attitude in representation to which I have already referred (Conroy Jackson, 1986; Connelly, 1993; Prendeville, 1988; Sharkey, 1993b; Smyth, 1993). Key questions include familial law, issues of abortion, divorce and contraceptive provision. But we might also point to developments in gender-related matters which complicate the picture: advances in secularizing the state, the lowering of the age of consent for young gay men, the provision of exemplary employment legislation which protects lesbian and gay people from discrimination in the workplace, the level of provision of publicly funded child care and, of course, the fact of a female head of state (all of which compare favourably with the case of Britain, for example). The 1995 divorce referendum where the yes vote was carried by a 1 per cent majority is a recent subject requiring careful study.

Revisiting Northern Ireland

Again a revisionist perspective on Northern Ireland may form a component part of Irish Studies. For, interestingly, while the study of Northern Ireland has become a significant area of academic study in its own right, some critical aspects have received scant attention within recent accounts. Sectarianism, as upheld by the state in Northern Ireland, has merited little comment though it is in fact a major inhibitor of multicultural

development. Instead there have been glib dismissals of Northern Irish 'atavism' and 'tribal loyalties', thus obfuscating an examination of sectarianism which exists there as part of a colonial legacy. Brewer (1992) points out that Northern Ireland is a settler society in which two communities through a range of social practices have managed to self-perpetuate easily. However, he stresses that this is not an example of 'benign ethnicity' (Rex, 1986, p.95) since the colonial background which originally forced the two communities together also left a legacy of inequality and conflict into which current stratification patterns fit (Brewer, 1992, p.354). When Britain established the government of Northern Ireland in 1920, it attempted to write in assurances that religious discrimination would not occur. But, as evidenced in the range of government commissions throughout the 1960s and 1970s, it was precisely the widespread discrimination against Catholics which precipitated the Civil Rights Movement in 1968. In the domain of culture, Brewer concludes, from a range of sociological analyses (Jenkins, 1984; Buckley, 1982), that sectarianism is relatively low key. 'Catholics and Protestants share significantly in a common culture, certainly more so than in inter-racial situations . . . at a cultural level Catholics and Protestants have as much in common with each other as not' (Brewer, 1992, pp.357–8). Brewer (p.358) claims that the distinction between the two communities is equally apparent:

> what they do not have in common is a consensus on the legitimacy of the state . . . religion is invoked as a difference despite other aspects of shared culture because it represents different socio-economic and political interests. Religion articulates the conflict between the relative economic privilege of one community and the relative economic dispossession of another . . . sectarianism operates whenever religion is invoked to draw boundaries and to represent or reproduce patterns of inequality and social conflict . . . religion is situationally appropriated to represent other conflicts and inequalities.

As Mike Tomlinson points out in a seminal article (1995), the British government still has a central *political* conflict over its role in Ireland (Tomlinson, 1995, p.15). To invoke religion as the explanatory factor in Northern Ireland is a misunder-

standing which Irish Studies students might wish to investigate further.

Religion, racial and colonial identity formations: forms of 'othering'

The marker of religion has proved extremely useful for a long time in the field of Anglo-Irish relations. A tradition of racial denigration which was formerly established by such figures as Gerald of Wales and Stanihurst aided early attempts to colonize the country. The racialization of the Irish in English discourse from the medieval period has been recognized and well discussed (Jones, 1971; Lennon, 1978; Gillingham, 1990, 1992). From this medieval position a new British discourse pertinent to sixteenth- and seventeenth-century colonial expansion developed around the Reformation categorization by religion. This had the advantage of further reinforcing the subordinate status of the 'Irish' (a category which was then made to include the old English in Ireland, previous settlers who adhered to Catholicism), and could represent British appropriation of lands and reallocation into the hands of English, Scots and Welsh as part of a Protestant, providential narrative.

It is important to note how Ireland has been specifically positioned over many centuries as an Other against which a British state formulated itself. Although the general debates about the rise of the state and of nationhood are often set very late, usually from the Enlightenment period and then the nineteenth century onwards, it can be argued that the late sixteenth and early seventeenth centuries are regarded as the early modern period in which a new awareness of concepts such as nation and state arose in Britain, informed in part by experiences of colonial expansion. As the start of empire coincides with that of national self-awareness, the colony provides an interesting site in which ideas about state and nation and myths of formation relating to the same were projected and consciously discussed. Given that the state and nation often appear a more coherent entity precisely in their external and international relations, an examination of the practices in operation in the colonial site often reflects on the national self-consciousness in the colonizing country.

The relevance of Ireland in any discussion of early modern colonialism is no longer disputed. Historians such as Andrews *et al.* (1979), Brady (1986,1989), Bradshaw *et al.* (1993), Canny (1973, 1987), Quinn (1945, 1966) have stated the case and it has recently achieved a more general recognition in comparative studies of colonization. Loomba, for example, notes that several studies have now pointed out that the case of the Irish provided a model for slavery and colonialist discourse in Africa and India (Loomba, 1994, p.30). Boose (1994, pp. 36–7) on the subject of racial discourse in early modern England comments:

> If 'race' originates as a category that hierarchically privileges a ruling status and makes the Other(s) inferior, then for the English the group that was first to be shunted into this discursive derogation and thereafter invoked as almost a paradigm of inferiority was not the black 'race' – but the *Irish* 'race'. In tracts such as Spenser's *A View of the Present State of Ireland*, the derogation of the Irish as 'a race apart' situates racial difference within cultural and religious categories rather than biologically empirical ones. But when that discourse then places the Irish into analogy with what twentieth-century Americans would call 'people of colour', within what category do these claims of difference belong – the biological, the cultural, or the theological? In early modern English treatises on New World 'Indians' the Irish frequently appear as analogous because similarly primitive/ barbaric. In *The White Devil*, John Webster repeatedly associates the black Zanche with the Irish.

In the grand narrative of relations between Britain and Ireland it is notable that the *othering* of the Irish was mobilized in specific ways over historical periods for the purposes of constructing aspects of the British state and of British nationalism. Demonized and the butt of anti-Catholic riots, the Irish were mobilized as representational resources in consolidating a nineteenth-century British working class, and a British nation (Belchem, 1985; Best, 1967; Cahill, 1957; Holmes, 1988; Kirk, 1980). In the twentieth-century era of new Commonwealth immigrants and new racisms, the strategy changed from one of ostracism and *othering* to one of enforced assimilation. The Irish were to be undifferentiated as an ethnic minority, part of an un-

deconstructed whiteness (Hickman and Walters, 1995) despite clear signs in landlords' windows indicating the contrary: *No Irish, no blacks.* The strategy for the British state at this point involved shifting the axis of absolutist othering on to colour lines so that new and conveniently exclusivist 'British' selves could be produced. British anxiety about the Irish is still prevalent, as evidenced in the February 1995 football riots, provoked by neo-fascists, which stopped the Ireland–England game in Dublin, or the press response to the CRE (Centre for Racial Equality) research initiative into anti-Irish racism. While *The Sunday Times* merely disapproved, the *Sun* (22 January 1994, p.9) dismissed the exercise as 'codswallop' and printed a page of anti-Irish jokes to aid the researchers.

Such data also needs to be investigated within Irish Studies in Britain.

Some concluding hypotheses regarding methodology

As one currently involved in Irish as well as British Cultural Studies programmes in Britain I am conscious that part of the excitement of these studies is that they can potentially draw upon the experiential and upon local, urban and national forms of knowledge.

The accessing of the experiential as a legitimate resource within the academy is a link between Cultural Studies and Irish Studies. Moreover, where an Irish Studies programme is interdisciplinary, it can provide a set of methodological tools pertinent to key disciplines and, at the same time, operate from border territories where the specific strengths and limitations of different methodologies are apparent. It may adopt some key tenets of other cultural studies, too. Culture may be read as the maps of meaning whereby a particular group of people make sense of everyday practices (Hall and Gieben, 1992, p.233), and a culture may therefore be studied through the historically specific interrelating of identity factors, such as age, gender and generation with social institutions, employment, leisure and education. If cultures are composite, involving dominant, residual and emergent elements (Williams, 1971, pp.121–8) then uneven developments and contradictions can be identified and explored.

Finally, considering that 'tradition', like history, in Irish Studies as elsewhere, is always a selective construct, excluding as well as privileging, a reflexive mode of analysis of the specific maps of meaning currently in circulation may be adopted. Rather than believe that there are reified maps of a culture which we can roll up, carry with us and give or withhold at whim, I am suggesting that in pursuing Irish Studies we might consciously participate in the processes of formations and deconstructions of the maps of meaning in a culture. Britain has belatedly begun this process, in part under the aegis of Cultural Studies. Here, too, Irish Studies has a significant contribution to make.

References

Anderson, B., *Imagined Communities: Reflections on the Origin and Spread of Nationalism* (London: Verso, 1991)

Andrews, K.R., Canny, N. and Hair, P.E., *The Western Enterprise. English Activities in the Atlantic and America 1480–1650* (Detroit: Wayne State University Press, 1979)

Balibar, E. and Wallerstein, I., *Race, Nation, Class: Ambiguous Identities* (London: Verso, 1991)

Bartlett, T. *et al.* (eds), *Irish Studies: A General Introduction* (Dublin: Gill and Macmillan, 1988)

Beale, J., *Women in Ireland: Voices of Change* (London: Macmillan, 1986)

Belchem, J., 'English Working-class Radicalism and the Irish, 1815–50', in S. Gilley and R. Swift (eds), *The Irish in the Victorian City* (Beckenham: Croom Helm, 1985), pp.85–98

Best, G.F., 'Popular Protestantism in Victorian Britain', in R. Robson (ed.), *Ideas and Institutions in Victorian Britain* (London: Bell, 1967), pp.115–42

Boose, L.E., 'The Getting of a Lawful Race', in M. Hendricks and P. Parker (eds), *Women, 'Race' and Writing in the Early Modern Period* (London: Routledge, 1994)

Boyce, D.G., *Nationalism in Ireland* (London: Routledge, 1991)

Bradshaw, B., 'Robe and Sword in the Conquest of Ireland', in C. Cross, D. Loades and J. Scarisbrick (eds), *Law and Government under the Tudors: Essays Presented to Sir Geoffrey Elton on His Retirement* (Cambridge: Cambridge University Press, 1988), pp.139–62

Bradshaw, B., Hadfield, A. and Maley, W. (eds), *Representing Ireland: Literature and the Origins of the Conlict, 1530–1660* (Cambridge: Cambridge University Press, 1993)

Brady, C., 'Spenser's Irish Crisis: Humanism and Experience in the 1590s', *Past and Present*, vol. 111, 1986, pp.17–49

Brady, C., 'The Road to the *View*: On the Decline of Reform Thought in Tudor Ireland', in P. Coughlan (ed.), *Spenser and Ireland: An Interdisciplinary Perspective* (Cork: Cork University Press, 1989), pp.25–45

Brewer, J.D., 'Sectarianism and Racism, and their parallels and differences', *Ethnic and Racial Studies*, vol. 15, no. 3, 1992, pp.352–65

Brown, T., *Ireland. A Social and Cultural History 1922–1985* (London: Fontana, 1985)

Buckley, A., *A Gentle People* (Belfast: Ulster Folk and Transport Museum, 1982)

Cahill, G.I., 'Irish Catholicism and English Toryism', *Review of Politics*, vol. 18, 1957, pp.62–76

Cairns, D. and Richards, S., *Writing Ireland: Colonialism, Nationalism and Culture* (Manchester: Manchester University Press, 1988)

Canny, N.P., 'The Ideology of English Colonization: From Ireland to America', *William and Mary Quarterly*, vol. XXX, 1973, pp.575–98

Canny, N.P., 'Identity Formation in Ireland: The Emergence of the Anglo-Irish', in N. Canny and A. Pagden (eds), *Colonial Identity in the Atlantic World, 1500–1800* (Princeton, NJ: Princeton University Press, 1987), pp.159–212

Carlson, J., *Banned in Ireland. Censorship and The Irish Writer* (London: Routledge, 1990)

Connelly, A. (ed.), *Gender and the Law in Ireland* (Dublin: Oak Tree Press, 1993)

Connolly, J., *Labour in Irish History* (Dublin: Colm O'Lochlainn, 1910)

Conroy Jackson, P., 'Women's Movement and Abortion: The Criminalization of Irish Women', in D. Dahlerup (ed.), *The New Women's Movement: Feminism and Political Power in Europe and the USA* (London: Sage, 1986)

Curtis, C. *et al.* (eds), *Gender in Irish Society* (Galway: Galway University Press, 1987)

Curtis, Liz, *Nothing but the Same Old Story: The Roots of Anti-Irish Racism* (London: Information on Ireland, 1984a)

Curtis, Liz, *Ireland and the Propaganda War, The British Media and the 'Battle for Hearts and Minds'* (London: Pluto Press, 1984b)

Curtis, L. Perry, *Apes and Angels: The Irishman in Victorian Caricature* (Washington: Smithsonian Institution Press, 1971)

Deane, S. (ed.), *The Field Day Anthology of Irish Writing*, 3 vols (Derry: Field Day & Faber, 1991)

Eagleton, T., *Heathcliff and the Great Hunger: Studies in Irish Culture* (London: Verso, 1995)

Farrell, B., *De Valera's Constitution and Our Own* (Dublin: Gill & Macmillan, 1988)

Field Day Theatre Company, *Ireland's Field Day* (Notre Dame, IN: University of Notre Dame Press, 1986)

Foster, R.F., *Paddy and Mr Punch. Connections in Irish and English History* (Harmondsworth: Penguin, 1993)

Friel, B., *Translations* (London: Faber & Faber, 1981)

Gibbons, L., 'Coming out of Hibernation? The Myth of Modernity in Irish Culture', in R. Kearney (ed.), *Across the Frontiers. Ireland in the 1990s* (Dublin: Wolfhound, 1988)

Gilley, S. and Swift, R., *The Irish in the Victorian City* (Beckenham: Croom Helm, 1985)

Gillingham, J., 'The Context and Purposes of Geoffrey of Monmouth's *Historia Regum Brittaniae*', *Anglo-Norman Studies*, vol. 13, 1990, pp.99–118

Gillingham, J., 'The Beginnings of English Imperialism', *Journal of Sociology*, vol. 5, 1992, pp.392–409

Gilroy, P., *Small Acts* (London: Serpent's Tail, 1993)

Gray, J., *City in Revolt: James Larkin and the Belfast Dock Strike* (Belfast, 1985)

Hall, S. and Gieben, B., *Formations of Modernity* (Oxford: Polity, Open University and Oxford University Press, 1992)

Heaney, S., 'An Open Letter' (Derry and Belfast: Field Day, 1983)

Hickman, M. and Walters, B., 'Deconstructing Whiteness: Irish Women in Britain', *Feminist Review*, no. 50, 1995, pp.5–19

Hillyard, P., *Suspect Community. People's Experience of the Prevention of Terrorism Acts in Britain* (London: Pluto Press, 1993)

Hoggart, R., *The Uses of Literacy* (Harmondsworth: Penguin, 1957)

Holmes, C., *John Bull's Island: Immigration and British Society 1871–1971* (London: Macmillan, 1988)

Jenkins, R., 'Understanding Northern Ireland', *Sociology*, vol. 18, no. 2, 1984, pp.252–64

Jones, W.R., 'England against the Celtic Fringe: A Study in Cultural Stereotypes', *Journal of World History*, no. 13, 1971, pp.155–71

Joyce, J., *Ulysses* (1922) (Harmondsworth: Penguin, 1985)

Kearney, R. (ed.), *Across the Frontiers. Ireland in the 1990s* (Dublin: Wolfhound, 1988)

Keogh, D., *The Rise of the Irish Working Class* (Belfast: Appletree Press, 1982)

Kirk, N., 'Ethnicity, Class and Popular Toryism, 1850–70', in K. Lunn (ed.), *Hosts, Immigrants and Minorities* (Folkestone: Harvester, 1980) pp.64–106

Lees, L. Hollen, *Exiles of Erin: Irish Migrants in Victorian London* (New York: Cornell University Press, 1979)

Lennon, Colm, 'Richard Stanihurst and the English Identity', *Irish Historical Studies*, vol. 82, 1978, pp.121–43

Lloyd, D., *Anomalous States. Irish Writing and the Post-colonial Moment* (Dublin: Lilliput, 1993)

Longley, E. *The Living Stream. Literature and Revisionism in Ireland*, Newcastle-upon-Tyne: Bloodaxe, 1994)

Loomba, A., 'The Colour of Patriarchy: Critical Difference, Cultural Difference and Renaissance Drama', in M. Hendricks and P. Parker (eds), *Women, 'Race' and Writing in the Early Modern Period* (London: Routledge, 1994)

Luddy, M., *Women in Ireland 1800–1918: A Documentary History* (Cork: Cork University Press, 1995a)

Luddy, M., *Women and Philanthropy in Nineteenth-century Ireland* (Cambridge: Cambridge University Press, 1995b)

Luddy, M. and Murphy, C., *Women Surviving: Studies in Irish Women's History in the 19th and 20th Centuries* (Dublin: Poolbeg Press, 1989)

MacCurtain M. and O'Corrain, D., *Women in Irish Society. The Historical Dimension* (Dublin: Arlen House, 1978)

MacCurtain, M. and O'Dowd, M. (eds), *Women in Early Modern Ireland* (Dublin: Wolfhound, 1991)

Maley, W., 'Cultural Devolution? Representing Scotland in the 1970s', in B. Moore-Gilbert (ed.), *The Arts in the 1970s: Cultural Closure* (London: Routledge, 1994), pp78–98

Mitchell, A., *Labour in Irish Politics* (Dublin: Wolfhound, 1974)

Patterson, H., *Class Conflict and Sectarianism* (Belfast: Appletree Press, 1980)

Prendeville, P., 'Divorce in Ireland. An Analysis of the Referendum to Amend the Constitution, June 1986', *Women's Studies International Forums*, vol. 2, no. 4, 1988, pp.355–63

Quinn, D.B., 'Sir Thomas Smith (1513–1577) and the Beginnings of English Colonial Theory', *Proceedings of the American Philosophical Society*, vol. 89, 1945, pp.543–60

Quinn, D.B., *The Elizabethans and the Irish* (New York: Cornell University Press, 1966)

Rex, J., *Race and Ethnicity* (Milton Keynes: Open University Press, 1986)

Rockett, K. *et al.*, *Cinema and Ireland* (London: Routledge, 1987)

Rolston, B. and Waters, H. (guest editors), *Race and Class*, vol. 37 no. 1, July–Sept. 1995

Scannell, Y., 'The Constitution and the Role of Women', in B. Farrell (ed.), *De Valera's Constitution and Our Own* (Dublin: Gill & Macmillan, 1988)

Sharkey, S., 'Frontier Issues: Irish Women's Texts and Contexts', *Women. A Cultural Review*, vol. 4, no. 2, 1993a, pp.125–36

Sharkey, S., 'Gendering Inequalities: The Case of Irish Women', *Paragraph: A Journal of Critical Theory*, vol. 16, no. 1, 1993b, pp.5–23

Sharkey, S., 'And Not Just for Pharaoh's Daughter: Irish Language Poetry Today', in H. Ludwig and L. Fietz (eds), *Poetry in the British Isles* (Cardiff: University of Wales Press, 1995)

Smith, A.D., *Nations and Nationalism in a Global Era* (Oxford: Polity Press, 1995)

Smyth, A., *Irish Women's Studies Reader* (Dublin: Attic Press, 1993)

Thomson, E.P., *The Making of the English Working Class* (London: Gollancz, 1963)

Tomlinson, M., 'Can Britain Leave Ireland? The Political Economy of War and Peace', *Race and Class*, vol. 37, no. 1, July–Sept. 1995, pp.1–22

Walter, B., *Irish Women in London* (London: Ealing Women's Unit, 1989)

Ward, M., *Unmanageable Revolutionaries: Women and Irish Nationalism* (London: Pluto Press, 1983)

Wiener, Carol Z., 'The Beleaguered Isle. A Study of Elizabethan and Early Jacobean Anti-Catholicism', *Past and Present*, no.51, 1971, pp.27–62

Wilde, O., *The Importance of Being Earnest* (London: Methuen, 1992)

Williams, R., *Marxism and Literature* (Oxford: Oxford University Press, 1971)

9

Teaching West Indian literature in Britain

DAVID DABYDEEN

I

The West Indies, in the words of the Nobel Laureate Derek Walcott is 'The world's most accessible fuck.'[1] Not surprisingly, courses on the region's culture are considered 'sexy', they are swamped by eighteen to twenty-one-year-old white undergraduates who come seeking excitements other than the intellectual. Some have black lovers, or have smoked marijuana. All have danced to Bob Marley. The richer ones have lain under the sun of Barbados. Speaking generally, they attend West Indian Literature classes because they find their own culture jaded, lacking frisson and danger. To be a West Indian Literature student is to be cool, hip and sub-cultural, like the subject of their enquiry, the blacks who inhabit the ghettos of Kingston or Brixton.

The teacher's business is to disabuse them of their expectations and to police their enthusiasms. The teacher is killjoy. The teacher instructs them to read the unreadable, to speak the unspeakable: post-colonial and postmodernist theory. The student in an early class on Sam Selvon who exclaimed, 'but Trinidad is such a *vibrant* place, all that music and rhythm and sand and simple speech. Whoever would want to live in England!', by the end of the course speaks of West Indian culture in sombre, terrorist terms – it subverts canons, it

interrogates the great tradition, it challenges the direct author-
ity of the dominant, it contests the ideological hegemony of
cultural precepts, it mugs the Queen's English. At the end of
the day, West Indian culture equals mugging, in spite of the
high-falutin rhetoric. And the students' initial innocence has
been lost to the more mature pleasures of mastering the techno-
chip jargon of theory.

The fault is partly ours. We are West Indian teachers in
single numbers inhabiting the margins of the Western acad-
emy. Our jobs were not necessarily created out of the acad-
emy's desire to enlarge and enrich its humanities curriculum
by being more fully representative of humanity, but out of post-
imperial guilt, or the social pressure exerted by street-blacks.
Our centres are handouts, forms of welfare cheques. The
Centre for Caribbean Studies at the University of Warwick, the
first of its kind at a British university, was, after all, created in
the wake of the Brixton and Toxteth riots, and the American
invasion of Grenada. The West Indies, in the words of George
Lamming, is 'a unique experiment', characterized by fantastic
survivals, hybridities and amalgamations.[2] Through immigra-
tion multicultural societies emerged; a complex mixture of
Amerindians, Africans, Asians and Europeans living together
with the varied legacies left by Spanish, English, French and
Dutch colonizers and now within the shadow of the United
States. There is scarcely an ideology in the Third World that
does not have a Caribbean provenance, the most striking
expression of which is perhaps the Cuban revolution.[3] The
Western academy, however, remains to be convinced of the
intellectual potential of 'Caribbean Studies'. Hence the mar-
ginal status reflected in marginal and precarious funding.

The survival and career enhancement of the marginal and
tokenistic West Indian scholar in the Western academy de-
pends on mastery of the Western idiom. The same goes for
other 'Third World' scholars in their own countries. As the
Indian academic, Meenakshi Mukherjee puts it, 'a generation
ago, when I began to study literature as an academic discipline,
I submitted to the central ideologies of power in the literary
and intellectual domain which at that time were Anglo-
American in origin and male in outlook'. European critical
traditions have since displaced the Anglo-American, but the
problem remains that validation is the business and privilege

of the 'Centre'. Thus the radical ideas of a critic like Edward Said have had to 'pass through the Centre ... in order to return to the periphery'. If, as Mukherjee argues, the most crucial terms and concepts of the new critical discourse are 'historically linked with certain phases of literary development in Europe', then their inapplicability to 'Third World' literature should be evident. Yet the West Indian teacher, with minor and vulnerable status in the Western academy, knows with what his bread is buttered. And it's French butter. Instead of devising a West Indian poetic in which to read West Indian literature, the teacher reaches for brand names and market leaders – Lacan, Derrida, *et al*. The result is, as Mukherjee states memorably, 'mime and ventriloquism'.[4]

The writers have done what they can to sneer at the new theoreticians, none more brilliantly than Derek Walcott in arguing for chaos, paradox and non-sense as sources of creativity:

> A lot of dead fish have beached on the sand. Most of the fish are French fish, and off their pages there is the reek of the fishmonger's hands. I have a horror, not of that stink, but of the intellectual veneration of rot, because from the far off reek which I get from the stalls of the academy, there is now a school of fishermen as well as schools of fish, and these fishmongers are interested in examining the disembowelled entrails of poetry, of marketing its guts and its surrounding conversation of flies. When French poetry dies the dead fish of French criticism is sold to the suckers. 'Moby Dick is nothing but words, and what are words, and what do I mean when I say Moby Dick, and if I say Moby Dick what exactly do I mean?' It convinces one that Onan was a Frenchman, but no amount of masturbation can induce the Muse ... I cannot think because I refuse to, unlike Descartes. I have always put Descartes *behind* the horse.[5]

Walcott's is an ancient Romanticist charge against the critic that is 'murdering to dissect'. Wole Soyinka's charge is more contemporary; it is against the atomic white light of theory which threatens abstraction and annihilation:

> We have been blandly invited to submit ourselves to a second epoch of colonization – this time by a universal – humanoid

abstraction defined and conducted by individuals whose theories and prescriptions are derived from the apprehension of *their* world and *their* history, *their* social neurosis and *their* value systems. It is time, clearly, to respond to this new threat.[6]

The challenge to the West Indian teacher then, within the Western academy, is to abandon Western critical theory as being inappropriate to an understanding of West Indian literature, and to take the consequences in terms of career, or in terms of being seen to be unfashionable or intellectually backward. The West Indian teacher will then have to offer for analysis a set of propositions about the history and culture of the region – a particular region, *derived from the body of creative writing itself.* The primacy of the writing must be restored, otherwise the centuries-old struggle for self-expression will be denied. The work of Pauline Melville, to cite but one writer arbitrarily, emerged from the plundering and silencing of her Amerindian ancestors. We can either be alert to her writing – its specific body of ideas, its specific form and texture – or we can drown her living voice – and the voices of the past – in a chorus of *their* (French, Anglo-American) techno-speak. And if we are to quarrel with Pauline Melville's ideas or craft, then that disputation is best served by positioning another West Indian literary work against hers. The books should speak with each other, the task of the teacher being to host the dialogue. The criteria for literary judgement should be derived from the works themselves and not from Plato and his footnoters.

II

The problem with postmodernist theories is that they tend to dismiss 'presence' as a kind of metaphysical conceit and valorize 'absence', 'aporia' and 'kenosis'. Such approaches may be suited to an exploration of such a novel as *Flaubert's Parrot*, but they should be anathema to students of literature written by blacks. Take Olaudah Equiano, for instance, the eighteenth-century African–British writer, whose central concern was with textual presence – placing himself before the audience, asserting his humanity ('am I not a man and a brother?') at the height of the slave trade, the philosophical justification of which was the designation of blacks as a species of lower primates. Post-

Structuralism thinks of literature as a dance of the pen. For Equiano, it was anything but. Writing for him was a deadly serious business. It was bound up with his own personal salvation as well as with the Abolitionist cause. As a slave in the Americas, his mastery of the English language saved him from beatings and brutilizations, since he could argue eloquently against violence and injustice, quoting biblical precepts to his Christian persecutors. When he published his autobiography in Britain in 1789, he lived by its revenues, travelling all over Britain reading from it and in the process selling thousands of copies to a new market of readers – the Abolitionists. Equiano had found a niche in the market for books and out of his blackness he created a text which exploited that niche and became, literally, a best-seller. Equiano made such a fortune from the sale of his book that he became a moneylender, his clients being white Englishmen! The wide currency of the book, as well as its literary merit, ensured that it became a potent weapon in the hands of Abolitionists.

A postmodern, a historical approach, which for good measure also kills off the author, is patently inappropriate to a reading of Equiano. Deconstruction, for instance, mocks the notion of referentiality and representation, it sunders the link between word and world. In the words of Sukhdev Sandhu, 'this is most pernicious. Equiano emerged from and wrote of social milieux which he knew about with a kind of painful intensity. To say that his book stems from a particular period and body of social circumstances is not to deprecate its literary qualities, but to make the point that you cannot fully appreciate his work without a firm grasp of the social and historical materiality that underpins it.'[7]

To illustrate, I quote in full a story Equiano tells of a venture in which he was involved, with a fellow slave, both of them sailors on ships trading between the Caribbean islands:

. . . and at our sailing he had brought his little all for a venture, which consisted six bits' worth of limes and oranges in a bag, I had also my whole stock, which was about twelve bits' worth of the same kind of goods, separate in two bags, for we had heard these fruits sold well in that island. When we came there, in some little convenient time he and I went ashore with our fruits to sell them, but we had scarcely

landed when we were met by two white men, who presently took our three bags from us. We could not at first guess what they meant to do, and for some time we thought they were jesting with us, but they too soon let us know otherwise, for they took our ventures immediately to a house hard by, and adjoining the fort, while we followed all the way begging of them to give us our fruits, but in vain. They not only refused to return them, but swore at us and threatened if we did not immediately depart they would flog us well. We told them these three bags were all we were worth in the world, and that we brought them with us to sell when we came from Montserrat, and showed them the vessel. But this was rather against us, as they now saw we were strangers as well as slaves. They still therefore swore and desired us to be gone, and even took sticks to beat us, while we, seeing they meant what they said, went off in the greatest confusion and despair. Thus in the very minute of gaining more by three times than I ever did by any venture in my life before, was I deprived of every farthing I was worth. An insupportable misfortune! but how to help ourselves we knew not. In our consternation we went to the commanding officer of the fort and told him how we had been served by some of his people, but obtained not the least redress: he answered our complaints only by a volley of imprecations against us, and immediately took a horse-whip in order to chastise us, so that we were obliged to turn out much faster than we came in. I now, in the agony of distress and indignation, wished that the ire of God in his forked lightning might transfix these cruel oppressors among the dead. Still however we persevered, went back again to the house, and begged and besought them again and again for our fruits, till at last some other people that were in the house asked if we would be contented if they kept one bag and gave us the other two. We seeing no remedy whatever, consented to this, and they, observing one bag to have both kinds of fruit in it, which belonged to my companion, kept that; and the other two, which were mine, they gave us back. As soon as I got them I ran as fast as I could, and got the first negro man I could to help me off; my companion, however, stayed a little longer to plead; he told them the bag they had was his, and likewise all that he was worth in the world, but this was of no avail

and he was obliged to return without it. The poor old man, wringing his hands, cried bitterly for his loss, and indeed he then did look up to God on high, which so moved me with pity for him that I gave him early one-third of my fruits. We then proceeded to the markets to sell them, and Providence was more favourable to us than we could have expected, for we sold our fruits uncommonly well; I got mine for about thirty-seven bits. Such a surprising reverse of fortune in so short a space of time seemed like a dream to me, and proved no small encouragement for me to trust the Lord in any situation.[8]

Over the years, in teaching this passage, I have stressed the following:

- The pathos, consciously created by alliteration, rhythm and repetition, designed to appeal to an age of sentimentality ('we told them that these three bags were all we were worth in the world').
- The story's conscious mimicry of the structure of biblical parables (including a powerful moral ending), designed to appeal to an age of religious seriousness.
- The emotional and symbolic power of the goods of oranges and limes (as opposed to meats, which Equiano would have also traded in), in line with the tastes of an age of romanticism.
- The careful and rational arguments ('we told them . . . we showed them . . .') Equiano uses to regain his goods, appealing to an age of enlightenment.
- The deft shifts of linguistic registers, revealing something of Equiano's command of narrative in an age of narrative. (The line 'An insupportable misfortune! but how to help ourselves we knew not', moving from the rhetorical flourish to quick pragmatic monosyllables, recalling Robinson Crusoe's apostrophe to money; the shift from the rhetorical to the realistic is repeated later, Equiano's voice swelling to Old Testament proportions to damn the cheats – 'the ire of God in his forked lightning' – then quickly returning to earth with 'still however we persevered'.)
- The exceedingly polite and literary turn of phrases, revealing Equiano's adoption of the mask of an eighteenth-century gentleman, in an age of slavery which sought to prove the

inferiority of blacks by reference to their inability to arrive at language. ('He answered our complaints only by a volley of imprecations against us, and immediately took a horse-whip in order to chastise us, so that we were obliged to turn out much faster than we came in.')

Other linguistic strategies in this brief passage include the questioning of the moral authority of whites to rule and subjugate. The use of the religious word 'chastise', for instance ('took up a horse-whip in order to chastise us'), evokes a topsy-turvy world in which the sinner is confused with the sinned against. The white man plays God when he is mere thief and wielder of a callous whip. The world-turned-upside-down is of course the 'moral' of Equiano's tale ('such a surprising reversal of fortune in so short a space of time . . .'), as it was of many eighteenth-century pieces of white writing, but in Equiano's case the trope is deeply painful since it originates not from the philosophical imagination but from the weals on his black skin. The 'moral' of Equiano's tale may read like an ordinary piece of Christian wisdom, but its consciously conventional tone disguises a profound 'existentialist' sorrow at the day-to-day experience of black people: its uncertainties, aborted hopes and cruel vicissitudes. As a slave, Equiano knew the condition of non-being; he knew that *being*, in the context of an age of commerce, depended on owning *something*, and on making it subject to his will (hence the measuring of his life according to the worth of his oranges and limes, and his freedom to dispose of *his* goods). Equiano saved £40 and purchased his own freedom. He bought his own life, then sold it in the form of an autobiographical publication, making a massive profit out of the 'existentialist' transaction. The 'moral' of his tale, 'to trust the Lord in any situation' is massively ironic when we consider the commercial meaning of the word 'trust'. In God he trusts, everyone else must pay him cash.

I teach Equiano as an artful storyteller and writer, one who is always conscious of the moods and trends of his age, and exploits these for the sake of money-making and for the liberation of his fellow blacks. The exploited becomes the exploiter, with a moral and ethical purpose, thereby undermining the very foundations of eighteenth-century commerce: the bifurcation between ethics and business, expressed in the

eighteenth-century dictum, 'religion is one thing, trade another', was the very rationale for slavery.[9] Above all I teach Equiano as an eighteenth-century travel writer, one who knew the 'tricks' of contemporary travel writing, its mixture of money-making, exotic adventure and Christian zeal; one who mimicked the 'tricks' so as to expose their hollowness and hypocrisy.

Such approaches to Equiano are very different from those of some of my white students who impose upon the writer their own secondhand theories, thereby trivializing the literary genius of the man. Hence the student who took a pseudo psychoanalytic view, describing Equiano's longing for his mother (from whom he was separated as a boy, and enslaved) as an Oedipal concern; who argued that the oranges represented Equiano's testicles, and that their theft symbolized the persistent emasculation of the black and white supremacists since the seventeenth century. Westerners whose idea of liberation is the arousal of the clitoris, and who meditate upon their genitalia for the meaning of emancipation, obviously have utterly different perspectives and lifestyles from Equiano and the mass of his descendants. By all means they should wank over their own texts, but to do so over ours is to repeat the sexual patterns of slavery in which the black could be violated in silence (the silence of the Letter of the Law), word and world severed in a manner prophetic of postmodern theories.

III

How to avoid Western theory, which will exoticize, capture and Calibanize the black subject, is the challenge before the West Indian teacher in Britain. Suspicion of Western theory must go hand in hand with a reconceptualization of the nature of West Indian-ness, one which foregrounds the existence of cultures only partially affected by contact with the European. Teachers of Caribbean Studies in Britain still tend to focus on the ways Britain impacted on the economy, social and kinship institutions and psyche of African slaves and their descendants. The prevalent view still is that the region was made (or to use Walcott's imagery, *laid*) by Britain. In other words we are mulattos and mimic men and women; we play cricket, but with sufficient exuberance and flair to make us a little distinctive; we

speak English, but with sufficient grammatical oddities to justify our different colour. Little attention is paid to the myriad ways in which Africans altered British manners and thinking, even in the era of slavery. The creative impact of African languages, philosophies and cultural practices on the day-to-day lives of white masters and overseers is hardly understood. No-one denies the massive erasure of African cultures in the era of slavery, but few investigate and document the ways in which the British became 'Africanized' in the process. Caribbeanists remain habituated to reading colonial history as a one-way traffic of values, in which British culture supplanted and superseded that of the African while remaining 'unadulterated' by anything African. The Western academy also appears unable to read non-Western Caribbean traditions in their total or partial survivals, preferring to focus instead on the Western effort to eradicate these traditions. As a result, notions of colonizer/colonized, centre/periphery, and so on continue to dominate descriptions of the historic relationships between British and West Indian cultures.

Of Caribbean intellectuals, it is the Guyanese painter Aubrey Williams who is most explicit in his championing of the non-Columbian values of the region. He confesses that working in Europe, and with a European education, the images of his canvas are inevitably 'glossed over with European angst, European psychology, European everything because I am still a captured individual'. He is also trapped in the materiality of Europe in that he uses canvases and oils; he cannot 'go back' to grinding pigments and using fats. And yet his whole life's struggle, as a Guyanese of Amerindian, African, Indian and European ancestry has been to banish the European aspect from his art. He concludes on a confused note of defiance and despair, 'all my life I have been trying to get rid of it, but I don't know whether I can. If we can get rid of it in ourselves it will be a great achievement. I don't think that getting rid of economic structures, or changing them, is enough. We have to find new values, new directions, which we can now do only with the coming generations. Not so much with ourselves.'[10] Williams's position is open to the charge that it evokes the very notions of ethnic purity and essentialism which underpinned the imperial project and which wreaked such havoc upon the very pre-Columbian peoples who inspire his art. I think,

however, that Williams simply wanted a downgrading of the role of Europe in our making, in favour of a greater recognition of our native resources, the communities of native values which survived in spite of the conquistadors, planters and missionaries.

I would suggest that one of the ways of fulfilling Williams's quest for 'new values and new directions' in the region is by engagement with what is oldest in the region, namely our Amerindian cultures. In Guyana we have many such living cultures – Wai Wai, Macusi, Arawak, Carib – but Western Caribbeanists know next to nothing of Amerindian languages, oral and written expressions, myths, religions, art, music, diet, political economy, gender relations, and so on. Evidence of the wilful neglect of Amerindian cultures is stark: I know of no anthology of West Indian oral and written literature (and there are many, produced by such specialist publishers as Longman and Heinemann) which include a single Amerindian poem, chant, song, prayer or proverb. There is correspondingly a total ignoring of Amerindian ideas in books that purport to deal with the intellectual traditions in the region. There is not even a footnote in such books, explaining the absence. The simple fact is that the scholars who produce such texts – which form the basis of teaching Caribbean Studies in the Western academies – have rarely travelled into the interior to meet Amerindians, never mind studied their languages and cultures. To do so demands effort – the effort to *know* the subject. The dismal truth is that Caribbeanists are still very much timid external observers of the cultures of the region. Herskovitz's injunction that they should 'get down from their verandas' and live among the peoples they study falls on deaf ears. If the region has always been prey to piracy and quick plunder, today it endures new pirates from the metropolis – people who make quick visits, observe hastily and in fright of the native presence, then return to pronounce with authority in the centres in Britain.

The Amerindians, the most invisible of West Indian peoples, are paradoxically signposts of the future. What distinguishes their existence is the absence of recognition of boundaries. They carry no passports, seek no visas, observe none of the territorial imperatives and protocols of the colonial legacy. They have no sense of centre or periphery. Maps, colonial in conception, which demarcate the land, are alien to them.

Amerindians cross over at will to Venezuela and Brazil, ir-respective of the fact that the landmass was divided up by the Portuguese, the Spanish and the British. Similarly their sense of time is not linear and periodic but circular and continuous.[11] They are postmodern in the movements of their own lives without the bureaucracy of theory to inform them of the fact, or to validate their condition.

Another way of realizing Williams's desire for originality rooted in native form and native content is to attend to Asian cultures, another neglected aspect of Caribbean Studies. Among immigrants to the region, Indians proved to be the most resilient to Christian conversion. H.P.V. Bronkhurst, the nineteenth-century Methodist missionary, confessed to utter frustration at the stubbornness of Indian beliefs: 'In preaching to the coolies, whether in sugar estates, in the yards, villages and publicly, in large numbers or privately in their houses, we meet with endless objections brought before us again and again.'[12] So successful were they in resisting colonial brain-washing that today, 155 years after their first arrival, Indian cultures, centring on the mosque and Hindu temple, flourish in Guyana and Trinidad, in original and creolized forms. The resistance to Christianity was, of course, never total, and in addition Indian cultures were open to change within the slowly dissolving framework of tradition.

In a recent essay on the influence of Indian classical and folk music on the making of West Indian literature, Sasenarine Persaud, a Guyanese writer, has this to say of Sam Selvon: 'Sam Selvon's work is not without the influence of these rhythms and closer examination may well show that much of his often touted calypso rhythms are actually the rhythms of chowtals or taans.'[13] Persaud invites us to listen to the orality of Selvon's narrative with more subtlety and greater awareness of Indian songs, song-games, tales, proverbs, riddles, charms, oaths and jokes which constitute a distinctive Indo-Caribbean orality. Needless to say, critics of Sam Selvon have wholly ignored this dimension to his writing. Persaud proceeds to reveal how a West Indian novel can be Indian in structure and technique by reference to one of his own works, in which the division into three sections and the varying length of each section corres-pond to the three rhythms of the classical Indian raag, with the reversal of rhythms informed by the yogic view that there is no

beginning and no end, just cycles to and from pure con-
sciousness. The exploration of the nature of memory, which
constitutes Persaud's fiction, also has a distinctive Indian
motive. The nature of memory is a central Afro-Caribbean
concern, given the metropolitan efforts to erase the African-
ness of the African and the counter efforts of writers like
Equiano to remember the dismembered body of the past by the
fusion of the living imagination and scholarly recovery of data.
Persaud's project differs in that he is not concerned with the
materiality of history within a particular time-span. Persaud is
concerned with 'essence of the reality of re-incarnation, which
is memory. If the individual can sit down and train the
consciousness to retrieve what the consciousness has recorded,
then he can see past, present and future. This is the essence of
yoga.'[14]

I would venture that Persaud's essay, if developed and
magnified, can offer completely new ways of reading certain
works by West Indian writers, East Indian or otherwise. The
critical terminology used, derived from Sanskrit literature and
Indian classical and folk music, is refreshingly different from
the jargon critics use today, which is almost entirely derived
from the West. If we are to deconstruct West Indian fictions,
then let us attempt to use a vocabulary and concepts derived
from Indian aesthetics, that are native and alive and present;
because they are still being used in every day and ritualistic life
by a substantial proportion by our Indo-Caribbean peoples. If
we learn the vocabulary, and the cultures that create and
sustain that vocabulary, we may well find surprising cor-
respondences with Western concepts we take on board with
such ready mimicry. Why are we, for instance, so engrossed
with Paul de Man's rejection of a metaphysics of presence,
when closer to home we have critics and priests who also reject
the notion of origin, but from a native yogic philosophy? And
if that yogic philosophy, which speaks of seamlessness, contra-
dicts the Afro-Caribbean search for specific roots and origins,
how can we embrace that contradiction to forge a sense of
national unity? Such Caribbean questions are possibly beyond
solution by the use of European conceptualizations, as Aubrey
Williams intimated.

Since 1838 we have had in the West Indies a body of texts
of staggering physical bulk and philosophical dimensions,

which have been almost completely ignored by Caribbeanists. I refer to the Hindu epics. The *Aeneid* of Virgil runs to 12,000 lines; the *Iliad* of Homer to double that number; the *Ramayana* rolls on to 100,000 lines, while the *Mahabarata* quadruples that sum; the *Vedas*, when collected, form eleven huge Octavo volumes, while the *Puranas* extend to 2 million lines. I mention *quantity* so as to highlight the fact that the act of ignoring these texts is an act of monumental bias. These native texts are available, they have existed in English translations for decades, and are regularly performed on stage and village grounds by the common people (as Derek Walcott reminded us in his reference to the Ramlila Festivals at the opening of his 1992 Nobel Prize speech).

The *Ramayana*, narrated, sung and dramatized by Indo-Caribbeans from the days of indentureship to today, was important for several reasons. The story of banishment, exile and displacement and perilous new encounters among strange tribes, the story of a fall from grace into a prison-house of misery, served as an allegory of the experience of indentureship. We don't have to keep imposing a Homeric grid on native life, or agonize over Western theories of tragedy, to express the character of our West Indian historical and individual selves. Exile and homecoming are the *Ramayana*'s themes.

The *Ramayana* ends with the rule of Rama, the Golden Age, or Ram Raj, the Age of Light. The absence of poverty, petty jealousies, diseases, hunger and death was, of course, the antithesis of life in nineteenth-century United Provinces and Bihar from where Indo-Caribbeans originated, as well as the life that awaited them in the colonial plantation. Scholars like Clem Shiwcharan have argued that the shame of the actual past, and the guilt of severing family ties and abandoning traditional duties in fleeing to the colonial plantation, encouraged Indians to forget their specific origins. What replaced the sense of history was a sense of the *Ramayana*, and as direct contact with India diminished with time, it was the *Ramayana* which represented India to the descendants of indentured workers. 'It was an India that was as opulent, magical and epic as the fables of the *Ramayana*; a land on the brink of a Golden Age (a view strengthened, incidentally, in the 1940s, when India fought for and won independence from Britain; the second colony to do so).'[15] In other words, India existed in the

realm of the imagination and as a result the image of India was susceptible to manipulations in order to fit specific exigencies. India (the past) was made and remade with the same freedom with which the *Ramayana* was constructed – the *Ramayana* having no single authorship but being a product of writings and rewritings, accretions and transformations. The *Ramayana* existed in different versions, and not merely as a printed text. The *Ramayana* had an oral existence – for the common people it existed as stories and songs and dramatic performances which could be altered according to the nature of the audience or the nature of the performances or the nature of the landscape and environment, or simply the contingencies of the moment. If we want to identify postmodernism in the West Indies we can look at the ancient *Ramayana* and to its reception and enactments in the region. The coolie, wielding his cutlass before the cane in the nineteenth-century plantation, was, in a peculiar way, at the cutting edge of critical theory.

To conclude, to teach West Indian literature in the Western academy will be a flawed and partial exercise *until* the Amerindian and the East Indian, with their particular cultural and philosophical dimensions, are placed at the centre of our considerations. To do so will involve recognition that West Indian peoples are not merely creatures of Britain, forged by British cultural values. It will involve, therefore, redefinition of the character of the West Indian, with emphasis on the cultural values and practices that survived British colonization. Caribbeanists will have to be retrained, at the very least in terms of learning Sanskrit, Hindi or an Amerindian language. A concomitant redefinition of Britishness will emerge inevitably, one that recognizes Britain's historic inability to penetrate 'other' cultures; and one that qualifies the belief that still prevails, about the crumbling of 'native' cultures before Britain's superior imperial might.

Notes

1 Address to Association of Commonwealth Language and Literature Studies, University of Kent, 1989.
2 George Lamming, 'The Indian Presence as a Caribbean Reality', in F. Birbalsingh (ed.), *Indenture and Exile: The Indo-Caribbean Experience* (Toronto: TSAR, 1989), pp.45–54.

3 Alistair Hennessy, (London: Macmillan, 'Warwick University Caribbean Studies series, 1994/5).

4 Meenakshi Mukherjee, 'The Centre Cannot Hold: Two Views of the Periphery', in S. Slemon and H. Tiffin (eds), *After Europe* (Sydney and Aarhus: Dangaroo Press, 1989), pp.41–8.

5 Derek Walcott, 'Caligula's Horse', in *After Europe*, op.cit. pp.138–42.

6 See Diana Brydon, 'Commonwealth or Common Poverty?', in *After Europe*, op.cit., pp.ix–xiii.

7 Private communication with author, August 1995.

8 Paul Edwards (ed.) *The Life of Olaudah Equiano* (London: Longman, 1983), pp.80–1.

9 See D. Dabydeen, 'Eighteenth Century English Literature on Commerce and Slavery', in D. Dabydeen (ed.), *The Black Presence in English Literature* (Manchester: Manchester University Press, 1985), pp.26–49.

10 Aubrey Williams in conversation with Rasheed Araeen, in Anne Walmsley (ed.), *Guyana Dreaming. The Art of Aubrey Williams* (Sydney and Aarhus: Dangaroo Press, 1990), pp.43–61.

11 I am grateful to George Simon and Pauline Melville for insights into Amerindian perspectives, and to various essays by George Mentor, Jannette Forte, Anne Benjamin and Desrey Fox, published by the Amerindian Research Unit, University of Guyana. See, too, Andrew Sanders, *The Powerless People* (London: Macmillan, Warwick University Caribbean Studies Series, 1987).

12 I am grateful to Clement Shiwcharan's excellent study of Indo-Guyanese history, 'Effort and Achievement' (unpublished PhD dissertation, Centre for Caribbean Studies, University of Warwick, 1989) for information on this and other subjects.

13 Sasenarine Persaud, 'Extending the Indian Tradition', in *Indo-Caribbean Review*, vol. 1, no. 1, 1994, pp.15–28.

14 Ibid.

15 Clement Shiwcharan, op.cit., pp.39–49.

References

K.A. Appiah, 'Is the Post- in Postmodernism the Post- in Post-colonial?', *Critical Inquiry*, vol. 17, Winter 1991, pp.336–57

Bill Ashcroft, Gareth Griffiths and Helen Tiffin, *The Empire Writes Back: Theory and Practice in Post-colonial Literatures* (London: Routledge 1989), *The Post-colonial Studies Reader* (London: Routledge, 1995)

Francis Barker, Peter Hulme and Margaret Iversen (eds), *Colonial Discourse/Postcolonial Theory* (Manchester: Manchester University Press, 1994)

E. Baugh, *Critics on Caribbean Literature* (New York: St Martin's Press, 1978)

Laura Chrisman and Patrick Williams (eds), *Colonial Discourse and Postcolonial Theory: A Reader* (London: Harvester, 1993)

S.R. Cudjoe (ed.), *Caribbean Women Writers* (Cambridge, MA: University of Massachusetts Press, 1990)

D. Dabydeen, (ed.) *The Black Presence in English Literature* (Manchester: Manchester University Press, 1985)

D. Dabydeen and B. Samaroo (eds), *India in the Caribbean* (London: Hansib, 1988)

Arif Dirlik, 'The Postcolonial Aura: Third World Criticism in the Age of Global Capitalism', *Critical Inquiry*, vol. 20, Winter 1994, pp.329–56

Franz Fanon, *Black Skin, White Masks* (1952) (London: Pluto Press, 1986); *The Wretched of the Earth* (1963) (London: MacGibbon and Gee, 1965)

Paul Gilroy, *The Black Atlantic: Modernity and Double Consciousness* (London: Verso, 1993)

C.L.R. James, *Spheres of Existence* (London: Alison and Busby, 1980)

B. King (ed.), *West Indian Literature* (London: Macmillan, 1979)

Neil Lazarus, 'Disavowing Decolonization: Fanon, Nationalism and the Problematic of Representation in Current Theories of Colonial Discourse', *Researches in African Literatures*, vol. 24, no. 4, Winter 1993, pp.69–98

H. Maes-Jelinek, *Wilson Harris, The Uncompromising Imagination* (Sydney and Aarhus: Dangaroo Press, 1991)

Maso Miyoshi, 'A Borderless World? From Colonialism to Transnationalism and the Decline of the Nation State', *Critical Inquiry*, vol. 19, Summer 1993, pp.726–51

Chandra Mohanty, 'Under Western Eyes: Feminist Scholarship and Colonial Discourse', *Feminist Review*, vol. 30, Autumn 1988, pp.61–88

V.Y. Mudimbe, *The Invention of Africa* (London: Currey, 1988)

E. O'Callaghan, *Women Version* (London: Macmillan, 1993)

K. Ramchand, *The West Indian Novel and its Background* (revised edition) (London: Heinemann, 1983)

Venkat Rao, 'Self-formations: Speculations on the question of postcoloniality', *Wasifiri*, Spring 1991, pp.7–10

Edward Said, *Orientalism* (London: Routledge, 1978); *Culture and Imperialism* (London: Chatto and Windus, 1993)

Helen Tiffin, 'Postcolonialism, Postmodernism and the Rehabilitation of Postcolonial History', *Journal of Commonwealth Literature*, vol. 23, no. 1, 1988, pp.169–81

10
Shakespeare in quotations
JOHN DRAKAKIS

In his *Preface to Shakespeare* (1765) Samuel Johnson expressed some doubt that to isolate individual passages from Shakespeare was a worthwhile activity: 'he that tries to recommend him by select quotations, will succeed like the pedant in *Hierocles*, who, when he offered his house to sale, carried a brick in his pocket as a specimen.'[1] Imagine Dr Johnson's consternation if he were to read in a national daily newspaper, a justification for abridging Shakespeare on the grounds that complex structures could be reduced to 'sound-bites' and 'highlights'. In an article in the *Guardian* of 24 November 1992, entitled 'Soundbite Shakespeare', the following justification for carrying bricks in one's pocket was put: 'Anyone who watches sport on television will know that "highlights" from a football match are the best bits: the goals, the penalties, the exciting near misses. Highlights let viewers see all the important events in a game without seeing it all' (p.16). A more egocentric version of this principle might be the advent of Karaoke Shakespeare, available to what the *Guardian* has called 'Closet Branaghs or Oliviers' at a price of £50 for each play.

The analogy was, evidently, not lost upon those responsible for erecting what they believe to be a replica of Shakespeare's Globe Theatre in Southwark. In the 1993 Summer issue of *The Globe Newsletter* (p.5) the following item of news appeared:

Globe Education, Southwark Education Department and Millwall Football Club are working together to bring football and Shakespeare into the classroom this Autumn.

Millwall FC will team up with Globe Education Players to take workshops into Southwark secondary schools, inspiring classroom work on crowd and rehearsal scenes from a number of different Shakespeare plays.

Participating students will visit the new Millwall ground, attend a team training session and watch a match as guests of the directors of the club. Students will also be given tickets to a Shakespeare production prior to giving their own performances of chosen scenes on the Shakespeare Globe Museum Theatre stage.

Globe Education is grateful to Millwall FC for their generous contribution and support – funding is now being sought to ensure the Globe gets a result!

As the images of competitive sport, crowd allegiances, and educational goals gather momentum in this extraordinary narrative, we might be forgiven for thinking for a moment that, contrary to the view once expressed by the Wharton Professor of English at Oxford that 'Whatever *King Lear* may be about, it's not about Manchester United',[2] here, an attempt is being made *through* an alignment with a particular and controversial English football club, to reinvest Shakespeare with a 'popular' cachet as a prerequisite to an acceptance of the Bard. The disingenuousness of this appeal is manifest in its attempt to negotiate the chasm between 'high' and 'low' culture while implying that Shakespeare has something to offer by way of an understanding of the control of football crowds. What emerges also from this report is an anxiety of being overwhelmed by uncultured crowds, a fear of being submerged in a hostile, and by definition antagonistic *popular* culture for which Shakespeare, once a practitioner of 'popular culture', has come to carry little authority.

And yet, such projects are predicated upon the Shakespeare canon as a resource for what Dr Johnson called 'practical axioms and domestick wisdom'[3] and as a repository for universal truths. It is, in short, predicated upon the more general view that literature is a source of actual experience, and has always

fulfilled this cultural function. As such this practice has a long literary pedigree and one of its chief cultural effects is one of legitimation. Let us consider two examples of this process, both from the nineteenth-century novelist Charlotte Brontë. In *Jane Eyre*, while Jane is at Thornfield Hall, she is invited to have her fortune told by a 'sybil':

> She had on a red cloak and a black bonnet: or rather, a broad-brimmed gipsy hat, tied down with a striped hand-kerchief under the chin. An extinguished candle stood on the table; she was bending over the fire, and seemed reading in a little black book, like a Prayer Book, by the light of the blaze: she muttered the words to herself, as most old women do, while she read; she did not desist immediately on my entrance: it appeared she wished to finish a paragraph.

Jane is told that her master, Mr Rochester, with whom she is in love, is shortly to be married to Miss Ingram, and after receiving a description of her own character, the sybil instructs her, in a different voice from the one she had used throughout the interview, to 'Rise, Miss Eyre: leave me; "the play is played out"'. This induces a feeling of reverie in Jane as the sybil removes her cloak and hat with the words: '"There, then – Off, ye lendings!" And Mr Rochester stepped out of the disguise.' The quotation from *King Lear* is not entirely accurate: 'un-accommodated man is no more but such a poor, bare, forked animal as thou art. Off, off, you lendings! Come; unbutton here' (*King Lear*, III.iv.109–12). But, then, nor does it accurately record the identity of Rochester, who at this point permits Jane to think that by discarding his disguise he is now revealed in his 'true' colours. It is not until some six chapters later, when Jane is on the verge of marrying Rochester, that she discovers the 'truth' about him, that he is already married: 'Mr Rochester was not to me what he had been; for he was not what I had thought him.' In order to grasp the full irony of this intertextual encounter it is necessary to be aware that in the Shakespearean text Lear's discarding of his clothes is part of a more profound search for identity. Our awareness of the source of the quota-tion as a model of truth sharpens our perception of the impact of Rochester's distortion, and we are persuaded to realize, long before Jane does, that 'the attribute of stainless truth was gone from his idea'.

In a similar manner, in the later novel *Shirley*, Caroline Helstone, on a visit to the intransigent mill-owner, Mr Robert Moore, invites him to read *Coriolanus* so that he may 'discover by the feelings the readings will give you at once how low and how high you are':

Coriolanus in glory; Coriolanus in disaster; Coriolanus banished, followed like giant-shades one after the other. Before the vision of the banished man, Moore's spirit seemed to pause. He stood on the hearth of Aufidius's Hall, facing the image of greatness fallen, but greater than ever in that low estate . . .

The march on Rome, the mother's supplication, the long resistance, the final yielding of bad passions to good, which ever must be the case in a nature worthy the epithet of noble, the rage of Aufidius at what he considered his ally's weakness, the death of Coriolanus, the final sorrow of his great enemy; all scenes made of condensed truth and strength, came on in succession, and carried with them in their deep, fast flow, the heart and mind of reader and listener.

This invocation of Shakespeare as a touchstone of education, as well as a perennial source of universal truths, presupposes what Michel Foucault has called, in another context, particular 'relations of meaning',[4] and we would do well to bear in mind the various *historical* and *cultural* connections which inhere in such relations. Indeed, the erasure of context from individual quotations, or from those works as a whole that we designate 'literary', is an irreducibly *ideological* operation which the larger study of culture and its internal structures is concerned to elucidate.

The extent to which Shakespearean analogies and/or quotation can be used to shore up or, indeed, to thematize, if not to occlude entirely the real conditions of social reality, can be gauged by the narrative of the fall of Margaret Thatcher in November 1990. Here, a tawdry piece of political in-fighting was systematically recast by journalists and politicians alike as a tragedy of Shakespearean proportions. In *The Times* of 23 November 1990 the former Tory MP Matthew Paris cited Dr David Owen, former leader of the British Liberal Democratic Party, who had invoked the analogy of *Julius Caesar*. Paris

thought *Coriolanus*'s 'Bring in the crows to peck the eagles' a more appropriate epigraph. By the beginning of the following week, an unseemly political *coup* had been reconstituted as a truly Shakespearean drama, to the point where on Monday 26 November, the *Guardian* theatre critic, Michael Billington, in an article whose title is itself a Shakespearean echo, 'Are You Content to Resign the Crown?' could, with a full sense of irony, reinscribe the punctual demise of Mrs Thatcher within the teleological models of Shakespearean and Sophoclean tragedy; half- seriously, he asked: 'Did Shakespeare – or Sophocles – prophesy Thatcher's downfall?' Again, the *Julius Caesar* analogue was the occasion for comment:

> It is ironic that everyone has dipped into the Bard to describe Thatcher's downfall: it was, after all, her shift from public subsidy to corporate sponsorship that helped to drive Shakespeare off all but a tiny handful of our stages. David Owen and others have also rather cornily looked to Julius Caesar for parallels with Mrs T's demise. True, Mrs Thatcher, like Shakespeare's Caesar had a penchant for 'sleek-headed men' and I suppose it is just possible to see Howe as an agonizing Brutus and Heseltine as a lean and hungry Cassius. But it is a bit difficult to cast Norman Tebbitt in the role of sexy hedonist, Mark Antony.[5]

This mischievous gallimaufry of Shakespearean quotations functions inadvertently both to raise the status of Mrs Thatcher, and to adjust, in an almost mock-Thatcherite manner, the relationship between an outrageously blinkered egocentric, and the ostensible source of legitimizing the narrative of her downfall. Indeed, Billington's favourite analogy was with *Richard II*, for like Shakespeare's hapless hero, Mrs Thatcher was 'capricious, impetuous, authoritarian, surrounded by favourites and plagued by insoluble Irish problems ("We will ourselves in person to this war" even has a vaguely Thatcherite ring)'. We may note in passing that the parenthesis here effectively *reverses* the relationship between Mrs Thatcher and Richard II; it is now Mrs Thatcher's narrative which can validate Shakespeare's; she is, in this reading, more English than the Bard himself, the icon of Englishness, and the touchstone of tragic experience. This interesting and momentary reversal produces a repetition of Shakespeare's fictive

historical narrative, as Billington encourages us to transform reality into fiction. In this fiction Mrs Thatcher's rival, Michael Heseltine, becomes the ambitious figure of Bolingbroke waiting for the king (Mrs Thatcher) to give up the crown:

> Wednesday night [November 21] in Downing Street must have been exactly like the scene at Barkloughly Castle where a succession of messengers enter bearing news that makes the abdication of the king inevitable. In defeat Richard, like Mrs Thatcher, acquires a sympathy vote he never achieved in power. But there is an even more serious parallel: the extent to which both, despite swingeing taxes, allowed the realm to fall into disrepair.

This attempt to *produce* an organic history from a more mundane, contradictory chronology of events can be made to disclose the conditions of its fabrication. The transformations of gender that take place as Mrs Thatcher becomes a tragic hero, or even more, the actual model for a Shakespearean tragic hero, permits the corporeal body of the 'Iron Lady' famed for her 'resolute approach' to succumb to the demands of a secretive providence, while permitting the *corpus mysticum* of Thatcherism to live on. The tacit assumption here is that the hermeneutic mastery that is the precondition of our acceptance of Shakespeare as a cultural icon may now be ascribed to that other master/mistress, Mrs Thatcher, whose reputation has rested upon her claim to be an icon of Englishness. What is also tacitly assumed is that Shakespearean quotations hold good, that they are a manifestation of Shakespearean 'presence', whatever the context, and that this is coterminous with what is essentially the model of 'Englishness', as clear an example of the ideological imbrication of 'truth' in the networks of power as one could wish for.

The complexity of this teleological narrative is focused in one surprising 'quotation'. In one sense, it conforms to Derrida's rule concerning the *iterability* of every sign. In a discussion which has far-reaching consequences for the study of literature, and which complicates considerably the notion of context to which I alluded earlier, Derrida asserts the following:

> Every sign, linguistic or non-linguistic, spoken or written (in the current sense of this opposition), in a small or large unit

can be *cited*, put between quotation marks; in so doing it can
break with every given context, engendering an infinity of
new contexts in a manner which is absolutely illimitable.[6]

In the *Sunday Telegraph* of 25 November 1990, the chief editor,
Sir Peregrine Worsthorne began a leader column bearing the
title, 'Who'll Speak for England?' with the following Shakes-
pearean epigraph: 'the odds is gone,/And there is nothing left
remarkable/Beneath the visiting moon.' The quotation is from
Antony and Cleopatra, and its originary context is the moment,
not of Cleopatra's death, but of Antony's. The scene begins
with Antony's own admission that 'Not Caesar's valour hath
o'erthrown Antony,/But Antony's hath triumph'd on itself.'
(IV.xv.14–15). Some three years later, in a television interview,
Mrs Thatcher was to describe her own demise as 'Treachery.
It was treachery with a smiling face.' Sir Peregrine Worst-
horne's identification of Mrs Thatcher with the dying Mark
Antony, and his implicit arrogation to himself of the iden-
tity of Cleopatra, all in the interests of a truly Thatcherite
xenophobia, renders this narrative model both complex and
problematic. Nor is Worsthorne's grasp of history any more
controlled than his grasp of Shakespeare. His quotation is
followed by this astonishingly revisionist statement:

> Only the British care about, and take pride in, their political
> institutions, which have developed over 1,000 years of
> unbroken constitutional history. Our nationalism is not so
> much cultural or economic as political, and only an ignorant
> fool could believe that a Euro-state would adopt the British
> parliamentary system.[7]

Worsthorne's quotation derives a peculiar significance from its
iterability. It inadvertently foregrounds a very problematic
exercise in metaphoric cross-dressing, but it also hints darkly
at the erotic roots of national political power, in addition to
enlisting the National Bard in a *political* discussion about who,
in the absence of Mrs Thatcher, is now qualified to *speak* for
England. This eroticizing of power enlists a particular Shakes-
pearean 'figure' for a usage in what Roland Barthes would call
'the signifying economy of the amorous subject'.[8] Moreover,
Worsthorne enlists, through the 'figure' of the National Bard,
the identity of the Oriental (Cleopatra/Worsthorne) lamenting

the demise of an imperial Roman colonizer (Antony/Mrs Thatcher) whose reputation, paradoxically, rests upon an unstinting propensity to 'Speak for England'.

This 'consultation' of Shakespearean texts is nothing other than a process of mythmaking. That is to say, historically contingent events, bound up in questions of power, gender and national identity, whose precise details are still uncertain and contradictory, are submitted to a series of exemplary fictions, with the result that they are emptied of almost all but their aesthetic significance. Moreover, what we witness here is the *production* of a series of essentialist meanings which function to transform a sequence of historical and political events into a series of permanent, one might say almost literary, 'truths'. Ironically, this peculiar use of quotation exposes to view the fundamental *disunity* and *relativity* of the 'myth' whose unity and absolute source it is ostensibly designed to sustain.

This process is worth glossing in a little more detail. In an early work, *Mythologies* (1957), the late Roland Barthes described myth as a special type of language; he observed that 'myth is a system of communication . . . it is a message', and that once this is accepted, 'This allows one to perceive that myth cannot possibly be an object, a concept or an idea; it is a mode of signification, a form.'[9] By insisting that myth is *form* rather than *content*, Barthes directs our attention to the question of 'style', an addition to language that exposes its irreducibly *social*, and hence rhetorical and political function. For Barthes, myth derives its signifying power from its capacity to perform a double function: 'it points out and it notifies, it makes us understand something and it imposes it on us'. Moreover, it generates conflict derived from a confrontation between *meaning* inherent in the language object itself which is 'already complete', and which 'postulates a kind of knowledge, a past, a memory, a comparative order of facts, ideas, decisions', and its process of becoming form where, 'meaning leaves its contingency behind; it empties itself, it becomes impoverished, history evaporates, only the letter remains'.[10] The narrative of the fall of Mrs Thatcher subscribes to the kind of distortion that myth produces, enabling the National Bard, a symbol of Englishness, to be deployed as a means of *inflecting* a contemporary political crisis in order to divert attention away from its historical specificity. The result is that a series of historically contingent

events is rendered a 'tragic' necessity, initiated and sustained by an impersonal, quasi-divine, 'natural order'. Thus, what Barthes defines as 'the very principle of myth' is satisfied: 'it transforms history into nature'.[11]

In this instance it is a complex transformation, since, among other things, it elides the concepts of national history and universal truth through the legitimizing medium of a cultural icon, Shakespeare.[12] Crucial also to the present concern is the notion of myth as the product of an exchange which takes place between a historically contingent reality and the eternal, the effect of which is to produce what Barthes calls *depoliticized speech*. Reality, it can be shown, 'enters language as a dialectical relation between activities, between human actions', but it emerges from myth as 'a harmonious display of essences'.[13] In this way the narrative of Mrs Thatcher's downfall, curiously, occludes politics, and becomes a tragic drama in the Sophoclean or Shakespearean mould.

II

Thus far, I have been concerned with forms of quotation which are dependent upon the originary authority of Shakespeare, quotations which reinforce the view that literature is the model, and in some senses the explanation, of cultural experience. Individual events bask in a reflected glory, and human actions, whether in fiction or in everyday reality are reconstituted in a legitimized form as a consequence of their acknowledgement of a Shakespearean archetype. We are in some sense back with Dryden's claim that Shakespeare: 'was the man who of all Modern, and perhaps Ancient Poets, had the largest and most comprehensive soul. All the Images of Nature were present to him, and he drew them not laboriously, but luckily'.[14] I will now turn to another species of quotation for which the terms burlesque and parody might be a useful starting point, but also for which the term 'appropriation' might indicate a general sense of political engagement. This engagement takes the form of a challenge to the monologic claims made in the name of iconicity, and in doing so restores a degree of historicity and cultural specificity to the process. Such quotation, I want to argue, systematically challenges monologic authority, serves as a means of giving the process of mythologizing Shakespeare a

specific historical context, and promotes the idea of Shakes-pearean texts as sites of contestation, as opposed to being repositories of cultural wisdom.

In his *Rabelais and His World* Mikhail Bakhtin distinguished between medieval parody with its combination of degradation and regeneration, and what he called 'the purely formalist literary parody of modern times, which has a solely negative character and is deprived of regenerating ambivalence'.[15] In an analysis of 'Contemporary Shakespearean Parody in British Theatre', Clive Barker has attempted to distinguish between the kind of intellectual parody which is 'philistine and con-temptuous', and 'the less literate and less intellectual Music Hall parodies' which, he argues, 'do have in them some respect for cultural values'.[16] The issue of cultural value, is, of course, a vexed one in that it implies an opposition between those continuities which we associate with tradition, and a much more historically specific, relativistic, ethos which is driven by an impetus for change and transformation. Of course, parody *can only be* respectful to 'cultural values' in a purely relativistic sense, since what it evinces is an implicitly politically inflected approach to an original rather than an identification with its cultural value. To this equation we should also add the demise of what Walter Benjamin called 'the authenticity' of the original, the challenge mounted by mechanical reproduction to 'the essence of all that is transmissible from its beginning, ranging from its substantive duration to its testimony to the history which it has experienced'.[17] The form of reproduction which parody, like any other form of reproduction, involves extracts from the original its 'aura', and in this process of prying 'the object from its shell', the ritual function of art is dimin-ished, and the work comes to be based on 'another practice – politics'.[18] This is a very different process from that which asserts a continuity between the original and its subsequent incorporation into the structures of contemporary experience, in short, its iconic value.

This returns us to Foucault's concept of 'the relations of meaning', which I mentioned earlier, and to the intersecting of politics with epistemology that this involves. Foucault goes on to argue that these relations of meaning are implicated dynam-ically in a 'general politics of truth':

truth isn't outside power, or lacking in power: contrary to a
myth whose history and functions would repay further study,
truth isn't the reward of free spirits, the child of protracted
solitude, nor the privilege of those who have succeeded in
liberating themselves. Truth is a thing of this world: it is
produced only by the multiple forms of constraint. And it
induces regular effects of power. Each society has its 'general
politics' of truth: that is, the types of discourse which it
accepts and makes function as true; the mechanisms and
instances which enable one to distinguish true and false
statements, the means by which each is sanctioned; the
techniques and procedures accorded value in the acquisition
of truth; the status of those who are charged with saying what
counts as true.[19]

We are familiar with those emblems of 'the Shakespeare myth'
which appear on English £20 notes, on advertisements for
cigars, lager or soft drinks. When Juliet leaves Romeo 'with
these words . . . Can't beat the feeling . . . Coke' or, more
intriguingly, when, in a 'lonely hearts' advertisement, the line
'Wherefore art thou, Romeo?' is glossed with the comment
'They didn't join *Dateline*', what appears to be at issue is the
combination of universal culture and global capitalism locked
in an arabesque of mutual validation. No longer does the line
'Wherefore art thou, Romeo' signal a tragic dilemma, rooted
at the heart of language itself, rather 'Dateline' is offered as a
solution to the problem of partnership: 'Whether you are looking
for new friends or a partner for life, Dateline could be for you.'
In other words, in its attempt to isolate the 'romantic' elements
of Shakespeare's drama, 'Dateline' seeks to rewrite the tragedy;
had Romeo and Juliet used 'Dateline' then theirs could have
been one of many 'long-lasting relationships'. Here the mani-
fest strategy of invoking a Shakespearean quotation as an
instrument of legitimation is radically undermined by the
implied suggestion that the tragic impasse to which the 'star-
crossed' lovers are brought is negotiable at a purely secular and
'affordable' level.

 Alan Sinfield has recently shown how, in an extraordinary
advertisement in the February 1989 issue of *Armed Forces Journal
International* for the Royal Ordnance Company, a nostalgia for
lost imperial power is aligned with an allusion to Shakespeare's

Globe Theatre, as the newly privatized company which took advantage of the entrepreneurial opportunities offered by the Gulf War claimed to 'Play the Globe. All of it'. Sinfield continues:

> The Globe is indeed famous all round the globe; it is the part of English achievement that still flourishes; the best-known 'royal' institution after the monarchy is the Royal Shakespeare Company. For US entrepreneurs, it may yet recall the power that blasted out a world-wide empire, once including Iraq; once even including North America.[20]

Here a British company, formerly publicly owned, is shown exporting both its products, military arms, and a culture which it uses to validate its own economic imperialism, even to those countries which were part of its former empire. Sinfield shrewdly identifies the relation which exists between a 'military-industrial complex' and 'cultural power'[21] but there is a sense in which at the level of the exchange of cultural icons the process is two-way. The export of military arms and cultural cachet is matched, and has been for some time, by the reimportation of the very source of that cultural power in the guise of a universal touchstone of experience.

Differences of social class emerge sharply in two examples of British parody, both from the world of popular television comedy. The first is a sketch by the late Tommy Cooper, a comedian noted for his incompetence as a magician. In this sketch, entitled 'Tommy the Troubadour', Cooper assumes the role of Hamlet, and engages the skull of the jester Yorrick in a dialogue which gestures irreverently towards a particular performance of this part of Shakespeare's text, that made famous by Lord Olivier. The comedy works through a series of incongruities which function to reinscribe the scene from Olivier's *Hamlet* within Cooper's own familiar lexicon of incompetent performances. 'Tommy the Troubador' extrapolates from Olivier's performance the comic ventriloquistic possibilities implicit in Hamlet's instruction to Yorrick's skull to: 'Now get you to my lady's chamber and tell her, let her paint an inch thick, to this favour must she come' (V.i.186–8). Mockery and self-mockery are subtly intertwined in Cooper's performance, involving a rewriting and a negotiation of Shakespeare's text *and* Olivier's rendition of it, as it passes from one

context, that of the 'legitimate' theatre, to a series of rival institutions, Music Hall, and its popular successor, television. Cooper's intercutting of the inaccurately formulated Shakespearean quotation – 'Alas poor Yorrick. I knew him well' – with other popular entertainment routines systematically erodes the problematic 'authenticity' of the original. Moreover, Cooper's unkempt hair, his corpulent figure, and his enlistment of the skull in a thoroughly incompetent ventriloquist's routine combine to produce a carnivalesque demystification from below of an episode which has always elicited reverential awe from Shakespearean critics. Stripped of its 'aura', the scene becomes just one of a number of sketches whose fragmentary existence as a series of televisual performances radically undermines whatever unity or coherence the original material may have possessed.

The second example is of a similar kind but more complicated. As with the Tommy Cooper sketch, Morecambe and Wise, two very popular television comedians, clearly had a particular performance in mind. Their contribution to the celebration of 'the quatro-centenary celebration of our National Bard, William Shakespeare' in 1964 was a performance of Marc Antony's funeral oration from *Julius Caesar*, and the prefatory image of Marlon Brando as Antony gestures towards the Joseph Mankiewicz film of 1953. The late Eric Morecambe played Antony, and his partner Ernie Wise played 'the body of Caesar', in a performance which sees the body become animate and assisting in various ways in the performance, various interpolations and interjections which undercut the complex Shakespearean rhetoric, a parodying of the 'seriousness' of Antony's speech, culminating finally in the body of Caesar carrying Antony from the stage. In what is ostensibly a 'celebration', Morecambe and Wise systematically demystify the conventions of theatrical performance; demolishing them, in the words of Albert Hunt, 'from the inside'.[22] Unlike Tommy Cooper, who systematically misquotes Shakespeare, Morecambe remains substantially faithful to the original, occasionally commenting on its general efficacy, and upon the difficulties of his own performance, while the combination of absurd physical gesture and the animation of 'the body of Caesar' punctures the mimetic aspirations associated with traditional 'live theatre'. Here the 'popular' reinterprets the

'highbrow', though it has to be said that in each case the 'original' is not the authentic Shakespeare, but a film version, and an American film version at that. Here institutional and class politics constitute themselves around the figure of the National Bard whose identity admits of yet another imperialist inscription: he is the National Bard of America, a former colony, which can now lay equal claim to this valuable cultural property.

But what effect does this comic deflation of 'aura' have on our perception of the status of 'Shakespeare'? In his *Jokes and Their Relation to the Unconscious*, Freud locates laughter as a moment when 'a quota of psychic energy which has earlier been used for the cathexis of particular psychic paths has become unusable, so that it can find free discharge.'[23] I want to emphasize that the energy cathected with objects such as *Hamlet* or *Julius Caesar* derives its existence primarily from a constellation of social factors including the affiliations of class, and the oppositions between 'high' and 'low' culture, and, in the cases that I have just quoted, possible colonial rivalries. Our relationship as spectators to the performers corresponds both to the dynamic of the joke *and* to the function of comedy, which Freud outlines. Cooper and Morecambe are both the objects of our laughter – and as such their situation corresponds to Freud's notion that 'the comic process is content with these two persons: the self and the person who is the object'[24] – *and* they enable us to assume the identity of 'the *third* person' who is the recipient of the joke and for whom the object of laughter is 'Shakespeare'. Ironically, Freud uses a quotation from Shakespeare's *Love's Labours Lost* to emphasize his point: 'A jest's prosperity lies in the ear/Of him that hears it, never in the tongue/Of him that makes it'.[25] The overall result is to prise this cultural icon free from that cultural energy with which it is cathected, and to dissolve the 'essence' of its mythology in a carnivalesque laughter, where the boundaries between the roles of actor and spectator are fluid.[26]

The effect of this process is to disintegrate the Shakespearean text to the point where it becomes, like all other texts, what Julia Kristeva would call 'a mosaic of quotations'.[27] This dispersal of originary presence prises the text free from its own formal narrative teleology, redefines its status in *relative* terms, and thus renders it amenable to revision or alteration which

discards the principles of relevance, sameness and continuity in favour of an emphasis upon alterity and cultural *difference*. With the endless circulation of Shakespearean quotations now sharing the same status as other forms of representation, we have entered the realm of the postmodern.

III

The challenge to grand narratives and the crisis of epistemology, both of which typify postmodernism, have done much to disperse the originary power of Shakespearean texts within Western culture generally. But there is something more complicated going on here than a simple reimportation into the host culture of its own exported cultural products. Potentially conflictual claims are negotiated on the site of Shakespearean texts, and are manoeuvred into narratives of social experience within which they are domesticated, even naturalized. John McTiernan's film *Last Action Hero* (1993), an attempt to explore at a popular level the consequences of an anti-humanist contempt for heroic Enlightenment narratives, gestures ambivalently, in this way, towards the originary authority of cultural icons. The boy Daniel Madigan, besotted with his 'action hero' Jack Slater (played by Arnold Schwarzenneger), leaves the cinema where he indulges his fantasies for the classroom where a teacher, played by Joan Plowright, is teaching *Hamlet*. The ironies proliferate as she attempts to make the play 'relevant' by suggesting that the Prince was 'one of the first action heroes'. Hamlet is, of course, played by her late husband Lord Olivier, who, she suggests patronizingly, the class will recognize for his roles in Polaroid commercials, and as Zeus in the film *Clash of the Titans*. Here the reputation of an established British actor is reduced to the level of popular Hollywood film, and his widow, Joan Plowright, registers a laconic irony that this should be his fate, one that appears to parallel that of Shakespeare, although she is manifestly unaware of the contradiction of her own position here. The wordiness of the Shakespeare original is shown up as a manifestation of *inactivity* compared with the Schwarzenneger alternative. Images are superimposed on each other, as Olivier's ponderousness gives way to the figure of a Nietzschean psychopath, for whom even Yorrick's skull, Tommy Cooper's ventriloquist's 'dummy', now becomes a

weapon in what is an exercise in ruthlessly efficient 'house-cleaning'. This is not Karaoke Shakespeare, so much as the alignment at the level of strict equivalence of one myth – Schwarzenneger as Jim Slater, as Hamlet – with another, that of Shakespeare as cultural and educational icon, imported and transformed, articulated in the register of the Hollywood cartoon. Hamlet's Renaissance 'efficiency' is shown to be irrelevant to the requirements of the postmodern present where superior power is determined only by complete mastery of a bewildering array of destructive technology, itself uncomfortably aestheticized. In its movement between different levels of illusion, the film works, to use a formulation of Jean-Francois Lyotard, 'without rules in order to formulate the rules of *what will have been done*'.[28] In the film the future is with the proto-Nietzschean Danny able to preserve his hero by a manipulation of levels of illusion, and to participate in the correction of the fictional Slater's filmic past. Indeed, the film never settles down to a coherent narrative.

Once the iconic status of Shakespeare has been dissipated on a truly global stage, then possession of the canon becomes a matter of struggle at the level of representation. For example, in Paul Verhoeven's film *Robocop* (1987) the ethos of *Last Action Hero* is anticipated in two contradictory references to *Hamlet*. In the first, the chief of a now privatized police force justifies the violence of law in the following terms: 'Old Detroit has a cancer. The cancer is crime and it must be cut out before we can employ the two million workers that will breathe new life into this city again.' There is little to choose between crime and free enterprise in the film, and this passing reference to *Hamlet*, which links the first two letters of *De*nmark with *De*troit, and the dream city of the future, the crime-free *De*lta City, gives way to a horrifying encounter as the Hamlet-like figure of the policeman, Murphy, confronts a group of psycopathic killers whose leader, it turns out, is in the pay of the chief's deputy. Now it is the villains, demonized agents of a ruthless trans-atlantic economic individualism, who quote Shakespeare, in an anarchic gesture which subverts law and mocks the assumed efficacy of culture. Again, the problem can only be solved by a curious combination of technology and ethics rather than by the invocation of cultural icons.

Perhaps the most sophisticated example of this form of

contestation, which foregrounds the very colonialist struggle for powerful cultural icons manifested in these and many other examples from American film, occurs in Nicholas Meyer's *Star Trek VI: The Undiscovered Country* (1992). The video blurb announces that 'a Shakespeare quote from *Hamlet* relating to a future of universal peace is an excellent link between past, present and future. Serving as a metaphor for the recent ending of the Cold War this is the basis for the sixth instalment of the Star Trek movies.' Throughout the film it is the evil Klingons who articulate, in a variety of tones, the various stages in the narrative through the mediating glass of Shakespearean quotations. The process begins with the arrival of a Klingon diplomatic mission aboard the USS Enterprise, and with the proposing of a toast by the Klingon chancellor Gorkon: 'To the undiscovered country: the future.' Mr Spock, a Vulcan, and whose logical bent of mind eliminates any capacity for human feeling, identifies the quotation and considers it inappropriate: 'more appropriate to a wake than to a diplomatic dinner'. This becomes the occasion for a contestation of meaning as Gorkon asserts: 'You've not experienced Shakespeare until you've read him in the original Klingon.' Indeed, Gorkon's statement avails itself of a strategic essentialism in an attempt to appropriate a cultural icon whose authority is truly intergalactic, and who also happens to be Captain Kirk's 'favourite author'. This powerful challenge to gatekeepers of history such as Kirk has spilled over from fiction into reality as a group under the direction of an American professor of psychology, Lawrence Shoen, have begun to translate Shakespeare into Klingon, and have plans also to translate the Bible.[29] In Meyer's film an evil empire makes of the Shakespeare canon a postmodern montage of quotations, which are returned to their legitimizing origins in tones of mockery designed to divest them of their authority. The film presents itself as a 'mining', indeed, an 'overmining', of Shakespeare, whose ultimate effect is to 'undermine' its cultural authority. The film's 'uncloaking' of Klingon treachery involves also the exposure of the United Space Federation's own 'cloaked' mechanisms of sustaining its imperial power. Inadvertently, the *ideological* content of the Shakespeare myth is disclosed and its hegemonic position is challenged from the intergalactic margins.

In *Star Trek VI* a contemporary political debate is conducted

in part through the metaphor of Shakespeare. The claim to originality mounted by the Klingons is itself not original.[30] The issue here, of course, is to do with myths both of origin and of essentialist meaning. Terence Hawkes puts the matter succinctly in his general observation regarding Shakespearean texts:

> A text is surely better served if it is perceived not as the embodiment of some frozen, definitive significance, but as a kind of intersection or confluence which is continually traversed, a no-man's land, an arena, in which different and opposed readings, urged from different and opposed positions, compete in history for ideological power: the power, that is, to determine cultural meaning – to say what the world is and should be like.[31]

In *Star Trek VI* Shakespeare is subsumed into a more general cultural and moral allegory in which the power of literary icons is used to augment the devastating power of laser cannons. What makes the film a surprisingly rich cultural document is its use of Shakespearean quotation as the medium through which different political ideologies engage in a contest. Possession of Shakespeare in itself is no guarantee of cultural supremacy. In fact the film 'uncloaks' the mystified power of a thinly disguised Western alliance which is now subjected to assault from the very cultural weapons that it could normally expect to count on in its imperial quest to colonize deep space. In some respects we can read the film as an allegory of the political battle waged to harness the power of cultural icons, although the action is weighted very firmly in favour of one set of cultural and moral codes as opposed to another.

In considering texts which have come to possess lasting cultural value for us, it has been traditionally assumed that they offer a path upwards from barbarism to civilization, where the one state is to be deplored, and the other regarded as a desirable objective. Here the opposition between 'popular culture', which is considered negatively as the product of consumer capitalism, and 'high culture', which rises above such philistine concerns to offer a set of lasting values, shades into a mythology which all but effaces the conditions of its own production. The iconic power of Shakespeare in this process has depended upon his capacity to provide models for a human

experience that is, allegedly, unchanging. But with the persistent questioning of referential models of language, and the politicizing of modes of representation, the coherence of cultural icons has undergone radical challenge. The need to develop narratives which account more accurately for the conflicts and contradictions inherent in particular social formations has generated new modes of reading which resist the seductive power of an appeal to continuity and coherence. In this new context, the fragmentation of what was once a Shakespeare 'canon', and its dispersal across the full range of cultural productions, serves to empower those hitherto occluded from the sphere of 'high culture', and to demystify the process of civilization itself. Its effect is also to return Shakespeare to what Terry Eagleton has described as 'the material practices, social relations and ideological meanings in which it (Art) is always caught up, and raised to the status of a solitary fetish'.[32]

The step from *Star Trek VI* to John McTiernan's *Last Action Hero* is a short one indeed and is symptomatic of a radical shift of emphasis. Shakespeare now *is* primarily a collage of familiar quotations, fragments whose relation to any coherent aesthetic principle is both problematical and irremediably ironical. He is one of a number of instances in which simulacrum has become a material 'reality' in the same way that fiction is now not an escape from the real but a historically specific encounter with it. In this complex process in which cultural icons, such as 'Shakespeare', themselves are both fetishized and *at the same time* are deployed in resistance to fetishization, history is that pluralist, multiform trace of discontinuous, conflicting practices in which the variable elements of power cohere, disperse and are reconstituted.

Notes

1 Walter Raleigh (ed.) *Johnson on Shakespeare*, (reprinted, Harmondsworth: Penguin, 1957), p.12.
2 See K.M. Newton, 'Interest, Authority and Ideology in Literary Interpretation', *The British Journal of Aesthetics*, vol.22, no.2, 1982, pp.103ff.
3 Raleigh, op.cit., p.12.

4 Michel Foucault, *Power/Knowledge: Selected Interviews and Other Writings*, ed. Colin Gordon (Brighton: Harvester, 1980), p.114.

5 Michael Billington, 'Are You Content to Resign the Crown?', *Guardian*, 26 November 1990, p.35.

6 Jacques Derrida, 'Signature, Event, Context', *Glyph I*, ed. Samuel Weber and Henry Sussman, (Minneapolis: University of Minnesota Press, 1977), p.185.

7 Peregrine Worsthorne, 'Who'll Speak for England?', *Sunday Telegraph*, 25 November 1990, p.22.

8 Roland Barthes, *A Lover's Discourse: Fragments*, transl. Richard Howard (Harmondsworth: Penguin, 1990) pp.7–8.

9 Roland Barthes, *Mythologies*, transl. Annette Lavers (St Albans, Herts: Paladin, 1973), p.109.

10 Ibid, p.117.

11 Ibid., p.126.

12 See Simon Barker, 'Images of the Sixteenth and Seventeenth Centuries as a History of the Present', Francis Barker, Peter Hulme, Margaret Iversen and Diane Loxley (eds), *Literature, Politics and Theory: Papers from The Essex Conferences 1976–1984* (London: Routledge, 1986), p.180.

13 Barthes, *Mythologies*, op. cit., p.142.

14 Brian Vickers (ed.) *Shakespeare: The Critical Heritage Volume I 1623–1692*, (London: Routledge, 1974), p.138.

15 Mikhail Bakhtin, *Rabelais and His World*, transl. Helene Iswolsky, (Cambridge, MA, and London: MIT Press, 1968), p.21.

16 Clive Barker, 'Contemporary Shakespearean Parody in British Theatre', *Shakespeare Jahrbuch*, vol. 105, 1969, pp.110–11.

17 Walter Benjamin, 'The Work of Art in the Age of Mechanical Reproduction', in *Illuminations*, transl. Harry Zohn (Glasgow: Fontana/Collins, 1973), p.223.

18 Ibid., pp.225–6.

19 Foucault, op.cit., p.131.

20 Alan Sinfield, *Faultlines: Cultural Materialism and the Politics of Dissident Reading* (Los Angeles and Oxford: University of California Press, 1992), p.5.

21 Ibid.

22 Albert Hunt, 'Give Me Laughter', in Paul Barker (ed.), *Arts in Society* (Glasgow: Fontana, 1977), p.232.

23 Sigmund Freud, *Jokes and Their Relation to the Unconscious*, ed. Angela Richards (Harmondsworth: Penguin, 1976), p.199.

24 Ibid., p.195.

25 Ibid., p196.

26 See Julia Kristeva, *The Kristeva Reader*, ed. Toril Moi (Oxford: Blackwell, 1986), p.49, where she argues that 'A carnival participant is both actor and spectator, he loses his sense of individuality,

passes through a zero point of carnivalesque activity and splits into a subject of the spectable and an object of the game.'

27 Ibid., p.37.

28 Jean-Francois Lyotard, *The Postmodern Condition: A Report on Knowledge*, transl. Geoff Bennington and Brian Massumi (Manchester: Manchester University Press, 1984), p.81.

29 See the *Guardian*, 12 July 1994, 'Much Ado about Klingon', p.1.

30 One of its origins may be in a nineteenth-century Yiddish theatre joke, but we might also find it in John Bunyan's account of his own imprisonment. One allegation made against Bunyan was that he understood Scripture *literally*. Asked which of the Scriptures he understood literally, Bunyan responds: 'I said this, *He that believes shall be saved*. This was to be understood, just as it is spoken; that whosoever believeth in Christ, shall, according to the plain and simple words of the text, be saved.' But his interlocutor responds: 'how (said he) can you understand them, when you know not the original Greek?' See John Bunyan, *Grace Abounding to the Chief of Sinners*, (ed.) W.R. Owens (Harmondsworth: Penguin, 1987), p.92.

31 Terence Hawkes, *Meaning by Shakespeare*, (London: Routledge, 1992), p.8.

32 Terry Eagleton, *Literary Theory: An Introduction* (Oxford: Blackwell, 1983), p.21.

Bibliography

The bibliography contains all the works cited in this book. Some additional useful publications are indicated by an asterisk.

Aaron, Jane, 'Seduction and Betrayal: Wales in Women's Fiction 1785–1810', *Women's Writing*, vol. 1, no. 1, 1994

Aaron, Jane, Rees, Teresa, Betts, Sandra and Vincentelli, Moira (eds), *Our Sisters' Land: The Changing Identities of Women in Wales* (Cardiff: University of Wales Press, 1994)

* Abercrombie, Nicholas and Warde, Alan (eds), *Social Change in Contemporary Britain* (Oxford: Polity Press, 1992)

* Abercrombie, Nicholas, Warde, Alan and Urry, John *et al.*, *Contemporary British Society: A New Introduction to Sociology* (Oxford: Polity Press, 1988)

Althusser, Louis, 'Ideological State Apparatuses', in *Lenin and Philosophy* (London: New Left Books, 1977)

Althusser, Louis, *For Marx* (London: New Left Books, 1977)

Anderson, Benedict, *Imagined Communities: Reflections on the Origin and Spread of Nationalism* (London: Verso, 1991)

Anderson, Perry, 'Components of the National Culture', in A. Cockburn and R. Blackburn (eds), *Student Power: Problems, Diagnosis, Action* (Harmondsworth: Penguin, 1969)

Andrews, K.R., Canny, N. and Hair, P.E., *The Western Enterprise. English Activities in the Atlantic and America 1480–1650* (Detroit: Wayne State University Press, 1979)

Ang, I., *Watching Dallas* (London: Methuen, 1985)

Appiah, K.A., 'Is the Post- in Postmodernism the Post- in Post-colonial?', *Critical Inquiry*, vol. 17, 1991, pp.336–57

* Asch. R.G. (ed.), *Three Nations – A Common History: England, Scotland, Ireland and British History c.1600–1920* (Bochum: Universitäts Verlag, 1993)

Ashcroft, Bill, Griffiths, Gareth and Tiffin, Helen, *The Empire Writes Back: Theory and Practice in Post-colonial Literatures* (London: Routledge, 1989)

Ashcroft, Bill, Griffiths, Gareth and Tiffin, Helen, *The Post-colonial Studies Reader* (London: Routledge, 1995)

* Ashley, Bob (ed.), *The Study of Popular Fiction: A Source Book* (London: Pinter, 1989)

* Atkinson, Paul, *The Ethnographic Imagination. Textual Constructions of Reality* (London: Routledge, 1990)

* Aulich, James (ed.), *Framing the Falklands War. Nationhood, Culture and Identity* (Milton Keynes: Open University Press, 1992)

Bahktin, Mikhail, *Rabelais and His World*, transl. Helene Iswolsky (Cambridge, MA, and London: MT Press, 1968)

* Bailey, Richard, *Images of English: A Cultural History of the Language*, (Cambridge: Cambridge University Press, 1992)

* Baldick, C., *The Social Mission of English Criticism* (Oxford: Clarendon Press, 1983)

Balibar, F. and Wallerstein, I., *Race, Nation, Class: Ambiguous Identities* (London: Verso, 1991)

Balsom, Denis, 'The Three-Wales Model', in John Osmond (ed.), *The National Question Again: Welsh Political Identity in the 1980s* (Llandysul: Gomer Press, 1985), pp.1–17

Barker, Clive, 'Contemporary Shakespearean Parody in British Theatre', *Shakespeare Jahrbuch*, vol. 105, 1969

Barker, Francis, Hulme, Peter and Iversen, Margaret (eds), *Colonial Discourse/Postcolonial Theory* (Manchester: Manchester University Press, 1994)

Barker, Simon, 'Images of the Sixteenth and Seventeenth Centuries as a History of the Present', Francis Barker, Peter Hulme, Margaret Iversen and Diane Loxley (eds), *Literature, Politics and Theory: Papers from the Essex Conferences 1976–84* (London: Routledge, 1986)

* Barker, Martin and Beezer, Anne (eds), *Reading into Cultural Studies* (London: Routledge, 1992)

* Barley, N., *Native Land* (Harmondsworth: Penguin, 1990)

Barthes, Roland, *Mythologies* (St Albans, Herts: Paladin, 1973)

* Barthes, Roland, *The Pleasure of the Text* (New York: Hill Wang, 1975)

* Barthes, Roland, *Image-Music-Text* (London: Fontana, 1987)

Barthes, Roland, *A Lover's Discourse: Fragments* (Harmondsworth: Penguin, 1990)

Bartlett, T. *et al.* (eds), *Irish Studies: A General Introduction* (Dublin: Gill and Macmillan, 1988)

Barton, David, *Literacy: An Introduction to the Ecology of Written Language* (Oxford: Blackwell, 1994)

* Bassnett, Susan, *Comparative Literature: A Critical Introduction* (Oxford: Blackwell, 1993)

* Bassnett, Susan, 'Teaching British Cultural Studies: The Why and the How', *Journal for the Study of British Cultures*, vol.1, no.1, 1994, pp.63–75

Baugh, E., *Critics on Caribbean Literature* (New York: St Martin's Press, 1978)

Baumgratz-Gangl, G., *Persönlichkeitsentwicklung und Fremdsprachenerwerb* (Paderborn: Schöningh, 1990)

Beale, J., *Women in Ireland: Voices of Change* (London: Macmillan, 1986)

Becher, T., *Academic Tribes and Territories* (Milton Keynes: Open University Press, 1989)

Beddoe, Deirdre, 'Images of Welsh Women', in T. Curtis (ed.), *Wales: The Imagined Nation* (Bridgend: Seren, 1986)

Belchem, J., 'English Working-class Radicalism and the Irish, 1815–50', in S. Gilley and R. Swift (eds), *The Irish in the Victorian City* (Beckenham: Croom Helm, 1985)

* Belsey, Catherine, *Critical Practice* (London: Routledge, 1980)

* Belsey, Catherine, *Desire: Love Stories in Western Culture* (Oxford: Blackwell, 1994)

Benjamin, Walter, 'The Work of Art in the Age of Mechanical Reproduction', *Illuminations* (Glasgow: Fontana/Collins, 1973)

* Bennett, Tony, *Popular Culture: Themes and Issues* (Milton Keynes: Open University Press, 1981)

* Bennett, Tony, Mercer, Colin and Woollacott, Janet, *Popular Culture and Social Relations* (Milton Keynes: Open University Press, 1986)

Bercovitch, Sacvan, *The Rites of Assent: Transformations in the Symbolic Construction of America* (New York: Routledge, 1993)

* Berger, John, *Ways of Seeing* (Harmondsworth: Penguin, 1972)

* Berry, Dave, *Wales and Cinema: The First Hundred Years* (Cardiff: University of Wales Press, 1994)

Best, G.F., 'Popular Protestantism in Victorian Britain', in R. Robson (ed.), *Ideas and Institutions in Victorian Britain* (London: Bell, 1967), pp.115–42

* Bhabha, Homi, (ed.), *Nation and Narration* (London: Routledge, 1990)

* Bhabha, Homi, *The Location of Culture* (London: Routledge, 1994)

* Biedermann, Hans, *Dictionary of Symbolism: Cultural Icons and the Meanings Behind Them* (New York: Facts on File, 1992)

Billington, Michael, 'Are You Content to Resign the Crown?', *Guardian*, 26 November 1990

* Bird, Vivien, *Portrait of Birmingham* (London: Hale, 1970)

Bloom, B., *Taxonomy of Educational Objectives* (Harlow: Longman, 1956)

Blundell, Valda, Shepherd, John and Taylor, Ian, (eds), *Relocating Cultural Studies: Developments in Theory and Research* (London: Routledge, 1993)

* Bold, Alan, *Modern Scottish Literature* (London: Longman, 1983)

Boose, L.E., 'The Getting of a Lawful Race', in M. Hendricks and P. Parker (eds), *Women, 'Race' and Writing in the Early Modern Period* (London: Routledge, 1994)

Booth, Wayne C., *The Rhetoric of Fiction* (Chicago: University of Chicago Press, 1961)

Bourdieu, Pierre, *Distinction: A Social Critique of the Judgement of Taste*, (London: Routledge, 1986)

Boyce, D.G., *Nationalism in Ireland* (London: Routledge, 1991)

Bradshaw, B. 'Robe and Sword in the Conquest of Ireland', in C. Cross, D. Loades and J. Scarisbrick (eds), *Law and Government under the Tudors: Essays Presented to Sir Geoffrey Elton on his Retirement* (Cambridge: Cambridge University Press, 1988), pp.139–62

Bradshaw, B., Hadfield, A. and Maley, W. (eds), *Representing Ireland: Literature and the Origins of the Conflict, 1530–1660* (Cambridge: Cambridge University Press, 1993)

Brady, C., 'Spenser's Irish Crisis: Humanism and Experience in the 1590s', *Past and Present*, vol. 111, 1986, pp.17–49

Brady, C. 'The Road to the *View*: On the Decline of Reform Thought in Tudor Ireland', in P. Coughlan (eds), *Spenser and Ireland: An Interdisciplinary Perspective* (Cork: Cork University Press, 1989), pp.25–45

* Brantlinger, Patrick, *Crusoe's Footsteps: Cultural Studies in Britain and America* (New York: Routledge, 1989)

Brewer, J.D. 'Sectarianism and Racism, and their Parallels and Differences', *Ethnic and Racial Studies*, vol. 15, no. 3, 1992, pp.352–65

British Council, *Core Lists of Library Materials: British Studies* (London: The British Council, 1991)

Brown, Gillian and Yule, George, *Discourse Analysis* (Cambridge: Cambridge University Press, 1983)

Brown, T., *Ireland. A Social and Cultural History 1922–1985* (London: Fontana, 1985)

Brydon, Diana, 'Commonwealth or Common Poverty?' in S. Slemon and H. Tiffin (eds), *After Europe* (Sydney and Aarhus: Dangaroo Press, 1989)

Buckley, Anthony, *A Gentle People* (Belfast: Ulster Folk and Transport Museum, 1982)

Bunyan, John, *Grace Abounding To the Chief of Sinners*, ed. W.R. Owens (Harmondsworth: Penguin, 1987)

Burkhauser, Jude (ed.), *'Glasgow Girls': Women in Art and Design 1880–1920* (Edinburgh: Canongate, 1990)

Buttjes, Dieter, 'Landeskunde-Didaktik und landeskundliches Curriculum', in K. R. Bausch *et al.* (eds), *Handbuch Fremdsprachenunterricht* (Tübingen: Franke, 1988)

Byram, Michael, 'Foreign Language Teaching and Young People's Perceptions of Other Cultures', in B. Harrison (ed.), *Culture and the Language Classroom* (Basingstoke: Modern English Publications/Macmillan, 1990)

* Byram, Michael (ed.), *Culture and Language Learning in Higher Education*, special issue of *Language, Culture and Curriculum*, vol. 6, no.1, 1993

Byram, Michael and Morgan, Carol (eds), *Teaching-and-Learning Language-and-Culture* (Clevedon/Philadelphia/Adelaide: Multilingual Matters, 1994)

Byram, Michael and Zarate, G., 'Definitions, Objectives and Assessment of Socio-cultural Competence', (Paper for Council of Europe Education Committee, Strasbourg, Mimeo, 1994

Cahill, G.I., 'Irish Catholicism and English Toryism', *Review of Politics*, vol. 18, 1957, pp.62–76

Cairns, D. and Richards, S., *Writing Ireland: Colonialism, Nationalism and Culture* (Manchester: Manchester University Press, 1988)

* Calder, Angus, *Revolving Culture: Notes from the Scottish Republic* (London: I.B. Taurus, 1994)

Canny, N.P., 'The Ideology of English Colonization: From Ireland to America', *William and Mary Quarterly*, vol. XXX, 1973, pp.575–98

Canny, N.P., 'Identity Formation in Ireland: The Emergence of the Anglo-Irish', in N. Canny and A. Pagden (eds), *Colonial Identity in the Atlantic World, 1500–1800* (Princeton, NJ: Princeton University Press, 1987), pp.159–212

* Carey, James, *Communication and Culture: Essays on Media and Society* (Boston: Unwin Hyman, 1989)

Carlson, J., *Banned in Ireland. Censorship and the Irish Writer* (London: Routledge, 1990)

Cavell, Stanley, *Disowning Knowledge in Six Plays of Shakespeare* (Cambridge: Cambridge University Press, 1987)

* Chatman, J., *Story and Discourse* (Ithaca, NY: Cornell University Press, 1978)

* Cheshire, J., *Neglected Englishes* (Oxford: Blackwell, 1986)

Chrisman, Laura and Williams, Patrick (eds), *Colonial Discourse and Postcolonial Theory: A Reader* (London: Harvester, 1993)

Clarke, Gillian, *The King of Britain's Daughter* (Manchester: Carcanet Press, 1993)

* Clarke, J., Hall, S., Jefferson, T. and Roberts, R., 'Subcultures, Cultures and Class: A Theoretical Overview', in S. Hall and T. Jefferson (eds), *Resistance through Rituals; Youth Subcultures in Post-war Britain* (London: Hutchinson 1976)

* Clarke, John, Critcher, Chas and Johnson, Richard (eds), *Working Class Culture: Studies in History and Theory* (London: Hutchinson, 1979)

* Clifford, J. and Marcus, G.E. (eds), *Writing Culture: The Poetics and Politics of Ethnography* (Berkeley, CA: University of California Press, 1986)

Colley, Linda, *Britons: Forging the Nation 1707–1837* (New Haven and London: Yale University Press, 1992)

* Collins, Jim, *Uncommon Cultures: Popular Culture and Postmodernism* (New York: Routledge, 1989)

* Colls, R. and Dodd, P. (eds), *Englishness: Politics and Culture 1880–1920* (London: Croom Helm, 1986)

Connelly, A. (ed.), *Gender and the Law in Ireland* (Dublin: Oak Tree Press, 1993)

Connolly, J., *Labour in Irish History* (Dublin: Colm O'Lochlainn, 1910)

* Conran, Tony, *The Cost of Strangeness: Essays on the English Poets of Wales* (Llandysul: Gomer Press, 1982)

Conroy Jackson, P. 'Women's Movement and Abortion: The Criminalization of Irish Women', in D. Dahlerup (ed.), *The New Women's Movement: Feminism and Political Power in Europe and the USA* (London: Sage, 1986)

* Coulthard, Malcolm, *An Introduction to Discourse Analysis* (London: Longman, 1987)

* Coward, Roz and Ellis, John, *Language and Materialism* (London: Routledge and Kegan Paul, 1977)

Craig, Cairns (ed.), *The History of Scottish Literature*, 4 vols (Aberdeen: Aberdeen University Press, 1986–7)

* Crawford, Robert, *Devolving English Literature* (Oxford: Clarendon Press, 1992)

Crawford, Robert, 'Bakhtin and Scotlands', *Scotlands*, issue 1, 1994

Crawford, Robert, *Literature in Twentieth-Century Scotland: A Select Bibliography* (London: The British Council, 1995)

* Crichfield, R., *Among the British* (London: Hamish Hamilton, 1990)

* Crick, Bernard (ed.), *National Identities: Constitution of the United Kingdom* (Oxford: Blackwell, 1991)

* Crick, Bernard and Evans, Neil (eds), *National Identity in the British Isles* (Coleg Harlech Occasional Paper in Welsh Studies; Gwynedd: Centre for Welsh Studies, 1989)

* Crowley, Tony, *The Politics of Discourse. The Standard Language Question in British Cultural Debates* (London: Macmillan, 1989)

* Crowley, Tony, *Language in History. Theories and Texts* (London: Routledge, 1995)

Cudjoe, S.R. (ed.), *Caribbean Women Writers* (Cambridge, MA: University of Massachusetts Press, 1990)

Curtis, C. *et al.* (eds), *Gender in Irish Society* (Galway: Galway University Press, 1987)

Curtis, Liz, *Nothing but the Same Old Story: The Roots of Anti-Irish Racism* (London: Information on Ireland, 1984)

Curtis, Liz, *Ireland and the Propaganda War, the British Media and the 'Battle for Hearts and Minds'* (London: Pluto Press, 1984)

Curtis, L. Perry, *Apes and Angels: The Irishman in Victorian Caricature* (Washington: Smithsonian Institution Press, 1971)

Curtis, Tony (ed.), *Wales: The Imagined Nation* (Bridgend: Poetry Wales Press, 1986)

Dabydeen, David (ed.), *The Black Presence in English Literature* (Manchester: Manchester University Press, 1985)

Dabydeen, D. and Samaroo, B. (eds), *India in the Caribbean* (London: Hansib, 1988)

Daiches, David (ed.), *The New Companion to Scottish Culture* (Edinburgh: Polygon, 1993)

* Davies, Janet, *The Welsh Language* (Cardiff: University of Wales Press, 1993)

* Davies, John, *A History of Wales* (London: Allen Lane, 1993)

* Dawson, Graham, *Soldier Heroes* (London: Routledge, 1994)

Deane, S. (ed.), *The Field Day Anthology of Irish Writing*, 3 vols (Derry: Field Day & Faber, 1991)

Deleuze, Gilles and Guattari, Felix, *A Thousand Plateaus: Capitalism and Schizophrenia*, transl. B. Massumi (London: Athlone Press, 1988)

Derrida, Jacques, *Of Grammatology* (Baltimore: Johns Hopkins University Press, 1976)

Derrida, Jacques, 'Signature, Event, Context', *Glyph I*, ed. Samuel Weber and Henry Sussman (Baltimore and London: Johns Hopkins University Press, 1977)

Dirlik, Arif, 'The Postcolonial Aura: Third World Criticism in the Age of Global Capitalism', *Critical Inquiry*, vol. 20, 1994, pp.329–56

Dollimore, Jonathan and Sinfield, Alan, *Political Shakespeares: New Essays in Cultural Materialism* (Manchester: Manchester University Press, 1985)

Doyé, P. 'Neuere Konzepte der Fremdsprachenerziehung und ihre Bedeutung für die Schulbuchkritik', in M. Byram, (ed.), *Germany: Its Representation in Textbooks for Teaching German in Great Britain* (Frankfurt am Main: Diesterweg, 1993)

Doyle, Brian, *English and Englishness* (London: Routledge, 1989)

* Drakakis, John, *Alternative Shakespeares* (London: Routledge, 1985)

* Dunn, Douglas (ed.), *Scotland: An Anthology* (London: HarperCollins, 1991)

* Dunn, Douglas (ed.), *The Faber Book of Twentieth-century Scottish Poetry* (London: Faber & Faber, 1993)

* Dunn, Douglas (ed.), *The Oxford Book of Scottish Short Stories* (Oxford: Oxford University Press, 1995)

Dunn, T., 'The "British" in British Studies', *British Studies Now*, vol. 4, 1994, pp.11–12

During, Simon (ed.), *The Cultural Studies Reader* (London: Routledge, 1993)

Eagleton, Terry, *Literary Theory: An Introduction* (Oxford: Blackwell, 1983)

Eagleton, Terry, *Heathcliff and the Great Hunger: Studies in Irish Culture* (London: Verso, 1995)

* Easthope, Antony, *British Post-Structuralism since 1968* (London: Routledge, 1988)

* Easthope, Antony, *Literary into Cultural Studies* (London: Routledge, 1991)

* Easthope, Antony and McGowan, Kate, *A Critical and Cultural Theory Reader* (Buckingham: Open University Press, 1992)

* Eco, Umberto, *The Role of the Reader* (Bloomington: Indiana University Press, 1979)

Edwards, Paul (ed.), *The Life of Olauda Equiano* (London: Longman, 1983)

Elfyn, Menna, *Eucalyptus* (Llandysul: Gomer Press, 1995)

Elfyn, Menna, *Cell Angel* (Newcastle: Bloodaxe, 1996)

Evans, Colin, *Language People: The Experience of Teaching and Learning Modern Languages in British Universities* (Milton Keynes: Open University Press, 1988)

Evans, Colin, *English People: The Experience of Teaching and Learning English in British Universities* (Milton Keynes: Open University Press, 1993)

Evans, Colin, (ed.), *Developing University English Teaching: An Interdisciplinary Approach to Humanities Teaching at University Level* (Lewiston: Edwin Mellon Press, 1995)

Evans, Gwynfor, *Diwedd Prydeindod* (Talybont: Y Lolfa, 1981)

* Evans, Gwynfor, *Land of My Fathers: 2000 Years of Welsh History* (Swansea: John Penry Press, 1981)

* Fabb, Nigel, *et al.* (eds), *The Linguistics of Writing* (Manchester: Manchester University Press, 1987)

Fairclough, Norman, *Language and Power* (Harlow: Longman, 1989)

* Fairclough, Norman, *Discourse and Social Change* (Oxford: Oxford University Press, 1992)

Fanon, Franz, *Black Skin, White Masks* (1952) (London: Pluto Press, 1986)

Fanon, Franz, *The Wretched of the Earth* (1963) (London: MacGibbon and Gee, 1965)

Farrell, B., *De Valera's Constitution and Our Own* (Dublin: Gill & Macmillan, 1988)

Ferguson, William, *Scotland: 1689 to the Present* (Edinburgh: Oliver & Boyd, 1968)

Field Day Theatre Company, *Ireland's Field Day* (Notre Dame, Indiana: University of Notre Dame Press, 1986)

* Fiske, John, *Television Culture* (London: Methuen, 1987)

* Fiske, John, *Understanding Popular Culture* (London and Boston: Unwin Hyman, 1989)

* Fiske, John, Hodge, Bob and Turner, Graeme, *Myths of Oz: Reading Australian Popular Culture* (Sydney: Allen and Unwin, 1987)

Foster, R.F., *Paddy and Mr Punch. Connections in Irish and English History* (Harmondsworth: Penguin, 1993)

Foucault, Michel, *The Archaeology of Knowledge* (London: Tavistock Press, 1972)

Foucault, Michel, *Power/Knowledge: Selected Interviews and Other Writings*, ed. Colin Gordon (Brighton: Harvester, 1980)

Foucault, Michel, 'The Order of Discourse', in Robert Young (ed.), *Untying the Text: A Poststructuralist Reader* (London: Routledge, 1981), pp.48–78

Freire, Paolo, *Pedagogy of the Oppressed*, transl. B. Ramos (London: Sheed and Ward, 1972)

Freud, Sigmund, *Jokes and Their Relation to the Unconscious*, ed. Angela Richards (Harmondsworth: Penguin, 1976)

Friel, Brian, *Translations* (London: Faber & Faber, 1981)

* Fryer, Peter, *Staying Power. The History of Black People in Britain* (London: Pluto Press, 1984)

* Gallagher, Tom (ed.), *Nationalism in the Nineties* (Edinburgh: Polygon, 1991)

* Garlick, Raymond, *An Introduction to Anglo-Welsh Literature* (Cardiff: University of Wales Press, 1972)

Geertz, Clifford, *The Interpretation of Cultures* (New York: Basic Books, 1973; London: Lawrence and Wishart, 1983)

* Gellner, E., *Nations and Nationalism* (Oxford: Blackwell, 1983)

* George, Stephen, *An Awkward Partner: Britain and the European Community* (Oxford: Oxford University Press, 1990)

Gibbons, L., 'Coming out of Hibernation? The Myth of Modernity in Irish Culture', in R. Kennedy (ed.), *Across the Frontiers: Ireland in the 1990s* (Dublin: Wolfhound, 1988)

Gifford, Douglas and McMillan, Dorothy (eds), *A History of Scottish Women's Writing* (Edinburgh: Edinburgh University Press, forthcoming)

Gilley, S. and Swift, R., *The Irish in the Victorian City* (Beckenham: Croom Helm, 1985)

Gillingham, J., 'The Context and Purposes of Geoffrey of Monmouth's *Historia Regnum Brittaniae*', *Anglo-Norman Studies*, vol. 13, 1990, pp.99–118

Gillingham, J., 'The Beginnings of English Imperialism', *Journal of Sociology*, vol. 5, 1992, pp.392–409

Gilroy, Paul, *There Ain't No Black in the Union Jack: The Cultural Politics of Race and Nation* (London: Hutchinson, 1987)

Gilroy, Paul, *The Black Atlantic: Modernity and Double Consciousness* (London: Verso, 1993)

Gilroy, Paul, *Small Acts* (London: Serpent's Tail, 1993)

Glen, Duncan and France, Peter (eds), *European Poetry in Scotland* (Edinburgh: Edinburgh University Press, 1989)

Golby, M., 'Curriculum traditions', in B. Moon, P. Murphy and J. Raynor (eds), *Policies for the Curriculum* (London: Hodder and Stoughton, 1989), pp.29–42

Gramsci, Antonio, *Selections from the Prison Notebooks*, ed. and transl. Quintin Hoare and Geoffrey Nowell-Smith (London: Lawrence and Wishart, 1971)

Gray, J., *City in Revolt: James Larkin and the Belfast Dock Strike* (Belfast, 1985)

* Gray, Ann and McGuigan, Jim (eds), *Studying Culture. An Introductory Reader* (London/New York: Arnold, 1993)

* Grossberg, Lawrence, Nelson, Cary and Treichler, Pauls (eds), *Cultural Studies* (New York: Routledge, 1992)

Hall, Stuart 'Cultural Studies. Two Paradigms', *Media, Culture and Society* vol. 2, no. 2, 1980, pp.57–72

* Hall, Stuart, 'Old and New Identities, Old and New Ethnicities,' in A. King (ed.), *Culture, Globalization and the World-System* (London: Macmillan, 1991), pp.41–69

Hall, Stuart and Gieben, B., *Formations of Modernity* (Oxford: Polity, Open University and Oxford University Press, 1992)

* Hall, Stuart and Jacques, Martin (eds), *New Times. The Changing Face of Politics in the 1990s* (London: Lawrence and Wishart, 1989)

* Hall, Stuart and Jefferson, Tony (eds), *Resistance through Rituals: Youth Subcultures in Post-war Britain* (London: Hutchinson, 1976)

* Hall, Stuart, Hobson, Dorothy, Lowe, Andrew and Willis, Paul (eds), *Culture, Media, Language,* (London: Hutchinson, 1980)

* Hall, Stuart, Critcher, Chas, Jefferson, Tony, Clarke, John and Roberts, Brian (eds), *Policing the Crisis: Mugging, the State, and Law and Order* (London: Macmillan, 1978)

* Halliday, Michael, *Explorations in the Function of Language* (London: Arnold, 1973)

Halliday, Michael, *Language as Social Semiotic* (London: Arnold, 1978)

Hammersley, Martyn and Atkinson, Paul, *Ethnography: Principles in Practice* (London: Routledge, 1995)

Hammersley, M. and Hargreaves, A. (eds), *Curriculum Practice: Some Sociological Case Studies* (London: The Falmer Press, 1983)

* Hardie, William, *Scottish Painting 1837 to the Present* (London: Studio Vista, 1990)

Harrison, B. (ed.), *Culture and the Language Classroom*, ELT Documents 133 (Basingstoke: Modern English Publications/Macmillan, 1990)

* Harvie, Christopher, *Cultural Weapons: Scotland and Survival in a New Europe* (Edinburgh: Polygon, 1992)
* Harvie, Christopher, *No Gods and Precious Few Heroes: Scotland since 1914* (Edinburgh: Edinburgh University Press, 1993)
Havighurst, A.F., *Twentieth Century Britain* (New York: Harper & Row, 1966)
* Hawkes, Terence, *Structuralism and Semiotics* (London: Methuen, 1977)
Hawkes, Terence, *Meaning by Shakespeare* (London: Routledge, 1992)
* Hawkins, Harriet, *Classics and Trash: Traditions and Taboos in High Literature and Popular Modern Genres* (London: Harvester, 1990)
Heaney, Seamus, 'Englands of the Mind', in *Preoccupations: Selected Prose 1968–1978* (London: Faber & Faber, 1980)
Heaney, Seamus, 'An Open Letter' (Derry and Belfast: Field Day, 1983)
* Hebdige, Dick, *Subculture: The Meaning of Style* (London: Methuen, 1979)
Hennessey, Alistair, (London: Macmillan, Warwick University Caribbean Studies Series, 1994/5)
Hickman, M. and Walters, B., 'Deconstructing Whiteness: Irish Women in Britain', *Feminist Review*, no. 50, 1995, pp.5–19
Hillyard, P., *Suspect Community: People's Experience of the Prevention of Terrorism Acts in Britain* (London: Pluto Press, 1993)
* Hiro, Dilip, *Black British, White British. A History of Race Relations in Britain* (London: Paladin, 1991)
Hirst, P., *Knowledge and the Curriculum* (London: Routledge and Kegan Paul, 1974)
Hobsbawm, Eric, *The Age of Revolution* (London: Sphere Books, 1962)
Hobsbawm, Eric, *Nations and Nationalism since 1780: Programme, Myth, Reality* (Cambridge: Cambridge University Press, 1990)
Hobsbawm, Eric and Ranger, Terence, *The Invention of Tradition* (Cambridge: Cambridge University Press, 1983)
* Hodge, R. and Kress, G., *Social Semiotics* (Oxford: Polity, 1988)
* Hoftstede, G., *Cultures and Organizations* (New York: McGraw-Hill, 1991)
Hoggart, Richard, *The Uses of Literacy* (Harmondsworth: Penguin, 1957)
* Hoggart, Richard, *On Culture and Communication* (Oxford: Oxford University Press, 1978)
* Hoggart, Richard, *An Imagined Life* (Oxford: Oxford University Press, 1993)
Holmes, C., *John Bull's Island: Immigration and British Society 1871–1971* (London: Macmillan, 1988)
* Hooker, Jeremy, *The Presence of the Past* (Bridgend: Poetry Wales Press, 1987)

* Humphreys, Emyr, *The Taliesin Tradition* (London: Black Raven Press, 1983)

Hunt, Albert, 'Give Me Laughter', in Paul Barker (ed.), *Arts in Society* (Glasgow: Fontana, 1977)

* Hutcheon, Linda, *A Poetics of Postmodernism* (London and New York: Routledge, 1988)

* Inglis, Fred, *Cultural Studies* (Oxford: Blackwell, 1993)

James, C.L.R., *Spheres of Existence* (London: Alison and Busby, 1980)

* Jameson, Fredric, *Postmodernism or the Cultural Logic of Late Capitalism* (Durham, NC: Duke University Press, 1990)

* Jarman, A.O.H. and Hughes, G.R. (eds), *A Guide to Welsh Literature*, 2 vols (Cardiff: University of Wales Press, 1991)

Jenkins, R. 'Understanding Northern Ireland', *Sociology*, vol. 18, no. 2, 1984, pp.252–64

* Jenks, Chris, *Culture* (London: Routledge, 1993)

* John, Angela V. (ed.), *Our Mothers' Land: Chapters in Welsh Women's History 1830–1939* (Cardiff: University of Wales Press, 1991)

Johnson, Richard, 'What is Cultural Studies Anyway?' (Birmingham Centre for Contemporary Cultural Studies, stencilled paper no.74, 1983)

* Johnston, Dafydd, *The Literatures of Wales: A Pocket Guide* (Cardiff: University of Wales Press, 1994)

* Johnston, Dafydd (ed.), *Modern Poetry in Translation: Welsh Issue*, new series No. 7 (spring 1995)

* Jones, Glyn, *The Dragon Has Two Tongues* (London: Dent, 1988)

* Jones, Glyn and Rowlands, John (eds), *Profiles* (Llandysul: Gomer Press, 1980)

Jones, W.R., 'England against the Celtic Fringe: A Study in Cultural Stereotypes', *Journal of World History*, no, 13, 1971, pp.155–71

Joyce, James, *Ulysses* (1922) (Harmondsworth: Penguin, 1985)

Kachru, Braj. (ed.), *The Other Tongue: English across Cultures* (Oxford: Pergamon, 1982)

* Kearney, H., *The British Isles: A History of Four Nations* (Cambridge: Cambridge University Press, 1990)

Kearney, R. (ed.), *Across the Frontiers. Ireland in the 1990s* (Dublin: Wolfhound, 1988)

Kent, Raymond (ed.), *Measuring Media Audiences* (London: Routledge, 1994)

Keogh, D., *The Rise of the Irish Working Class* (Belfast: Appletree Press, 1982)

* Kerrigan, Catherine (ed.), *An Anthology of Scottish Women Poets* (with Gaelic translations by Meg Bateman) (Edinburgh: Edinburgh University Press, 1991)

* Kimpton, Laurence, *Britain in Focus* (London: Hodder and Stoughton, 1990)

* King, Anthony (ed.), *Culture, Globalization and the World-system* (London: Macmillan, 1991)

King, Bruce (ed.), *West Indian Literature* (London: Macmillan, 1979)

Kipling, Rudyard, *Rudyard Kipling's Verse. Inclusive Edition 1885–1927* (London: Hodder and Stoughton, 1927)

Kirk, N., 'Ethnicity, Class and Popular Toryism 1850–70', in K. Lunn (ed.), *Hosts, Immigrants and Minorites* (Folkestone: Harvester, 1980)

Klein, Melanie, *Envy and Gratitude and Other Works 1946–1963* ed. H. Segal (London: The Hogarth Press, 1975)

Klippel, F., 'Cultural Aspects in Foreign Language Teaching,' *Journal for the Study of British Cultures*, vol. 1, no. 1, 1994, pp.49–61

Knights, Ben, *From Reader to Reader: Theory, Text and Practice in the Study Group* (London: Harvester Wheatsheaf, 1982)

Kramer, Jürgen, 'Cultural Studies in English Studies: A German Perspective', *Language, Culture, Curriculum*, vol.6, no.1, 1993, pp.27–45

* Kramer, Jürgen, Lenz, Bernd and Stratmann, Gerd (eds), *Journal for the Study of British Cultures*. Issues include: *German Perspectives of the Study of British Cultures*, vol. 1, no. 1, 1994; *Thatcherism*, vol.1, no. 2 1994; *Positions, Polemics, Proposals*, vol.2, no.1, 1995; *Regional Cultures: The Difference Between*, vol. 2, no. 2, 1995

Kramsch, C., 'The Cultural Component of Language Teaching', Keynote Lecture delivered at the International Association of Applied Linguistics, Amsterdam, August 1993

Kress, G., *Linguistic Processes in Sociocultural Practice* (Oxford: Oxford University Press, 1989)

Kristeva, Julia, *The Kristeva Reader*, ed. Toril Moi (Oxford: Blackwell, 1986)

Kunar, Krishan, ' "Britishness" and "Englishness": What Prospect for a European Identity in Britain Today,' in N. Wadham-Smith (ed.) *British Studies Now: The Anthology* (London: The British Council, 1995) pp.82–97

Kureishi, Hanif, *The Buddha of Suburbia* (London: Faber & Faber, 1991)

Lamming, George, 'The Indian Presence as a Caribbean Reality', in F. Birbalsingh (ed.), *Indenture and Exile: The Indo-Caribbean Experience* (Toronto: TSAR, 1989)

Lawton, D. *The End of the Secret Garden? A Study in the Politics of the Curriculum*, Inaugural Lecture, 15 November 1978 (London: University of London Institute of Education, 1979)

Lazarus, Neil, 'Disavowing Decolonization: Fanon, Nationalism and the Problematic of Representation in Current Theories of Colonial Discourse', *Researches in African Literatures*, vol. 24, no. 4, 1993, pp.69–98

Leavis, F.R., *Mass Civilization and Minority Culture* (Cambridge: Gordon Fraser, 1930)

Lee, Simon, *The Cost of Free Speech* (London: Faber & Faber, 1990)

Lees, L. Hollen, *Exiles of Erin: Irish Migrants in Victorian London* (New York: Cornell University Press, 1979)

Leneman, Leah, *A Guid Cause: The Women's Suffrage Movement in Scotland* (Aberdeen: Aberdeen University Press, 1991)

Lennon, Colm, 'Richard Stanihurst and the English Identity', *Irish Historical Studies*, vol. 82, 1978, pp.121–43

Levine, Kenneth, *The Social Context of Literacy* (London: Routledge, 1986)

Lewis, Gwyneth, *Parables and Faxes* (Newcastle-upon-Tyne: Bloodaxe, 1995)

Lewis, Saunders, *Plays*, transl. J. Clancy, 4 vols (Swansea: Christopher Davies, 1985–6)

Lindsay, Maurice, *History of Scottish Literature* (London: Hale, 1977)

Llywelyn, Robin, *Seren Wen ar Gefndir Gwyn* (Llandysul: Gomer Press, 1992)

Llywelyn, Robin, *O'r Harbwr Gwag i'r Cefnfor Gwyn* (Llandysul: Gomer Press, 1994)

Lloyd, D., *Anomalous States: Irish Writing and the Post-colonial Moment* (Dublin: Lilliput, 1993)

Longley, Edna, *The Living Stream. Literature and Revisionism in Ireland* (Newcastle-upon-Tyne: Bloodaxe, 1994)

Loomba, Anita, 'The Colour of Patriarchy: Critical Difference, Cultural Difference and Renaissance Drama', in M. Hendricks and P. Parker (eds), *Women, 'Race' and Writing in the Early Modern Period* (London: Routledge, 1994)

* Lord, Peter, *The Aesthetics of Relevance* (Llandysul: Gomer Press, 1992)

* Lucas, John, *England and Englishness: Ideas of Nationhood in English Poetry, 1688–1900* (London: Methuen, 1991)

Luddy, Maria, *Women and Philanthropy in Nineteenth-Century Ireland* (Cambridge: Cambridge University Press, 1995)

Luddy, Maria, *Women in Ireland 1800–1918* (Cork: Cork University Press, 1995)

Luddy, Maria and Murphy, C., *Women Surviving: Studies in Irish Women's History in the 19th and 20th Centuries* (Dublin: Poolbeg Press, 1989)

* Ludwig, H. and Fietz, L. (eds), *Poetry in the British Isles* (Cardiff: University of Wales Press, 1995)

Lynch, Michael, *Scotland: A New History* (London: Century, 1991)

Lyotard, Jean-Francois, *The Postmodern Condition: A Report on Knowledge*, transl. Geoff Bennington and Brian Massumi (Manchester: Manchester University Press, 1984)

Llywelyn, Robin, *From Empty Harbour to White Ocean* (Cardiff: Parthian, 1996)

* McCrone, David, Kendrick, Stephen and Straw, Pat (eds), *The Making of Scotland: Nation, Culture and Social Change* (Edinburgh: Edinburgh University Press, 1989)

* McCrone, David, *Understanding Scotland. The Sociology of a Stateless Nation* (London and New York: Routledge, 1992)

McCrum, Robert, Cran, William and MacNeil, Robert, *The Story of English* (London: Faber & Faber and BBC Publications, 1986)

MacCurtain, M. and O'Corrain, D., *Women in Irish Society. The Historical Dimension* (Dublin: Arlen House, 1978)

MacCurtain, M. and O'Dowd, M. (eds), *Women in Early Modern Ireland* (Dublin: Wolfhound, 1991)

* Macdonell, Diane, *Theories of Discourse* (Oxford: Blackwell, 1986)

* MacDougall, Carl (ed.), *The Devil and the Giro: Two Centuries of Scottish Short Stories* (Edinburgh: Canongate, 1989)

* McGuigan, Jim, *Cultural Popularism* (London: Routledge, 1992)

* Mackenzie, John, *Propaganda and Empire: The Manipulation of British Public Opinion* (Manchester: Manchester University Press, 1986)

Macmillan, Duncan, *Scottish Art 1460–1990* (Edinburgh: Mainstream, 1990)

Macmillan, Duncan, *Scottish Art in the Twentieth Century* (Edinburgh: Mainstream, 1994)

* MacRae-Gibson, Gavin, *Secret Life of Buildings* (Cambridge, MA: MIT Press, 1985)

* McRobbie, Angela, *Postmodernism and Popular Culture* (London: Routledge, 1994)

* McRobbie, Angela and Nava, M. (eds), *Gender and Generation* (London: Macmillan, 1984)

Maes-Jelinek, H., *Wilson Harris: The Uncompromising Imagination* (Sydney and Aarhus: Dangaroo Press, 1991)

Maley, W., 'Cultural Devolution? Representing Scotland in the 1970s', in B. Moore-Gilbert (ed.), *The Arts in the 1970s: Cultural Closure* (London: Routledge, 1994), pp.78–98

* Marr, Andrew, *Ruling Britannia* (London: Michael Joseph, 1995)

Marwick, Arthur, *British Society since 1945* (Harmondsworth: Penguin, 1990)

* Marwick, Arthur, *Culture in Britain since 1945* (Oxford: Blackwell, 1991)

* Mathias, Roland, *Anglo-Welsh Literature: An Illustrated History* (Bridgend: Seren Books, 1986)

Melde, W., *Zur Integration von Landeskunde und Kommunikation im Fremdsprachenunterricht* (Tübingen: Gunter Narr, 1987)

Meredith, Christopher, *Shifts* (Bridgend: Seren Books, 1988)

Mitchell, A., *Labour in Irish Politics* (Dublin: Wolfhound, 1974)

Miyoshi, Maso, 'A Borderless World? From Colonialism to Transnationalism and the Decline of the Nation State', *Critical Inquiry*, vol. 19, 1993, pp.726–51

Mohanty, Chandra, 'Under Western Eyes: Feminist Scholarship and Colonial Discourse', *Feminist Review*, vol. 30, 1988, pp.61–88

Montgomery, Martin, 'Institutions and Discourse', *British Studies Now*, July 1993, pp.2–3

* Montgomery, Martin, *An Introduction to Language and Society* (London: Routledge, 1995)

Moon, B., Murphy, P. and Raynor, J. (eds), *Policies for the Curriculum* (London: Hodder and Stoughton, 1989)

Morgan, Edwin, *Sonnets from Scotland* (Glasgow: Mariscat Press, 1984)

Morgan, Edwin, *Nothing not Giving Messages: Reflections on Work and Life*, ed. H. Whyte (Edinburgh: Polygon, 1990)

Morley, David, *Television, Audiences and Cultural Studies* (London: Routledge, 1992)

Mowat, C.L. *Britain between the Wars, 1918–40* (London: Methuen, 1955)

Mudimbe, V.Y., *The Invention of Africa* (London: Currey, 1988)

Mukherjee, Meenakshi, 'The Centre Cannot Hold: Two Views of the Periphery', in S. Slemon and H. Tiffin (eds), *After Europe* (Sydney and Aarhus: Dangaroo Press, 1989), pp.41–8

Mulvey, Laura, 'Visual Pleasure and Narrative Cinema', *Screen*, vol. 16, no. 3, 1975

Mulvey, Laura, *Visual and Other Pleasures* (London: Macmillan, 1991)

Murphy, Peter F., 'Cultural Studies as Praxis: A Working Paper', *College Literature*, 1992, pp.31–43

* Nairn, Tom, *The Break-up of Britain* (London: New Left Books, 1977)

* Nairn, Tom, *The Enchanted Glass: Britain and its Monarchy* (London: Picador, 1990)

* Nation, Michael, *A Dictionary of Modern Britain* (Harmondsworth: Penguin, 1992)

Newton, K.M., 'Interest, Authority and Ideology in Literary Interpretation', *The British Journal of Aesthetics*, vol. 22, no.2, 1982

Norris, Christopher, *Deconstruction: Theory and Practice* (London: Methuen, 1982)

Oakland, John, *A Dictionary of British Institutions: A Student's Guide* (London: Routledge, 1993)

* Oakland, John, *British Civilization: An Introduction* (London: Routledge, 1995)

O'Callaghan, E., *Women Version* (London: Macmillan, 1993)

Ollman, B. and Vernoff, E. (eds), *The Left Academy: Marxist Scholarship on American Campuses* (New York: McGraw-Hill, 1982)

O'Rourke, Daniel (ed.), *Dream State: The New Scottish Poets* (Edinburgh: Polygon, 1994)

Osmond, John (ed.), *The National Question Again: Welsh Political Identity in the 1980s* (Llandysul: Gomer Press, 1985)

* Parekh, B. (ed.), *Colour, Culture and Consciousness* (London: Allen and Unwin, 1974)

Patterson, H., *Class Conflict and Sectarianism* (Belfast: Appletree Press, 1980)

Persaud, Sasenarine, 'Extending the Indian Tradition', *Indo-Caribbean Review,* vol. 1, no.1, 1994, pp.15–28

* Perryman, Mark (ed.), *Altered States: Postmodernism, Politics, Culture* (London: Lawrence and Wishart, 1994)

* Porter, Roy (ed.), *Myths of the English* (Oxford: Polity Press, 1993)

Pratt, M.L., 'Linguistic Utopias', in Fabb *et al.* (eds), *The Linguistics of Writing* (Manchester: Manchester University Press, 1987)

Prendeville, P., 'Divorce in Ireland. An Analysis of the Referendum to Amend the Constitution, June 1986', *Women's Studies International Forum*, vol. 2, no. 4, 1988, pp.355–63

Protherough, R., *Students of English* (London: Routledge, 1989)

Punter, David (ed.), *Introduction to Contemporary Cultural Studies*, (London: Longman, 1986)

Purser, John, *Scotland's Music: A History of the Traditional and Classical Music of Scotland from Early Times to the Present Day* (Edinburgh: Mainstream, 1992)

Quinn, D.B., 'Sir Thomas Smith (1513–1577) and the Beginnings of English Colonial Theory', *Proceedings of the American Philosophical Society,* vol. 89, 1945, pp.543–60

Quinn, D.B., *The Elizabethans and the Irish* (New York: Cornell University Press, 1966)

* Radway, Janice, *Reading the Romance: Women, Patriarchy and Popular Literature* (London: Verso, 1987)

Raleigh, Walter (ed.), *Johnson on Shakespeare* (reprinted, Harmondsworth: Penguin, 1957)

Ramchand, K., *The West Indian Novel and its Background* (revised edition) (London: Heinemann, 1983)

Rao, Venkat, 'Self-formations: Speculations on the Question of Postcoloniality', *Wasifiri*, spring 1991, pp.7–10

* Reid-Thomas, Helen and Montgomery, Martin (eds), *Language and Social Life* (London: The British Council, 1994)

Rex, John, *Race and Ethnicity* (Milton Keynes: Open University Press, 1986)

* Robbins, Keith, *Nineteenth Century Britain: England, Scotland and Wales. The Making of a Nation* (Oxford: Oxford University Press, 1988)

Robertson, Geoffrey, *Freedom, the Individual and the Law* (Harmondsworth: Penguin, 1989)

Rockett, K. *et al.*, *Cinema and Ireland* (London: Routledge, 1987)

Rolston, B. and Waters, H. (guest editors), *Race and Class* vol. 37, no. 1, July–Sept. 1995

* Ross, Andrew, *No Respect: Intellectuals and Popular Culture* (New York: Routledge, 1989)
* Royle, Trevor, *The Mainstream Companion to Scottish Literature* (Edinburgh: Mainstream, 1993)
* Rushdie, Salman, *Imaginary Homelands* (London: Granta Books, 1991)
Said, Edward, *Orientalism: Western Conceptions of the Orient* (London and New York: Routledge, 1978)
Said, Edward, *Culture and Imperialism* (London: Chatto and Windus, 1993)
* Sampson, Anthony, *The Essential Anatomy of Britain* (London: Hodder and Stoughton, 1992)
* Samuel, Raphael (ed.), *Patriotism: The Making and Unmaking of British National Identity: Volume 1: History and Politics* (London: Routledge, 1989)
* Samuel, Raphael (ed.), *Patriotism: Volume 2: Minorities and Outsiders* (London: Routledge, 1989)
* Samuel, Raphael (ed.), *Patriotism: Volume 3: National Fictions* (London: Routledge, 1989)
Sanders, Andrew, *The Powerless People* (London: Macmillan, Warwick University Caribbean Studies Series, 1987)
Saville-Troike, Muriel, *The Ethnography of Communication: An Introduction* (Oxford: Blackwell, 1982)
Scannell, Y., 'The Constitution and the Role of Women', in B. Farrell (ed.), *De Valera's Constitution and Our Own* (Dublin: Gill & Macmillan, 1988)
* Schiffrin, D., *Approaches to Discourse* (Oxford: Blackwell, 1994)
Scott, Paul H. (ed.), *Scotland: A Concise Cultural History* (Edinburgh: Mainstream, 1993)
Sharkey, Sabina, 'Frontier Issues: Irish Women's Texts and Contexts', *Women. A Cultural Review*, vol. 4, no. 2, 1993, pp.125–36
Sharkey, Sabina, 'Gendering Inequalities: The Case of Irish Women', *Paragraph: A Journal of Critical Theory*, vol. 15, no. 1, 1993, pp.5–23
Sharkey, Sabina, 'And Not Just for Pharaoh's Daughter: Irish Language Poetry Today', in H. Ludwig and L. Fietz (eds), *Poetry in the British Isles* (Cardiff: University of Wales Press, 1995)
Shiwcharan, Clement, *Effort and Achievement* (unpublished PhD dissertation, Centre for Caribbean Studies, University of Warwick, 1989)
Sinfield, Alan, *Faultlines: Cultural Materialism and the Politics of Dissident Reading* (Los Angeles and Oxford: University of California Press, 1992)
Singleton, D., *Language Acquisition. The Age Factor* (Clevedon: Multilingual Matters, 1989)
Skilbeck, M., *Culture, Ideology and Knowledge*, Open University Course E203, Unit 3 (Milton Keynes: Open University Press, 1976)

Smith, A.D., *Nations and Nationalism in a Global Era* (Oxford: Polity Press, 1995)

Smith, Dai, *Wales! Wales?* (London: Allen & Unwin, 1984)

Smith, G. Gregory, *Scottish Literature: Character and Influence* (London: Macmillan, 1919)

Smout, T.C., *A History of the Scottish People 1560–1830* (London: Collins, 1969)

Smout, T.C., *A Century of the Scottish People 1830–1950* (London: Collins, 1986)

Smythe, A., *Irish Women's Studies Reader* (Dublin: Attic Press, 1993)

* Soja, Edward W., *Postmodern Geographies: The Reassertion of Space in Critical Social Theory* (London: Verso, 1989)

Sperber, Dan, *On Anthropological Knowledge* (Cambridge: Cambridge University Press, 1985)

* Sperber, Dan, *Explaining Culture: A Naturalistic Approach* (Oxford: Blackwell, 1996)

* Sperber, Dan and Wilson, Deirdre, *Relevance: Communication and Cognition* (Oxford: Blackwell, 1986)

* Spivak, Gayatri, *In Other Worlds* (London: Routledge, 1988)

* Stephens, Meic (ed.), *Artists in Wales*, 3 vols (Llandysul: Gomer Press, 1971, 1973 and 1977)

Stephens, Meic (ed.), *The Oxford Companion to the Literature of Wales* (Oxford: Oxford University Press, 1986)

Stephens, Meic (ed.), *A Most Peculiar People: Quotations about Wales and the Welsh* (Cardiff: University of Wales Press, 1992)

Stern, H.H., *Fundamental Concepts in Language Teaching* (Oxford: Oxford University Press, 1983)

Street, Brian V., *Literacy in Theory and Practice* (Cambridge: Cambridge University Press, 1984)

Street, Brian V., *Social Literacies: Critical Approaches to Literacy in Development, Ethnography and Education* (London: Routledge, 1995)

Thomas, Edward, *House of America / Flowers of the Dead Red Sea / East from the Gantry*, ed. Brian Mitchell (Bridgend: Seren Books, 1994)

* Thomas, M. Wynn, *Internal Difference: Literature in Twentieth Century Wales* (Cardiff: University of Wales Press, 1992)

* Thomas, M. Wynn (ed.), *The Page's Drift: R.S. Thomas at 80* (Bridgend: Seren Books, 1993)

Thomas, Ned, *Derek Walcott: Bardd yr Ynysoedd / Poet of the Islands* (Cardiff: Welsh Arts Council, 1980)

Thomas, Ned, *The Welsh Extremist: Modern Welsh Politics, Literature and Society* (Talybont: Y Lolfa, 1991)

Thomas, R.S., 'Welsh', in *Welsh Airs* (Llandysul: Gomer Press, 1987)

Thomas, R.S., *Cymru or Wales?* (Llandysul: Gomer Press, 1992)

Thomas, R.S., *Collected Poems 1945–1990* (London: Dent, 1993)

Thomas, R.S., *R.S. Thomas: Selected Prose*, ed. Sandra Anstey (Bridgend: Seren Books, 1995)

Thompson, E.P., *The Making of the English Working Class* (London: Gollancz, 1963)

* Thompson, E.P., *The Poverty of Theory and Other Essays* (London: Merlin Press, 1978)

* Thomson, Derick S., *The Companion to Gaelic Scotland* (Oxford: Blackwell, 1983)

Thomson, Derick (ed.), *European Poetry in Gaelic* (Glasgow: Gairm, 1990)

* Tiffin, Chris and Lawson, Alan, *De-scribing Empire. Postcolonialism and Textuality* (London: Routledge, 1994)

Tiffin, Helen, 'Postcolonialism, Postmodernism and the Rehabilitation of Postcolonial History', *Journal of Commonwealth Literature*, vol. 23, no. 1, 1988, pp.169–81

Tomlinson, M., 'Can Britain Leave Ireland? The Political Economy of War and Peace', *Race and Class*, vol. 37, no. 1, July–Sept. 1995, pp.1–22

* Toolan, M., *Narrative: A Critical Linguistic Introduction* (London: Routledge, 1988)

* Trudgill, P., *Dialects in Contact* (Oxford: Blackwell, 1986)

* Turner, Graeme, *British Cultural Studies: An Introduction* (Boston: Unwin Hyman, 1990)

Vickers, Brian (ed.), *Shakespeare: The Critical Heritage Volume I 1623–1692* (London: Routledge, 1974)

* Wadham-Smith, Nick (ed.), *British Studies Now: The Anthology* (London: The British Council, 1995)

* Waites, Bernard, Bennett, Tony and Martin, Graham (eds), *Popular Culture: Past and Present* (London: Croom Helm, 1982)

Walcott, Derek, 'Caligula's Horse', in S. Slemon and H. Tiffin (eds), *After Europe* (Sydney and Aarhus: Dangaroo Press, 1989), pp.138–42

* Wallace, Gavin and Stevenson, Randall (eds), *The Scottish Novel since the Seventies* (Edinburgh: Edinburgh University Press, 1993)

Wallerstein, Immanuel, 'The National and the Universal: Can There Be Such a Thing as World Culture?' in A. King (ed.), *Culture, Globalization and the World-system* (London: Macmillan, 1991), pp.91–107

Walmsley, Anne (ed.), *Guyana Dreaming. The Art of Aubrey Williams* (Sydney and Aarhus: Dangaroo Press, 1990)

Walter, B., *Irish Women in London* (London: Ealing Women's Unit, 1989)

Ward, M., *Unmanageable Revolutionaries: Women and Irish Nationalism* (London: Pluto Press, 1983)

Watson, Roderick, *The Literature of Scotland* (London: Macmillan, 1984)

* Watson, Roderick (ed.), *The Poetry of Scotland* (Edinburgh: Edinburgh University Press, 1995)

Wiener, Carol Z., 'The Beleagured Isle. A Study of Elizabethan and Early Jacobean Anti-Catholicism', *Past and Present*, no. 51, 1971, pp.27–62

Wiener, M.J., *English Culture and the Decline of the Industrial Spirit* (Cambridge: Cambridge University Press, 1981)

Wilde, Oscar, *The Importance of Being Earnest* (London: Methuen, 1992)

* Williams, Glanmor, *The Welsh and their Religion: Historical Essays* (Cardiff: University of Wales Press, 1991)

* Williams, Gwyn, *An Introduction to Welsh Literature* (Cardiff: University of Wales Press, 1978)

Williams, Gwyn Alf, *The Welsh in their History* (London: Croom Helm, 1982)

Williams, Gwyn Alf, *When Was Wales?* (Harmondsworth: Penguin, 1985)

* Williams, J.E.C. (ed.), *Literature in Celtic Countries* (Cardiff: University of Wales Press, 1971)

Williams, Raymond, *Culture and Society 1780–1950* (Harmondsworth: Penguin, 1958; Revised edition, London: The Hogarth Press, 1993)

Williams, Raymond, *The Long Revolution* (Harmondsworth: Penguin, 1961)

Williams, Raymond, *Marxism and Literature* (Oxford: Oxford University Press, 1971)

Williams, Raymond, *The Country and the City* (London: Chatto & Windus, 1973)

Williams, Raymond, 'Base and Superstructure in Marxist Cultural Theory', *New Left Review*, Nov./Dec. 1973, pp.3–16

Williams, Raymond, *Television, Technology and Cultural Form* (London: Fontana, 1974)

Williams, Raymond, *Problems in Materialism and Culture* (London: Verso, 1980)

* Williams, Raymond, *Keywords* (London: Fontana, 1983)

* Williamson, Judith, *Consuming Passions: The Dynamics of Popular Culture* (London: Marion Boyars, 1986)

Winnicott, D.W., *Human Nature* (London: Free Association Books, 1988)

Wittig, Kurt, *The Scottish Tradition in Literature* (Edinburgh: Mercat Press, 1978)

* Wood, Ian S., *Scotland and Ulster* (Edinburgh: Mercat Press, 1994)

Worsthorne, Peregrine, 'Who'll Speak for England?', *Sunday Telegraph*, 25 November 1990

* Wright, P., *On Living in an Old Country: The National Past in Contemporary Britain* (London: Verso, 1985)

Young, M.F.D. (ed.), *Knowledge and Control* (London: Routledge and Kegan Paul, 1971)

* Young, Robert, *White Mythologies: Writing History and the West* (London: Routledge, 1990)

Zarate, G., *Enseigner une culture étrangère* (Paris: Hachette, 1986)

Index